New York, You're a Wonderful Town!

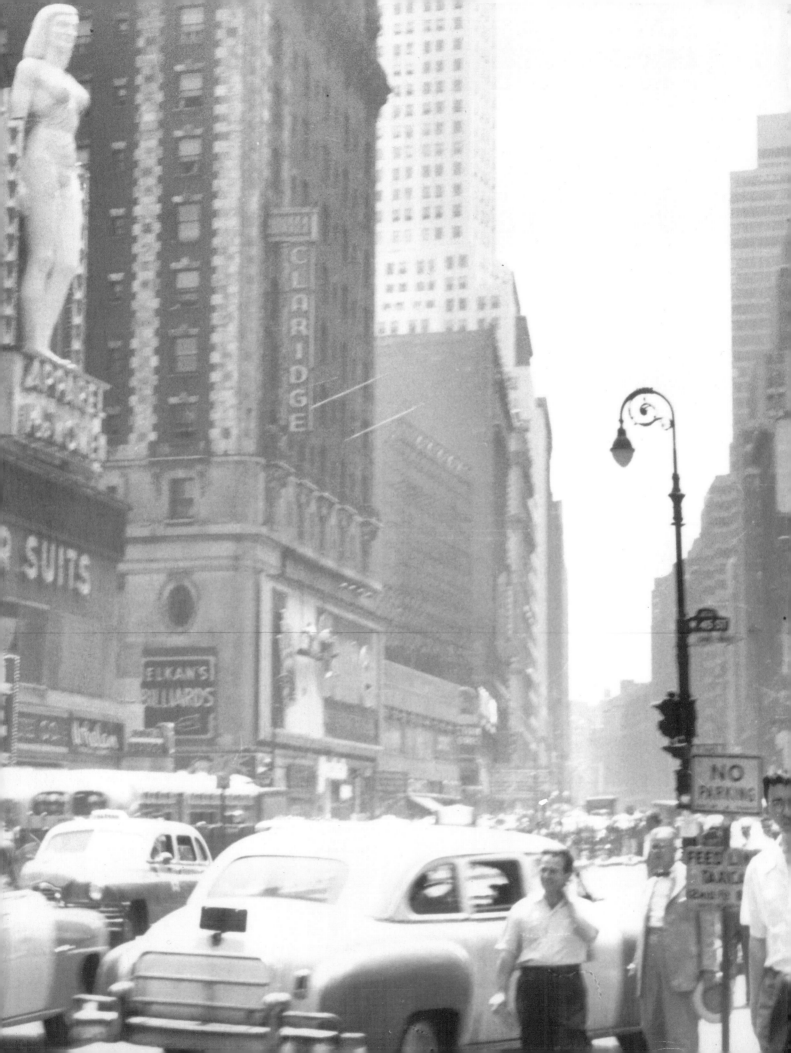

NEW YORK

You're a Wonderful Town!

Fifty-Plus Years of Chronicling Gotham

HENRIK KROGIUS

Arcade Publishing • New York

In memory of

Oswald Rothmaler
Peggy St. John
Charles M. Rice
Edgar Casparius
Hazel Bunce

FIRST EDITION

"Walking" by Frank O'Hara from *Collected Poems* by Frank O'Hara,
copyright © 1971 by Maureen Granville-Smith, Administratrix of the Estate of Frank O'Hara.
Used by permission of Alfred A. Knopf, a division of Random House, Inc.

Library of Congress Cataloging-in-Publication Data
Krogius, Henrik.
 New York, you're a wonderful town : fifty-plus years of chronicling
Gotham / Henrik Krogius. —1st ed.
 p. cm.
 ISBN 1-55970-698-8
 1. New York (N.Y.)—Social life and customs—20th century—Pictorial
works. 2. New York (N.Y.)—Social life and customs—20th century. 3.
New York (N.Y.)—Description and travel. 4. Krogius, Henrik—Homes and
haunts—New York (State)—New York. I. Title.
 F128.52.K73 2003
 917.47'10443—dc22 2003060082

Published in the United States by Arcade Publishing, Inc., New York
Distributed by AOL Time Warner Book Group

Visit our Web site at www.arcadepub.com

10 9 8 7 6 5 4 3 2 1

Designed by Charles Rue Woods

EB

Is seeing living?

Of a musician you might ask: is hearing living? How much does any one sense account for the experience of life? The moments of the city I've stopped with my cameras can't begin to tell the history of the city in my time, or of my time in the city. Nor can words. I'm forced to confront the realization that there is just too much—too much both "out there" and within me. Marcel Proust demonstrated how far a genius could carry verbal exploration of the world without and the world within, but even then he limited his canvas. Finally, there is incompleteness. Through word and image I can at best hope to stimulate associations, suggest allusions, and liberate memories that may enable you to create from this assemblage a degree of roundness, so that you may make and simultaneously eat your own cake, as it were—your experience of New York—and then judge whether it tastes good and is sufficiently filling.

In my notes, I find the worry that in trying to compose a record of the city as I knew it:

I was placing the specifics of the photographs—the photographs as bits of total recall—against the vagueness of my words, my memories. Not simply vagueness as a failure of recall about the receding past, but vagueness all along the line, in all confrontations with the here and now: satisfied not ever to be able to know all, or even enough, and not perhaps trying hard enough to know more.

And I had this stark thought: *The photographs stand as a contrast to my perceptions, my knowledge and my memory—perhaps even as a reproach.*

Without trying to read anything directly into the images before your eyes (you are free to read into them anything you want) I'm hoping to convey a sense of the multifariousness of the world, of which they are a tiny record. Through them I also hope to underscore that, in a time regarded as turbulent, life went on.

This book has had a long gestation. As winter turned to spring in 1959, I believed I had begun to see New York in a way people would find fresh and yet familiar. I had no thought then of a project that would span several decades. Rather, I was seeing a city that kept proclaiming: "*NOW!*" Developers were tearing down buildings with no regard to their possible historic value; only the new mattered. That then-current and very New York art form, Abstract Expressionism, had tossed all of art history on the dust heap—or so it seemed. In New York—no longer simply the world's financial capital but its cultural capital as well—everything was present tense. And yet, amid the changes, I felt I was capturing the reflection of an enduring New York essence that expressed itself not only through buildings but also through dress, mores, music, the ways of speech.

As a lover of cities, and this city in particular, I have always been interested in the everyday face of a city more than its noted sights or monuments. A city expresses much of its character at its street corners and in what goes on there. It can be as interesting at its edges as in its center. This, then, is a book by someone who has lived in a huge city for a long time and seen much of it, though by no means all (no one knows *all* of New York), and whose cameras have often caught more than he was aware he was recording. At the same time, it's not just a book of pictures. Words are also very much a part of experiencing the city—the life within it, and its relationship to the world outside. I hope that through the interplay of text and image I will have stirred memories and associations that bring alive the sense of a great city. Having in this new millennium already weathered a shocking tragedy, New York nears four centuries of existence with an undiminished blend of the buoyant, the brilliant, the determined, and the curmudgeonly.

—Brooklyn Heights, 2003

The city's towers, seen through the thriving leaves of Central Park, hinted at a season of life just beginning as nature's old year was dying.

STUDENT AND OFFICER
The Years to 1954

Most who have celebrated New York came from elsewhere. So did I, from quite far away, in fact. Still, I didn't come to the city entirely as a stranger. One of my great-grandfathers had settled in New York, and my mother was a born and bred Brooklynite. Then, too, my parents had brought me to New York for a visit two years before the permanent move.

My great-grandfather on my mother's side had been the New York agent for the Swedish-America Line and had acquired a weekly newspaper for Swedish-speaking Finns, a paper that he gave to his daughter and son-in-law to publish. Of their six children who survived to adulthood, my mother was the only one with some printer's ink in her veins, and she went to Columbia University's journalism school. Through the grapevine linking the immigrant community here with the old country, a young man in Finland with journalistic and literary ambitions heard of her and initiated a correspondence. The result was that she made a visit to Finland, met him, and they were married. I was the first product of their union (my brother, Tristan, followed four years later). My father, in the meantime, had been dissuaded by his parents from so uncertain, even disreputable, a profession as journalism and had become a chemical engineer. He was in charge of linen bleaching and dyeing for an iron-and-fabrics manufacturer, what you might call an early conglomerate, in the industrial city of Tampere, where I spent my earliest years.

I'm sure my mother always imagined an American future for her sons. By Finnish law you had to be seven years old to enter school, but the law didn't specify which grade. Knowing that most American children started first grade at six, Mother taught me at home for a year so that I could enter second grade at seven. She would tell me much later that I had complained about having to learn to read. "I can look at pictures and I can draw, and I don't need to read," I'm supposed to have told her. Perhaps that hinted at what would be my lifelong fascination with the visual, even if words and their use would in fact become my primary bread and butter. Some printer's ink must have been running in my veins, too.

On a somber last day of November 1939, when I was in the fifth grade, the awesome figure of the principal came into my geography classroom. A visit from him was out of the ordinary, and I sensed worriedly it had to do with me. "Henrik Krogius is wanted at home immediately," he announced. Oh no, I thought. Nobody had said so, but I was aware that my parents had been in long-distance telephone contact with my uncles and aunts in America—not routine communication in those days—and they had evidently talked about our going to America because war was looming. If we were going to have

a war with Russia, I wanted patriotically to stay in Finland with my friends and see it through. Disconsolately and anxiously I walked away from school along a sodden park path and dampened sidewalks.

When I got home I was told the Russians had bombed Helsinki, and my mother, brother, and I would be catching the afternoon train to Turku, the port city nearest Stockholm. Father would stay in Finland and help with the war effort. He took me aside and gravely told me I was now the man of our family, and I would have to treat my mother and brother with consideration. A bitter, frightening moment for a ten year old.

We caught the train, then an overnight steamer to Stockholm, from where, after a day or two, we traveled by train to Bergen, Norway, and boarded the recently built MS *Oslofjord* for New York. I have no idea how the arrangements were made—whether my father had ordered tickets, or whether my uncles had cabled travel funds—but it all went smoothly. (The *Oslofjord* was sunk a number of months later by German submarines.) It was just over a week before Christmas, 1939, when we entered spectacular New York Harbor. We were in the first group of refugees (a term my stylish mother disdained) from the Russo-Finnish Winter War. Reporters, coming aboard as the ship was still moving through the harbor, peppered Mother with

Arrive Here After Thrilling Escape From Finland

BROOKLYN EAGLE, SUNDAY, DECEMBER 17, 1

Packer Grad Tells of Flight From Finland

Arrives Here With First Refugees From Helsinki

The first Finnish refugees from the Russian invasion of that little country arrived here yesterday on the Norwegian-America liner Oslofjord, which docked at the foot of 58th St. Among those fleeing the Red drive over the little northern nation was a former Brooklynite, a Packer graduate, and her two children.

A few hours after the Oslofjord docked, the United States liner President Roosevelt sailed at 3 p.m. from Pier 59, foot of W. 18th St., Manhattan, for Bermuda, inaugurating a new American flag service between this port and the British-owned island resort, with 150 Christmas vacationists on board.

102 AMERICANS ARRIVE

The President Roosevelt is the first of the 11 United States Lines ships withdrawn from trans-Atlantic service because of the operation of the Neutrality Act, to get a new run. It is expected that the two crack ships of the line, the Manhattan and the Washington, will soon be put into service on the Mediterranean run to Italy.

The Oslofjord brought in 247 passengers, including 102 American citizens. Mrs. Valborg Antell Kroglus, 36, former Brooklynite, told a graphic story of their escape from Helsinki, Finnish capital. So did

Glad to be safe from invasion and bombings but worried about the fate of their husband and father are Mrs. Valborg Kroglus and her sons, Hendrik, 10, and Tristan, 6. They are staying with Mrs. Kroglus' mother, Mrs. Anna Antell, at 24 Monroe Place. They arrived yesterday on the Oslofjord, among the first group of refugees from stricken Finland. Mrs. Kroglus was born in Brooklyn and is an American citizen. She is a graduate of Packer Collegiate Institute and Columbia School of Journalism. She fled with her children from their home in Tammerfors, 125 miles from Helsinki, the day the Russians first bombed the latter city. Her husband, Helge, is still in Tammerfors. (Wide World Photo.)

BROOKLYN EAGLE ARTICLE, DECEMBER 17, 1939.

questions. The *New York Times,* the *New York World-Telegram,* and other papers told of our arrival, and the *Brooklyn Eagle* headlined our picture with the words "Thrilling Escape." On the strength of what Andy Warhol would have later called our fifteen minutes of fame, one of my uncles had no trouble getting scholarships for my brother Tristan and me to a Brooklyn private school, Adelphi Academy. I would spend almost five happy years there before moving on; the school's style seemed cheerfully informal after the rote learning and strict ordering of school in Finland.

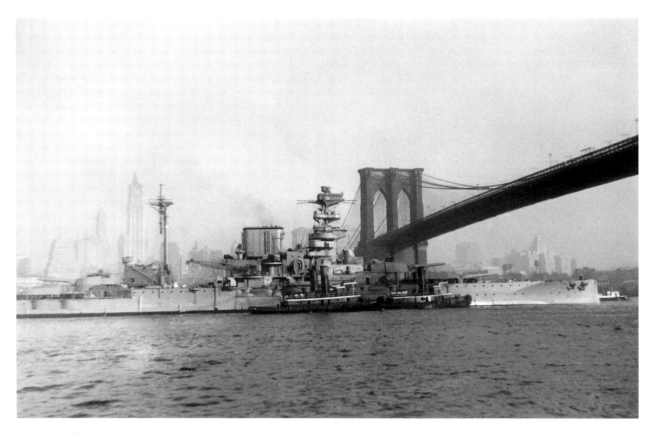

THE HMS *MALAYA* HEADS PAST THE BROOKLYN BRIDGE FOR REPAIRS AT BROOKLYN NAVY YARD, LATE 1940 OR EARLY 1941.

It must have been a year after our arrival that "Uncle Rote" Rothmaler, the husband of one of my aunts, gave me a Kodak 620 Brownie Special for Christmas. Maybe he saw a visual inclination in me. That simple box camera produced remarkably good pictures. One of the very early ones I took was of the HMS *Malaya* coming up the East River for repairs at the Brooklyn Navy Yard. I hurried down to Fulton Ferry Landing for a furtive shot of it, conscious that such photography was forbidden under wartime restrictions—even if the United States, while helping from the sidelines, had not yet formally entered the war. (Somehow, despite having jotted down "Malaya" in my scrapbook, I later came to believe I'd seen the powerful British battle cruiser HMS *Hood,* which was appallingly sunk in an encounter with the German battleship *Bismarck.* Not too long ago, however, someone addicted to naval history confirmed that my picture was indeed of the *Malaya.*)

I was probably exhibiting a not yet recognized instinct for journalism when I snapped the *Malaya,* but for the next several years I persuaded myself

that I wanted to be an architect. I went on to study architecture in college, and, when I took a trip back to Finland during a summer vacation, I mostly photographed the newer buildings in that forge of Modernism. After I got back to America I showed some of the results to the wife of the headmaster of a school I had attended, the vivacious Peggy St. John, who remarked: "Where are the people? I don't see any people in your pictures." How her reaction affected me should be obvious from this book, even though you will also find buildings here.

Constructing sentences, rather than designing buildings, seemed nevertheless to be what I did best. On graduating from college, where I'd taken part in the Air Force ROTC (Reserve Officers Training Corps, for those not attuned to military jargon or who don't remember the anti-ROTC ferment on campuses in the Vietnam years), I was assigned as a psychological warfare officer with a Swedish language specialty to Mountain Home Air Force Base, Idaho. (Although I had known Finnish as a child, my home language had been Swedish. Finland, having for some centuries prior to the

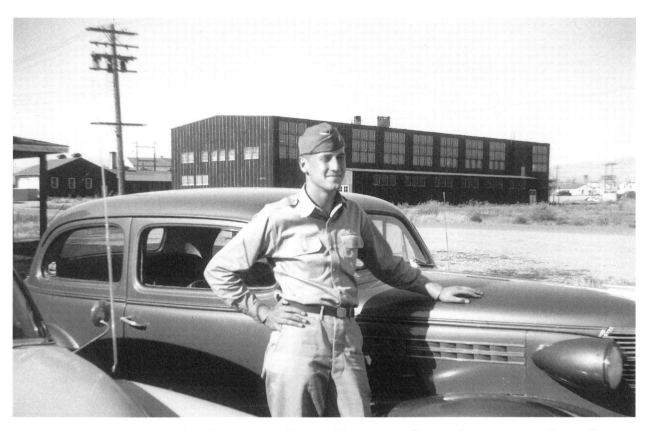

nineteenth been under Swedish rule, had many Swedes settling there—and the difficult Finnish tongue had slipped away from me in America.)

This was now 1951, and we were in the Korean War. For some unfathomable reason the Air Force had chosen to set up its new psychological warfare training center at a newly reactivated facility in the godforsaken desert of southwestern Idaho, a dilapidated base that had been closed down after World War II. Despite the romantic sounding name, the main scenic features were sagebrush and the carcasses of jackrabbits run over by pilots gunning their Hudson Hornets along dusty stretches of two-lane highway as if they were manning fighter planes. Our one research facility was a tiny public library in Boise, a sweltering hour-long bus ride from Mountain Home. Between what I found in the library's ancient *Encyclopaedia Britannica* and what I knew in my head, I wrote an "area study" on the region around the Gulf of Bothnia, which separates Finland and Sweden. Many months later, after I'd been away on temporary duty assignment, I found I couldn't get access to my study without clearance from my commanding officer; it had been classified.

We were a group of lieutenants, all college graduates, some with advanced degrees, exiled to this peculiar end of the earth. A half dozen or so of us liked to get together and agree that the United States was two coasts with a great void between. One fellow who joined our circle had been to St. John's College in Annapolis, but he hailed from Omaha. He suffered a bad loss of prestige in a debate over cocktail ingredients when he conceded he'd gotten his recipe for a French 75 from an Omaha bartender. Any Idaho girl we managed to date—including one dark-haired beauty I met— seemed not really interested in us, only in getting to New York. When my hand felt the stiff cup of her brassiere, it was as if I'd simply scraped the wall between us. And yet the lonely vastness of the place mirrored my own loneliness, almost consoling me when the one I thought to be my truest and most beautiful love stopped answering the letters I sent East. The rueful expanse of Idaho must have been designed to fit the poignancy of heartbreak.

I don't know if the Air Force brass recognized how ludicrous the Idaho base was for training area specialists and propagandists, but at least escapes were provided. A number of us got to spend a year in Washington at Georgetown University's Institute of Languages and Linguistics, where we received an excellent language brushup along with a rather Jesuitical view of the world. I was also given three months of propaganda training at the Army Psychological Warfare School in Fort Bragg, North Carolina. And, finally, I enjoyed half a year in the company of émigré intellectuals at the Voice of America, which was then based in New York, where I lived rent-free at home as a civilian while drawing per diem pay on top of my salary. There was wonderful conversation over inexpensive but delicious lunches at the Café Mont St. Michel, which then existed on West 57th Street. To be sure, there was supposed to be a price for these cushy assignments. For each one, I needed to sign up for extra time in the Air Force, and thus I was due to serve some four to five years. But then, while I was at the "Voice," a RIF (Reduction in Force) came through! The Air Force was having to cut its budget, and anyone who had served his required minimum time—mine was two years, which I had just completed—was eligible for discharge within thirty days. I quickly applied to the Columbia Graduate School of Journalism (it had been upped to "graduate" status since my mother's day), and, with my col-

lege record and military service, I was accepted despite the lateness of my application. The wonderful GI Bill would pay for my year's study.

Going to "J-School," as we called it, was in part an evasion of what I now felt as an obligation to stand on my own two feet. New York on my own, not as a guest of the Air Force, nor as a student home for holidays, but as a guy having to work for a living: that was a New York for which I had no emotional preparation—and no practical preparation. In fact, what did I really know of New York? I could say I knew Brooklyn Heights, where my family lived; something of the Times Square and Broadway area; a little of the Upper East and West Sides; downtown Brooklyn; a bit of Flatbush; I'd been on the Staten Island Ferry; I could get to Ebbets Field, Yankee Stadium, and the Forest Hills tennis courts, also Coney Island and the Bronx Zoo. Not much more. One day I walked along Fifth Avenue from the elegant uptown department stores (I'd been inside them) down to Washington Square. I hadn't known such a charming place existed! My Columbia year I discovered the city.

It was also more than that. Not only did I learn much I needed to know about reporting and organizing a news story; I also picked up important knowledge about photography and, quite unexpectedly, learned skills that would help lead to my eventual career in television news. While at the "Voice" I had moved up from my Brownie Special to a

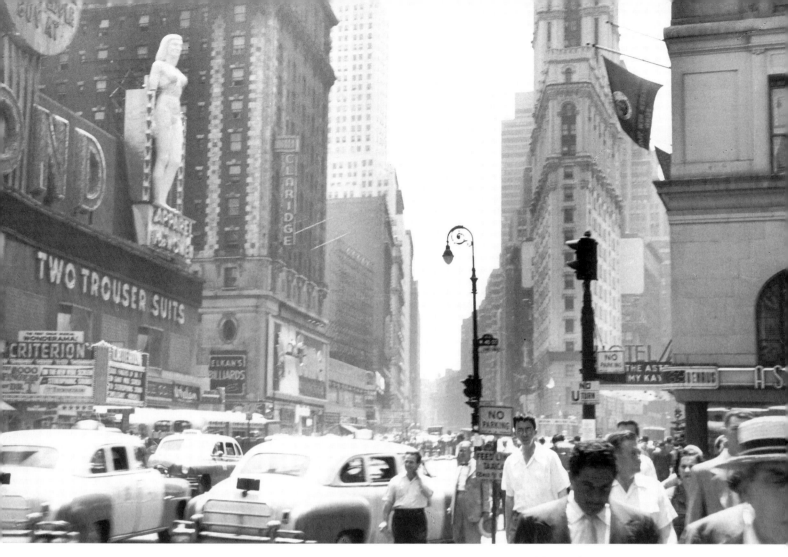

TIMES SQUARE, JULY 1953.

secondhand, 35-millimeter Voigtlander Vito II, and I began to see sunlight in the city in a new way. In Times Square I caught light washing over taxis and pedestrians in the canyon where Broadway and Seventh Avenue came together beneath towers and advertisements, including an artificial waterfall that didn't always fall and was flanked by a nearly nude male and maiden, who, strangely, represented ready-to-wear Bond Clothes. (But New York has always been marked by an off-and-on prudishness, and the male and maiden were soon replaced by giant Pepsi-Cola bottles.)

When Professor John Foster asked if any student would be interested in doing the camerawork for a student-produced weekly newscast to air on Channel 11 (then WPIX) I raised my hand, and lo, I became the program's cinematographer and film editor.

What a wonderful student experience that was—to air a program actually viewed by the general public, later impossible as even the non-network channels became more corporate. A kindly *New York Times* photographer named William Eckenberg taught me how to use the school's darkroom for developing negatives and printing pictures. (Later on I would set up makeshift darkrooms in the various places I lived.) And the demanding Professor John Hohenberg instilled both discipline in reporting and crucial advice on how to meet a deadline. No story could ever tell everything, he emphasized, and at some point—in the Hohenberg words engraved on the minds of generations of J-School graduates—"You have to go with what you've got." In other words, sit down and write as much as you know.

While, between school and a weekend copy boy's job at the *New York Times*, I had a pretty heavy schedule, I nevertheless managed to do a fair amount of photography just for myself. Probably unconsciously I was tapping into the spirit of the time. In the '50s we were officially still in the age of optimism, believing that things—machines, gadgets, things like cars—would solve real problems, including the ones that they themselves created. We still praised Robert Moses, the "master builder" who was bringing progress to New York. Just the same, I felt some underlying doubt, and in a notebook I wrote some lines under the title "Automobile":

Machine for chasing poetry,
You offer a phantom of escape,
An illusion of freedom.

Sleek,
powerful,
mysterious mechanism,
you promise to take us anywhere.

Your promise,
smooth as a politician's,
is just as false.

Weekend traffic,
Thousands of you,
piled one after one
in endless curving streams
past the next curve
and the hill after that—

This
Is what you
really give us.
Impatience,
Irritability
and only the barest glimpses of
poetry.

An arched overpass
amid foliage,
a reflecting pond
with children staring
at what we did not
have time to see,
the ascending curve
of the Whitestone Bridge
about to take us with its
beautiful rhythm
to infinity
(and depositing us only
in the traffic
on the other side).

These are the brief glimpses
we had of poetry.
We could not stay.

And on the return
we saw only more and more and more
cars,
And when we got back
the demands of the world
seemed more burdensome
than ever.

Still, I don't suppose many people then—certainly not I—could have imagined that serious thinkers would one day be advocating a ban on cars in the city.

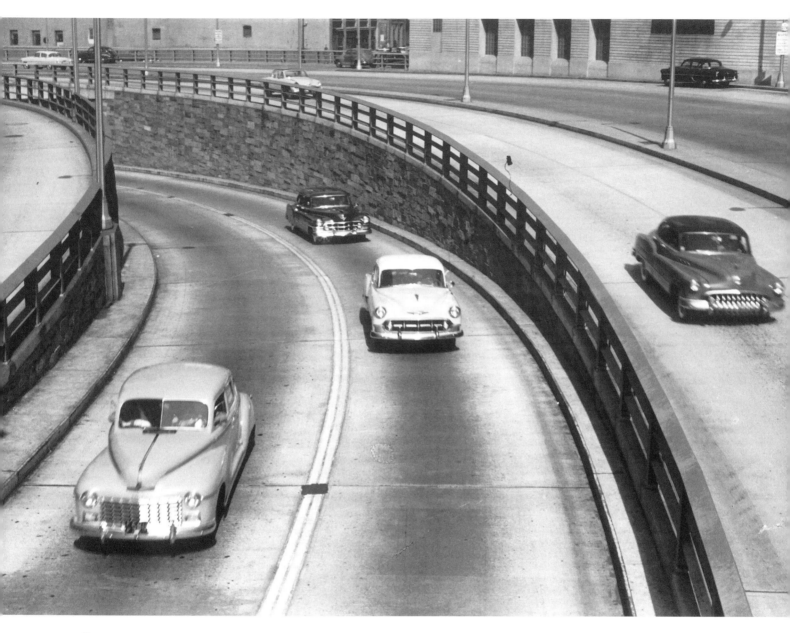

CARS APPROACHING THE ENTRANCE FROM TO THE THEN STILL NEW BROOKLYN–BATTERY TUNNEL FROM MANHATTAN, OCTOBER 1953.

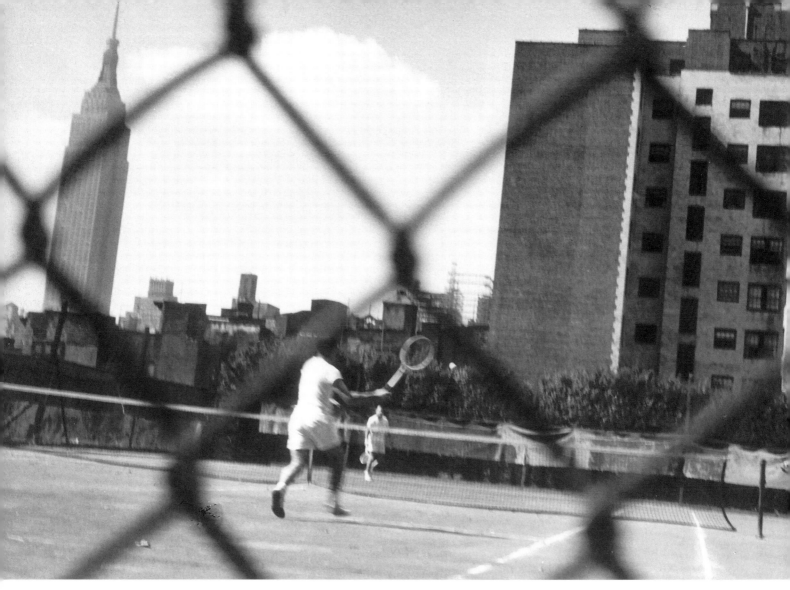

TENNIS AT TUDOR CITY NEAR 42ND STREET AND THE EAST RIVER, OCTOBER 1953.

The city was obviously frayed at the edges (at least, what seemed to me its edges), yet neither cars, nor slums, nor racial problems felt immediately threatening. The main threat was one's failure to make it in a city full of possibilities and amenities. "Amenities"—that's a word we only started using in the '60s for what we thought we had lost; I don't think we used it in 1953. *Then* it was possible to play outdoor tennis at Tudor City, within the shadow of the Empire State Building (not every lot in Midtown had yet been turned into an office building or a pending-construction parking lot). Outdoor tennis was not only possible but seemed within reason, in the middle of Manhattan.

Through these pages I make an effort to recall

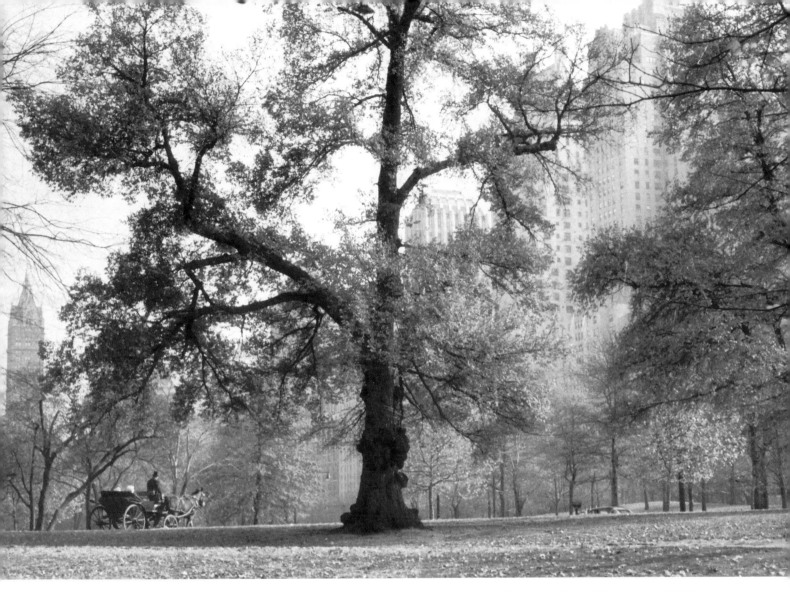

CENTRAL PARK, NOVEMBER 1953.

how it was, and how it changed—through memory of my awareness as it was, and how my perceptions developed, and through more "objective" sources like newspapers and television. My camera has, of course, been objective at least to the extent that it has always seen more than what I was consciously selecting at the time of taking a picture. In my writing, I've made an effort to distinguish between my later consciousness and my consciousness at the time. Whatever the city's changes—what I would call a New Yorkishness—ties time and place into a continuum with an enduring and recognizable identity. Anyone living here over the same period of time could have seen what is here recorded—by far, most of the pictures were taken in the public streets—and my hope is that you will find something of your New York, its lights and darks, in my New York.

New York in the fall of 1953 was not a place to accept or reject, but a place to be measured against. By god, it was there, and you had to have a pretty unromantic soul not to feel your aspirations going out to meet it. The city's towers, seen through the thinning leaves of Central Park, hinted at a season of life just beginning as nature's old year was dying. New York had not banished nature, not entirely, but had instead sprouted something that seemed almost greater than nature: the soaring habitations of humanity creating its own new universe.

To be sure, there were warning signs that this was a risky business. Later in the same month that Central Park had looked like such a dream, a smog hung over the city for six days, held there by a warm layer of air that formed a ceiling at about six hundred feet. People coughed and their eyes smarted, but they weren't yet talking knowledgeably about "inversion"—a term that was soon to come into play. Indeed, the smog itself looked kind of dreamy. (Later, quietly, it was estimated that 220 people died because of it—a low toll compared to the 4,000 deaths ascribed to a London fog the previous December.)

And the smog went away. Other problems remained, but they weren't *everybody's* problem. Some white people feared the city was being inundated by a Puerto Rican invasion; they hardly thought about the Negroes (the common term of the time), who were considered dormant in Harlem and giving little visible trouble. The Supreme Court's school desegregation ruling was several months in the future, and when it came there was no immediately noticeable change in New York: it was a matter for the South.

SMOG HIDES ALL BUT THE TOPS OF LOWER MANHATTAN'S TALLEST TOWERS, NOVEMBER 1953.

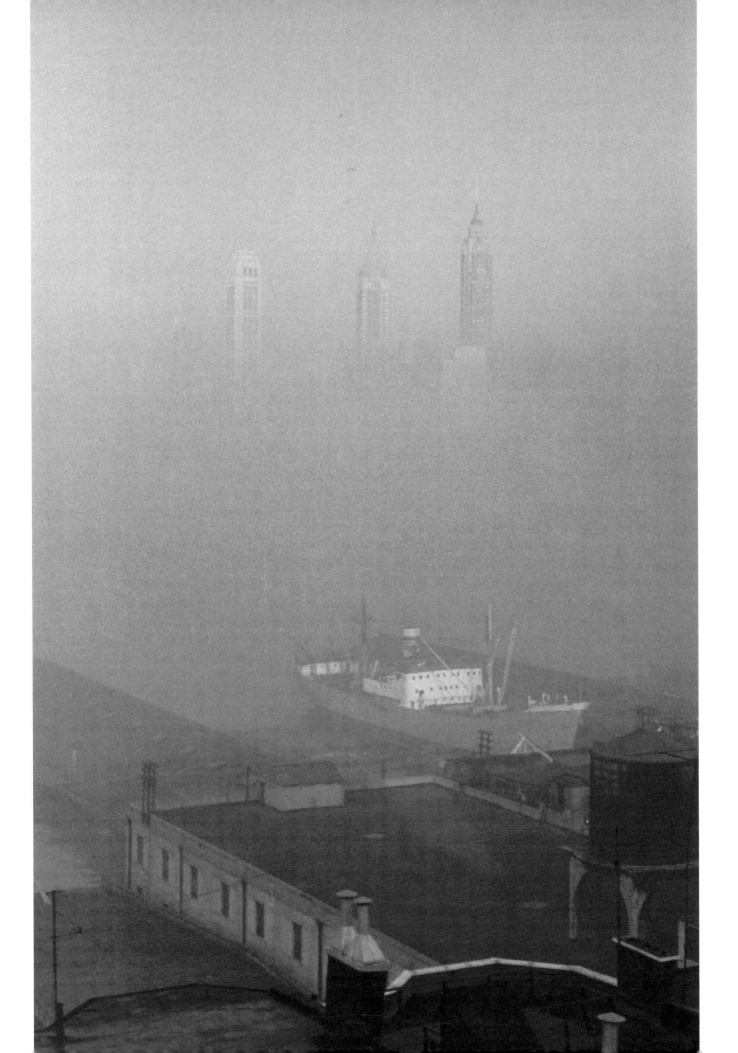

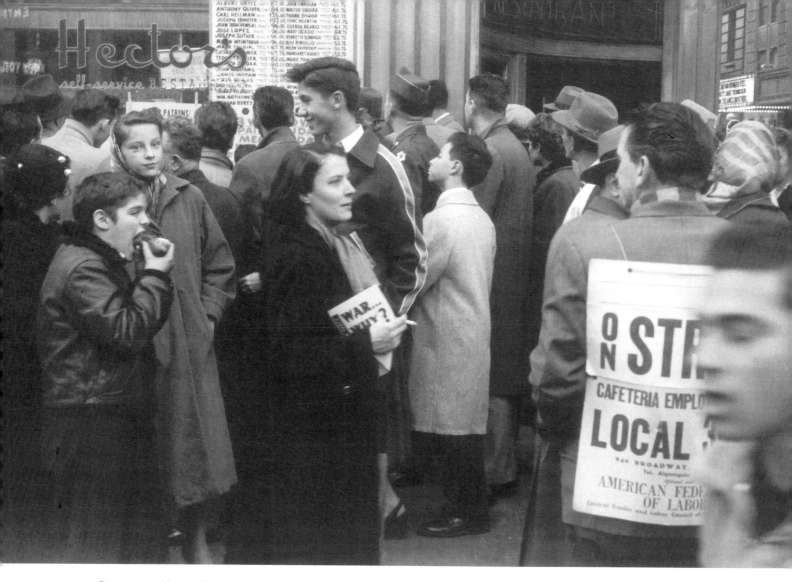

OUTSIDE A TIMES SQUARE CAFETERIA, PEOPLE CROWD PAST STRIKING EMPLOYEES TO READ THE MANAGEMENT'S SIDE, WHILE A TALL YOUTH NOTICES A GIRL AND A WOMAN CARRIES AN ANTIWAR SHEET, NOVEMBER 1953.

All the same, there were strikes, there was crime, there were gangs of youths fighting for domination of their turfs. People looked up from their newspapers and agreed that the city was in a hopeless mess. Yet life went on. The longest daily program of local television news lasted less than ten minutes. Unquestionably, though, the news was becoming more a part of people's lives, and would become even more so in the '60s, making people believe things had become much worse. Now, looking back from decades in the news business, having acted for years as a funnel for bad news, I'm sure I've become infected with a sense of a deteriorating world. Nevertheless, as I've wandered the city through the years, what I've come across has not been made up of demonstrations,

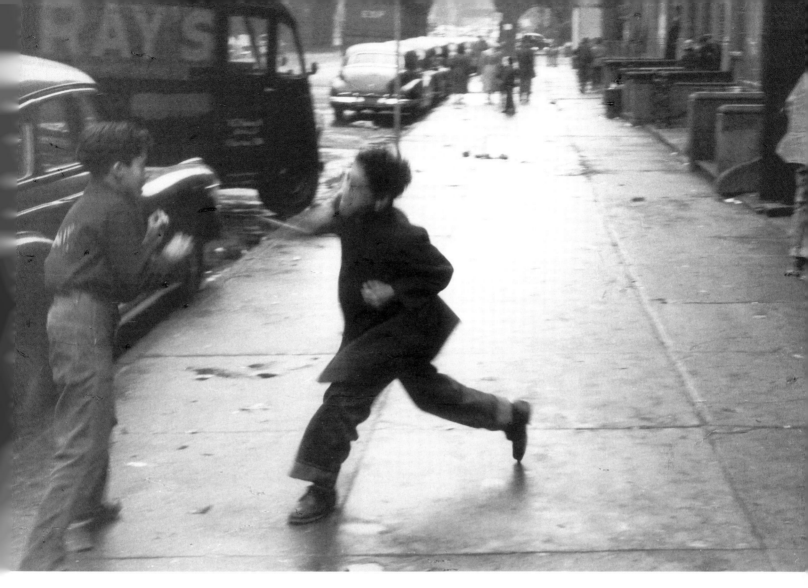

BOYS FIGHT ON EAST 106TH STREET. THE PARK AVENUE VIADUCT OF WHAT WAS THEN THE NEW YORK CENTRAL RAILROAD IS IN THE BACKGROUND, MARCH 1954.

riots, murders, or disasters. I've only most rarely happened across anything that would fit the usual notion of a news event.

Still, in my movements about town those years of 1953 and 1954, I saw almost as much that was disturbing as I've seen since. Some of it was by way of J-School assignments, like a visit to a police lineup. In my jottings I find an entry for February 3, 1954: *Morning: police lineup—the woman who stole to support her husband; Angel, the dope addict.* My jottings were often very cryptic; I suppose I thought the barest phrase would later recall the whole scene to me. For the same date I noted that I had been at a cocktail party in the early evening and had *discussion with a German girl about European and American values—realization of importance of* <u>protest</u> *in formation of*

American values antagonistic toward European cultural values—problem of transmitting to Europe a true American view of America. I don't know precisely what I meant by that, but I'm interested to see I underlined *protest*. The entry shows I had a date with another girl that night, and I commented about her *naive and confused economic thinking and people mistakenly thinking her a pro-Communist.* I'm sure it was all very platonic, and it sounds boring now; but it does hint at some small stirrings of dissent. These were the waning days of McCarthyism, a time when all questioning was suspect, but I was hardly enough of a dissenter or a person of sufficient consequence to feel in any personal danger.

Mostly my entries expressed anxiety about the career ahead and whether, and with whom, I was in love. I worried about the need for discipline. But New York as such was not a problem. New York meant things like a good Chinese restaurant or an affordable, good steak house. One day in Chinatown I overheard a guide tell a group of tourists on Doyers Street, "More murders were committed on this corner. . . ." In peaceful Chinatown! I couldn't believe it, but I enjoyed the apprehensive reactions of the tourists. Some years later there would be a return to violence in the area, as rival gangs extorted protection money from merchants and fought each other, and the established Cantonese felt beset by arrivals from other parts of China.

The more the unusually warm and sunny spring of 1954 wore on, the lovelier New York seemed. One Saturday night I was moved to comment:

The blue of the evening had not yet surrendered to night. The sky had perhaps a touch of green, the darker water a rich true blue. An unpictureable beauty lay on the harbor—a peaceful look such as one hardly associates with New York. The outline of the skyline clear but quiet (for on Saturday night the lights are few) like a mountain beside a lake. The yellow lights on a few small boats: touches of human contentment in the great scene.

Yet that spring was not without its damper days. Rain let up only long enough for an early May ceremony to mark the end of a four-year overhaul of the Brooklyn Bridge; vehicular lanes had been increased from four to six, trolley tracks were

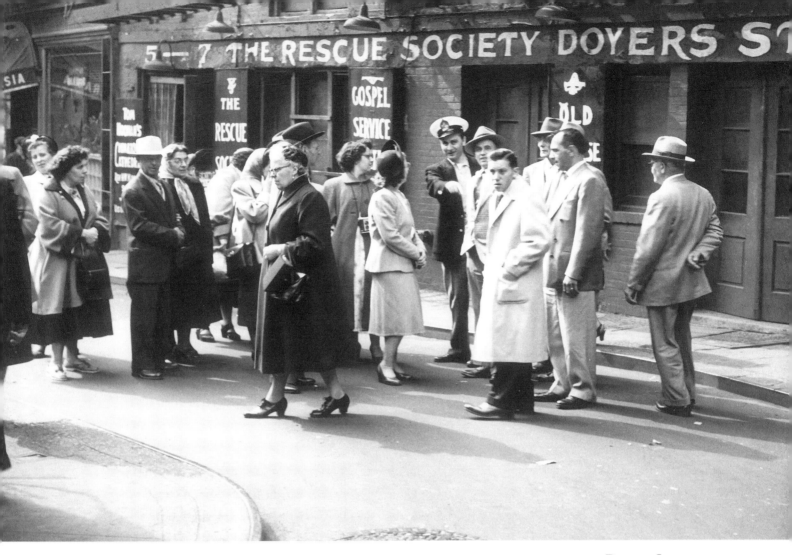

SIGHTSEEING GUIDE TELLS TOURISTS OF MURDERS COMMITTED AT THIS SITE, DOYERS STREET, CHINATOWN, MAY 1954.

eliminated, and decades of grime had been cleaned from the towers to reveal surprisingly light, pinkish stonework. Closed during the overhaul, the walkway was now reopened, and I had it all to myself as I strolled across four days after the opening ceremony and photographed the bridge's cables and their reflection in the wetly glistening walkway boards.

I did very well at J-School, winning a Pulitzer Traveling Scholarship as the year ended. When the award was first established by the publisher Joseph Pulitzer the stipend of $1,500 had been a generous sum, but it had not been increased in the intervening decades, and by 1954 it wouldn't begin to cover what it had been intended to cover—a year abroad. Most recent winners had gone abroad for maybe a couple of months, but I had in mind to

spend a year girdling the globe, using what I had saved from my Air Force pay to stretch out the grant. During the J-School year I had also worked as a weekend copy boy at the *New York Times,* and I thought the Pulitzer award would help me land a reporter's job there on my return. Disparagingly, the assistant managing editor for personnel told me, "A year on the *Herald-Tribune* would be my idea of a scholarship." At the *Wall Street Journal* I was told, "One of our fellows turned down one of those a few years ago, and now he's slot man on the copydesk." A slot man was the editor at the center of a horseshoe-shaped copyediting desk who assigned articles to other editors and endorsed the edited result. I didn't have the least ambition to be a slot man. I also came away with a feeling that some New York newspaper people had a shockingly parochial outlook.

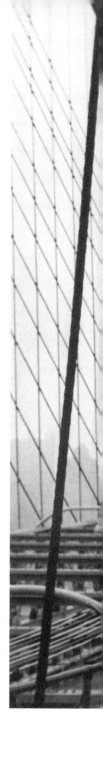

Nevertheless, those editors' reactions fed self-doubt and uncertainty. David Riesman's *The Lonely Crowd* spoke to members of my generation, as we grappled with vague but nagging feelings of discontent while prosperity was being continually advertised to us. I fastened on a description of the "other-directed" person: "He is often torn between the illusion that life should be easy, if he could only find his way to the proper group-adjustment practices, and the half-buried feeling that it is not easy for him." Still, I preferred to think of myself as more "inner-directed" than "other-directed." In a way, I suppose that Riesman grew out of Dale Carnegie and other, earlier self-improvers: the emphasis was still on judging the individual in terms of his adjustment to society rather that on judging the society (the system) on its relation to the individual. We hadn't yet hit on the "establishment" as that which we could set ourselves against.

In any event, I went ahead and spent thirteen months traveling as cheaply as possible ever eastward (with some jogs), writing as a stringer for the now-defunct syndicate, North American Newspaper Alliance (NANA), making my grant go as far as India, where I was employed for a couple of months at a literacy training center run by a woman I had met in New York. I continued on Air Force savings around Southeast Asia to Japan, where, through an old friend of my father's, the Finnish consul, I got a free passage across the Pacific working as an engine room wiper on a Norwegian freighter. I spent almost my last dollar on a Nikon camera for my father, and, when I reached San Francisco, had to borrow from the grandmother of a college room-

NEWLY REOPENED BROOKLYN BRIDGE WALKWAY, MAY 1954.

mate to pay for the Greyhound bus fare back to New York. At one point, during a stop in Taiwan, an American correspondent who had bought me a drink in a bar had warned, "Don't ever tell an editor in New York how far you've traveled on so little money."

Those were thirteen months in which I took no New York pictures. When I returned, I could no longer put off getting a job. Going into any kind of business still frightened me and seemed to require giving up everything that was worthwhile for a career of combat, but I didn't think I had any right to question the necessity of it. I understood that was what we were on earth for, and I would have to prove my adequacy. The 1950s were a time of going along with a promise and belief we didn't quite believe in.

If an unmarried person is going to be unhappy, he or she isn't going to be more unhappy for being in New York than anywhere else. It was then—and I would guess it still is—the place to be single.

EARLY CAREER DAYS
1955 to 1963

ooking for a job had to begin in earnest. I applied to a number of newspapers, including some in New Jersey. As I was getting into the round of interviews, an unexpected call came from Columbia. A young producer named Ted Yates had asked the school to suggest a graduate with some knowledge of film and pictures to write for a twice-daily television news program soon to start on Channel 5, then WABD, the chief station of what had briefly been the DuMont Television Network. The pay was half again as much as most newspapers were offering.

I wasn't sure this was something I wanted to get into, but I went for an interview, was impressed by the gung-ho enthusiasm of Yates, recently of the U.S. Marines, was offered a job, and took it. The station's innovative, if quirky, general manager, Ted Cott, had brought in an actor from Chicago, Mike Wallace, to be the anchor. A—compared to me—veteran TV news writer named Bill Kobin (he must have had a year's experience) would edit and write the national and international news, while I did local and entertainment news, as well as shooting publicity stills. A receptionist, secretary, and girl Friday named Marlene Sanders—who might have been another Barbara Walters or Diane Sawyer if she hadn't come along before the networks were ready for women news personalities (she did eventually become a correspondent and executive at ABC News and then a correspondent for CBS News)—kept the chaotic operation more or less together.

We worked from early in the morning until close to midnight, frantically trying to discover what we were doing. We had little to work with: we bought the syndicated newsfilm service and rented one crew locally from the Hearst-owned Telenews. And we took one wire service, the gossipy INS, also from Hearst. Without the late afternoon editions of the *World-Telegram* and *Journal-American* we'd never have filled the seven o'clock show, and without the early evening first editions of the *News, Mirror,* and *Times* we couldn't have updated for eleven. Ted Yates had the dramatic idea of placing a camera up high to shoot down on Wallace as he strolled around a huge map of New York City. The idea was abandoned when Mike's footprints proved all too visible. Our first dress rehearsal was a disaster. Nobody knew how to plan the length of the show, and what should have been fitted into a half hour spilled over by more than fifteen minutes. Afterward Cott eloquently ripped us apart—Ted, Mike, Bill, me, the director, the stage manager, everybody—but somehow we survived and managed to get the show on and off on time when it actually aired.

Some years later, doing a Middle East story for *David Brinkley's Journal* at NBC, Ted Yates was hit by a fatal bullet in Jordan. Mike Wallace, by contrast, would enjoy a long career. Under Ted Cott's tutelage, he became the anchor for *Nightbeat,* the first tough interview show on television, which eventually led to his role as the hard-hitting investigator on CBS's *60 Minutes.*

MIKE WALLACE WAITS IN FRUSTRATION FOR A PRODUCTION PROBLEM TO BE WORKED OUT, DURING REHEARSAL FOR HIS NEWS ANCHOR DEBUT ON DUMONT TELEVISION, OCTOBER 1955.

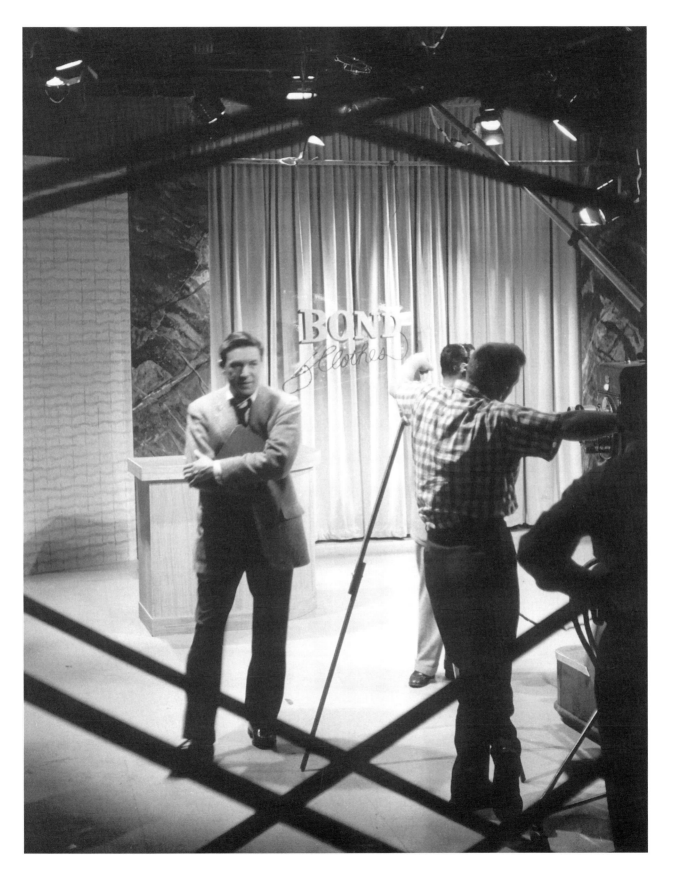

Meanwhile, the city I had returned to was changing faster than ever. As progress continued, by and large we accepted—if not always enthusiastically—the inevitability of it, the . . . well . . . progress of it. Manhattan's last elevated, the Third Avenue El, was torn down, opening the avenue to daylight and new building. Some of us regretted that it meant the end of the quaint old el stations and the likely end of the old, cheap Third Avenue saloons. I've never been good at remembering and telling jokes, but talk of Third Avenue provides me with an excuse to retell a joke I can still recall from the Korean War period: The son of South Korea's President Syngman Rhee had been given a job on *Life* magazine by Rhee's friend Henry Luce, and the young man later failed to show up for work for several days, until finally half the staff of *Life* was sent out to look for him. A reporter turned him up at a Third Avenue bar and exclaimed: "Ah, sweet Mister Rhee of *Life,* at last I've found you!"

So much for my taste in jokes. Anyway, there was no effort—certainly no concerted effort—to halt the demolition of the el until that never-never Second Avenue subway could replace it. Those who suffered on account of progress had to shift as they could. Slums were cleared with hardly a thought for rehousing those displaced. New York was under a one-party system—the Democratic machine well entrenched with as yet no obvious sign of any reform splinter. There was just the beginnings of an awareness that the city was being allowed to change in ways that were not necessarily for the greatest benefit to most of its inhabitants.

LOOKING SOUTH ACROSS THE REMAINS OF THE THIRD AVENUE EL FROM NEAR 67TH STREET, OCTOBER 1955.

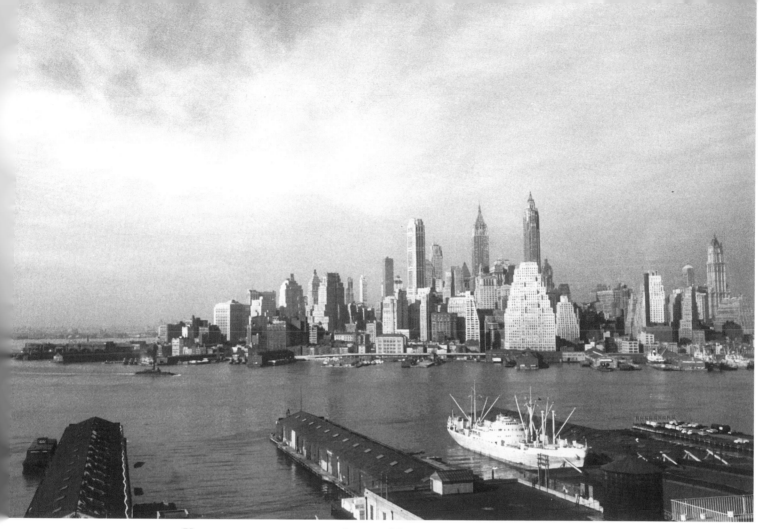

VIEW OF THE HARBOR AND LOWER MANHATTAN FROM MY ROOM IN BROOKLYN HEIGHTS,
JANUARY 1956.

WHITE HORSE TAVERN, AUGUST 1956.

At the same time, television and its commercials by and large sanctioned the official view of things, and most people of voting age clung to that. They would return Dwight Eisenhower to a second term with a landslide majority

Actually, though, 1956 was a rather newsy year. Arthur Miller married Marilyn Monroe shortly after testifying before the House Committee on Un-American Activities that he had once been involved with Red Front groups, but he refused to name other participants. The *Andrea Doria* went to the bottom of the sea after a collision with the *Stockholm*. The Hungarians rebelled against Communist rule, but their uprising was crushed by Soviet force. Israel was joined by Britain and France in a military attack on the Suez Canal after Egypt's Gamal Abdel Nasser had nationalized it, but the United States made the attackers pull back.

On the day after Nasser seized the canal, I was standing in a movie line with my erstwhile colleague Bill Kobin, and we clucked our professional disparagement over the *Times* having bannered a second-day headline of the *Andrea Doria* disaster above a much smaller headline about Nasser's action. We agreed there would be trouble over the Middle East for years to come, and we blamed it on Secretary of State John Foster Dulles's shortsightedness in having withdrawn American aid for the construction of the Aswan Dam. As we saw it, Dulles was too rigid in his judgment of the politics of non-Western nations and too blinded by Cold War concerns to appreciate the aspirations toward modernization in the Arab world, of which Egypt was then a conspicuous leader.

It was time to say farewell to my beloved skyline, as another new beloved had entered my life. Telenews, the service that had supplied newsfilm to WABD, hired me as a writer, and there I began an office romance with the young woman who handled client relations. I took a studio apartment in Greenwich Village. At the insistence of my new girlfriend I entered psychoanalysis. This was almost de rigueur at the time. I won't say it didn't help, but the marriage we entered into in 1957 was nevertheless too soon, at least for me, even if I was twenty-eight. Marriage meant *settling* in New York, becoming involved with leases, furniture, dinners at friends' apartments, and reciprocal dinners home. We still partook of New York's off-Broadway shows, art openings, and occasional restaurant dinners. But New York was not there on the same platter, and the change made me aware that I had never really thought of myself as living out my days in the city.

THE MOON SEEN OVER THE HARBOR OFF THE TIP OF MANHATTAN, FROM BROOKLYN HEIGHTS, JANUARY 1957.

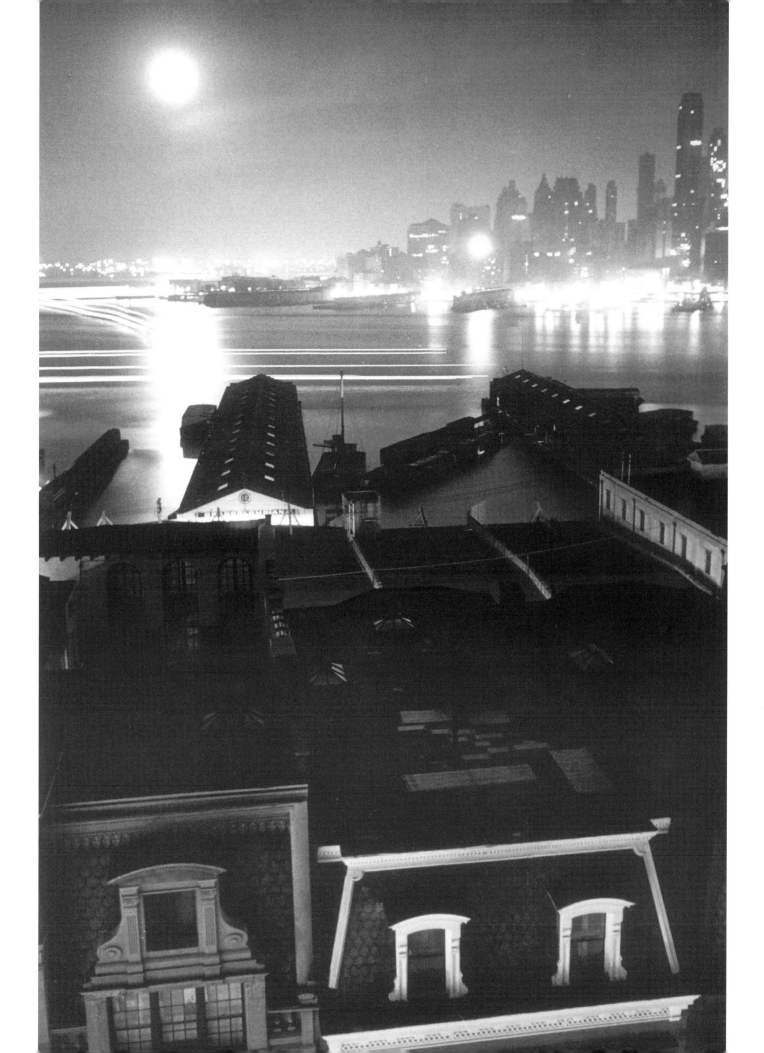

ack then, to sit on a park bench with a newspaper in one's declining years hardly seemed to me the attainment of life's goal. As a city boy, who even as a child in Finland lived in an apartment building, I had always had a sentimental longing for the country. The ultimate dream was Tennyson's

> *. . . island-valley of Avilion:*
> *Where falls not hail, or rain, or any snow,*
> *Nor ever wind blows loudly; but it lies*
> *Deep-meadowed, happy, fair with orchard-lawns*
> *And bowery hollows crowned with summer sea . . .*

Ask me now to name a place other than New York where I would like to end my days, and I can't do it. Having traveled on every continent except Antarctica, I can't think of a place (given total economic freedom) I would wish to settle in more than New York. Yet it has taken me a very long time to get over the sense that ultimately New York does not seem to be a place to *be*. Perhaps there has been a vestigial need for family or clan—however much I might chafe against it—which did not seem to be answered by New York's restless, crowded presence. On one of my early return visits to Finland, my father's brother (Swedish has one word for that uncle, *farbror,* and another for a maternal uncle, *morbror*) immediately took me to my grandfather's (*farfar*'s) grave; and I felt, if I ever wished to claim it, that here I had a place in the order of things, even if it was an estranged order. By comparison, what can a New York cemetery offer, even if both my father and mother are buried in one? Then again, I no longer feel a cemetery serves much desirable purpose. I believe in simply leaving the world, such as it is, to future generations.

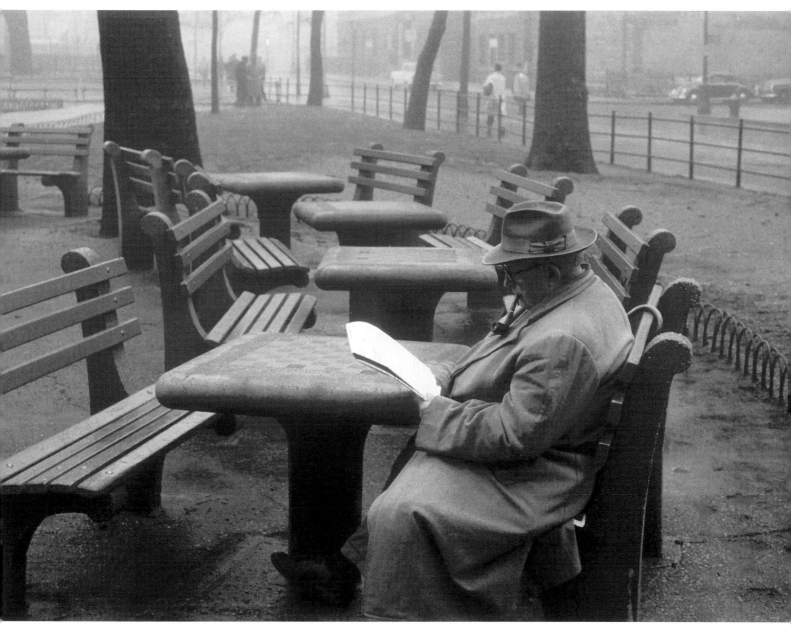

WASHINGTON SQUARE PARK, FEBRUARY 1958.

New York's attraction depends on one's sense of discovery. You have to come to terms with the city's complexity, be able to thrive on its changes and fashions. To do that, you have to find patterns within the seeming chaos, and the bigger and wider the patterns, the more nearly you encompass it. A less pressing job—writing a handful of thirty- to ninety-second film scripts daily was a vacation compared to WABD—and a more settled life also made the city seem less overwhelming. In 1959, with my camera I discovered a pattern of Manhattan that excited me: the pattern of the accidental vista. Previously, New York's architecture had bothered me: it had looked like an undistinguished and undistinguishable jumble. Considerable fuss was being made about Mies van der Rohe's new Seagram Building on Park Avenue, but to me it lacked a forceful presence; I didn't feel properly moved. In my photographs of it, the building seems to fade—tastefully, to be sure—into the setting of the new commercial Park Avenue. (A *New Yorker* cartoon made a wry comment, not necessarily about the Seagram, when it showed two men looking along a row of office buildings, with one of them remarking something like: "I understand the fourth one is by a famous architect.") But then, one late March afternoon, I realized that New York's buildings best fade into a pattern more striking than their individual selves.

I looked up and down the avenues and along the streets, and—with a 90-millimeter or a 135-millimeter lens on my secondhand Leica—I felt I was pulling in something of the distant promise and elusive glory of New York. For the first time, too, I felt that the longer lenses were giving me more than they were leaving out. And so, in 1959, I had a long-lens love affair.

FROM LOWER FIFTH AVENUE, MARCH 1959.

I looked along the unrelated facades and past the signs, across the pavements and tops of cars, to patterns beyond patterns of buildings forming and re-forming as I moved toward them. Packed in among the skyscrapers whose tops disappeared somewhere above my head, assaulted by signals and billboards, caught in impatient crowds, I saw the city with a new coherence by recognizing that it existed at different and separated planes of vision. Manhattan was not planned to be a skyscraper city and it was not a place for seeing buildings as such— but rather for seeing untrimmed rows in an orchard of uneven buildings. A row might lead nowhere— most of the vistas were unending, unclimactic—but every step toward the anticipated end meant a new juxtaposition of elements in the plane of my vision.

Cross any street and there it was: the omnipresent, accidental, onward-drawing vista—like a picture on a screen just beyond arm's length. You couldn't get closer to the pattern you saw (only to specific objects in it) by moving toward it; your movement only created new vistas, new patterns—each existing only at the point where you happened to be at the moment.

Sometimes I felt tempted to keep snapping as I walked along, except that the results would have looked as much repetitive as different from one another. I didn't anticipate that there would come a school of photographers whose very aim was to record slight variations in similar objects and scenes. I don't think I would have been interested in that even if I had anticipated it.

LOOKING UP BROADWAY TOWARD TIMES SQUARE,
APRIL 1959.

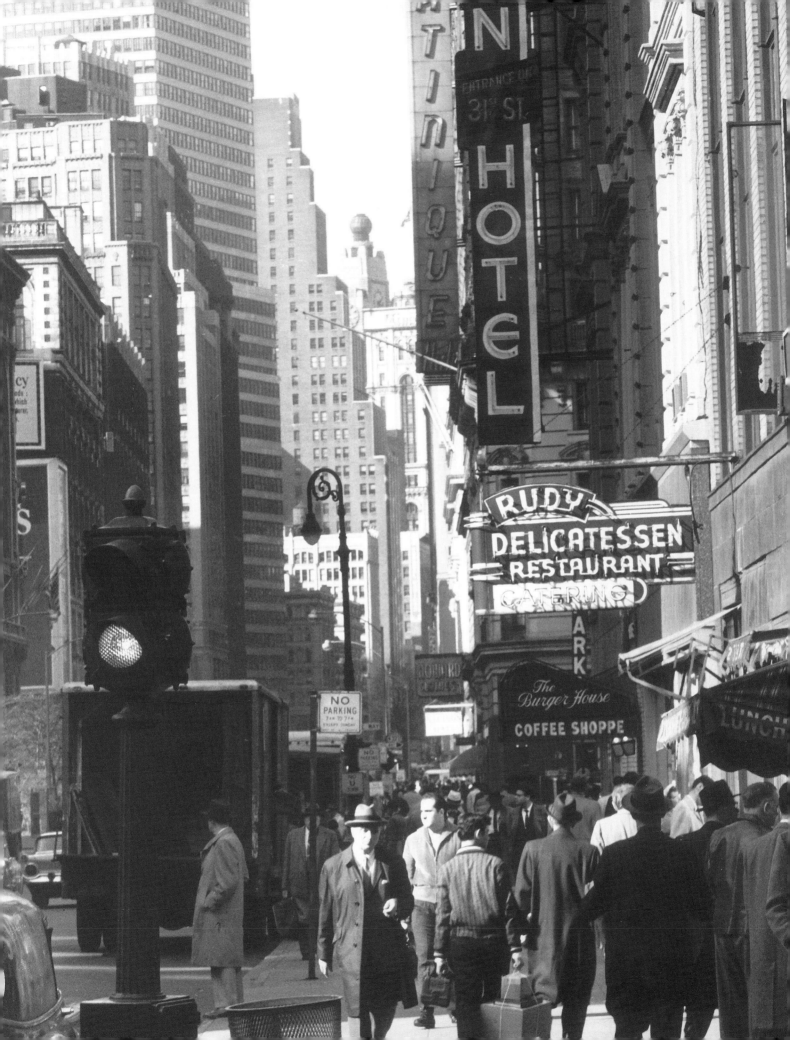

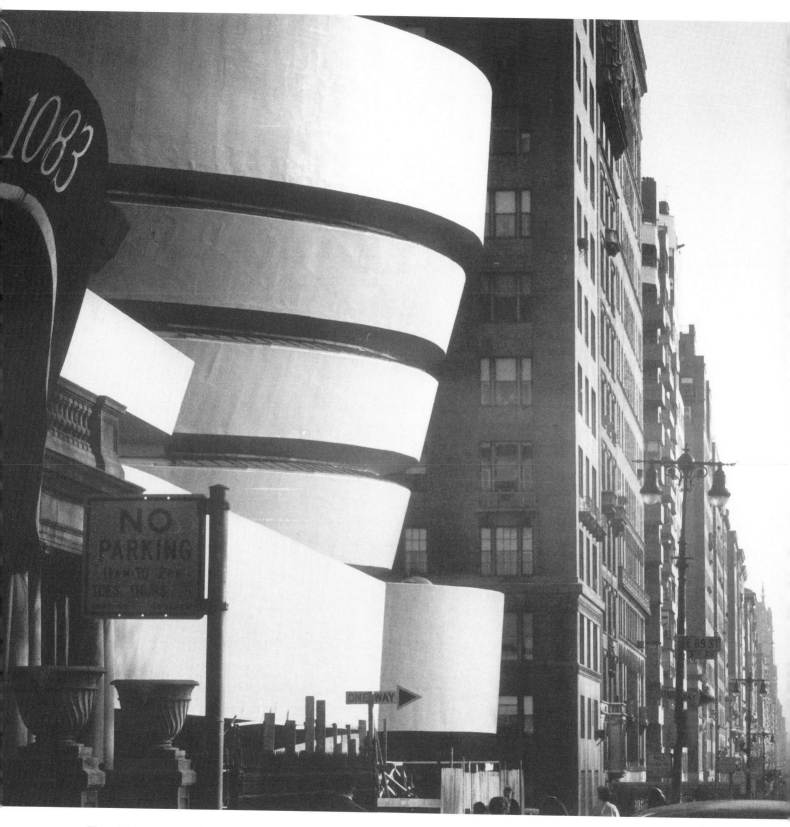

THE GUGGENHEIM MUSEUM, AUGUST 1959.

It was the year of Frank Lloyd Wright's death—and the year that his only building in New York was completed. It was commentary enough on the quality of New York's architecture that Wright should have lived almost to the age of ninety-two and have had only one New York building commission. Incredible as it seems now, on the day the Guggenheim Museum opened, the *New York Times* called it "the most controversial building ever to rise in New York." If nothing else, Wright had achieved one thing with the Guggenheim: he made a building that didn't fade into the vista, a building that survived the New York environment with its own wholeness intact. If the helical ramp and sloping walls at first seemed inimical to traditional rectangular paintings, they only prophesied new artistic freedoms to come. It was noteworthy was that the town was being stirred over a purely aesthetic controversy. A lesser front-page story in the *Times* that day carried the headline: "U.N. Lacks Proof of Laos Invasion." But Southeast Asia was far away.

Traffic was one-way on the avenues away from the central spine of Manhattan, but it still ran both ways on Madison Avenue (Madison and Fifth Avenues didn't become one-way until 1966). Two-way traffic has a civilized sedateness, and Madison was a most civilized avenue. But even as we were becoming more critical of the car's effects, we were trying to move cars faster through the city, only making life more hazardous for pedestrians and encouraging more vehicles to clog the streets.

One day, as I crossed Madison Avenue above 86th Street—the two-way traffic looking positively cheerful in the spring sunlight—my eye was caught by a vista that was punctuated by a tall building, but it didn't end there, as other towers in the distance beckoned the eye still farther. It occurred to me I didn't know what building that first tall tower was, but I didn't have the time just then to go and find out.

It was a month later that I discovered the building was the Carlyle Hotel. Indeed, I had been there not long before with a newsfilm crew to interview former President Truman as he came out for one of his morning strolls, but the only part of the building I had noticed then was the entrance. I had gotten no sense of the structure overhead. Thus I discovered another peculiarity of this unplanned skyscraper town: the near-impossibility of relating the bases of most skyscrapers to their tops. The building close-up was so different from the building at a distance. This was to change with the great increase of straight-rise slabs in the 1960s; it then became a question not just of tops and bottoms no longer looking different, but of the lack of any interesting difference between one slab and another.

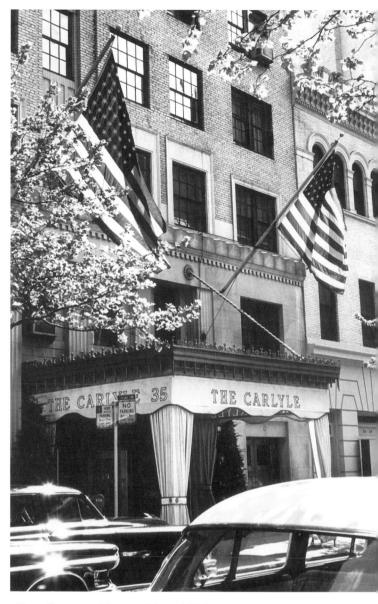

THE CARLYLE HOTEL, MAY 1959.

SOUTH ON MADISON AVENUE FROM ABOVE 86TH STREET, APRIL 1959.

44

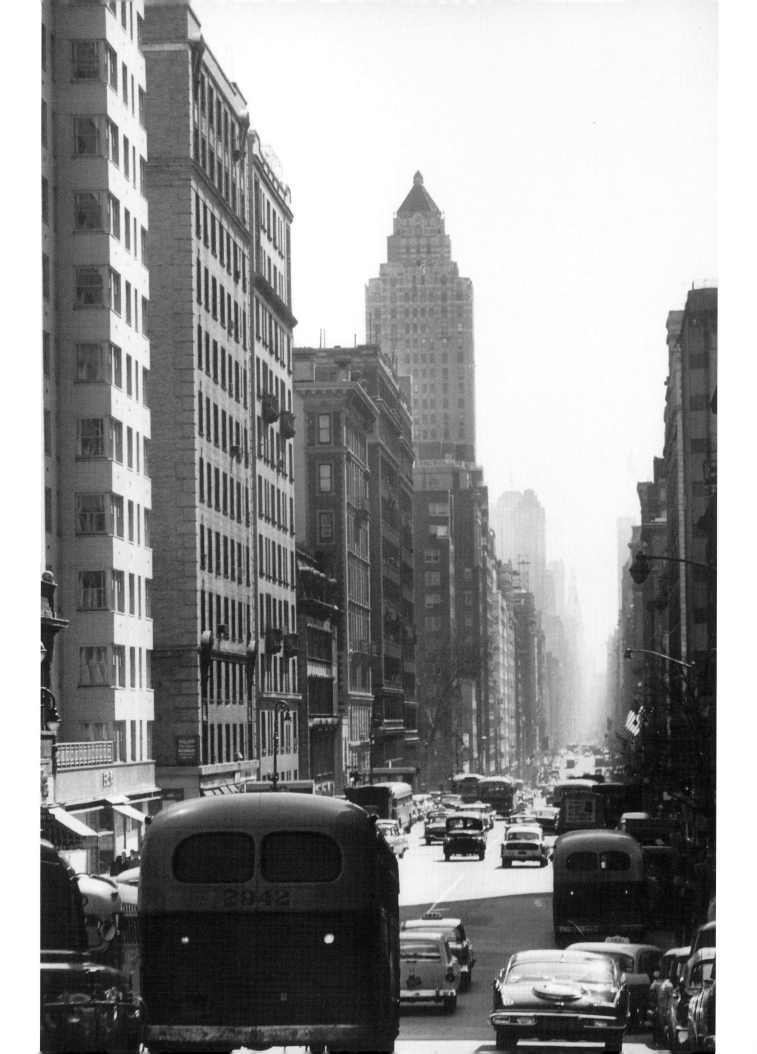

By now I had been promoted from writer of syndicated film scripts to writer of the Hearst-MGM News of the Day newsreel, which was still shown in many movie houses. This was a charmingly anachronistic occupation in the age of television. One of my first newsreel efforts was for one minute of film about the wedding of two aerialists on a high wire. Imagine the spirited and resonant narration of Peter Roberts in competition with fanfares and simulated sound effects:

> La Rochelle, a sleepy harbor town in France, is roused from its winter doldrums by a wedding that tops the social calendar. The bride is in high style for the ceremony, which practically takes place in the clouds. And the groom is a good catch—obviously a well-balanced, dependable sort. (BRING SOUND UP)
>
> The bride is all set to take the plunge. . . . I mean the big leap. . . . I mean, well, anyway, she can't turn back now. (BRING SOUND UP)
>
> What a lovely setting for a wedding! (BRING SOUND UP)
>
> They had a bit of trouble getting the mayor up high enough to perform the ceremony, but everything works out fine. Members of a troupe called the Sky Companions, the happy couple become partners for life. (BRING SOUND UP)

I considered myself quite well paid for three days' work per week—two editions of the newsreel and one day back on Telenews scripts—and I had never had more time to walk about the city. I had much opportunity to verify the truth of the saying that only tourists look up. It struck me that while a New Yorker might see what was immediately in front of his or her nose, and at least dimly perceive the vistas and the distant towers, no New Yorker ever saw what was so much as ten feet overhead. I began noticing that there was a world of its own at the second- and third-story levels. There existed a city of vertical levels as well as of horizontally receding planes. An amusing example was provided on a drizzly day as I watched three women with one umbrella walk past the Parke-Bernet Galleries on Madison Avenue below 77th Street, beneath a sculpture by Wheeler Williams that had provoked a bit of news some years earlier. The lady's breasts allegedly projected beyond the allowed building line, costing Parke-Bernet a penalty tax. (If the news reporters had been strictly accurate, they would have pointed out that the breasts did not protrude as far as her face.)

Several years later I found that my first son, beginning at about the age of two, noticed sculpted faces and other second-story details that I had passed unawares; so perhaps those decorative efforts were not in vain.

MADISON AVENUE, APRIL 1959.

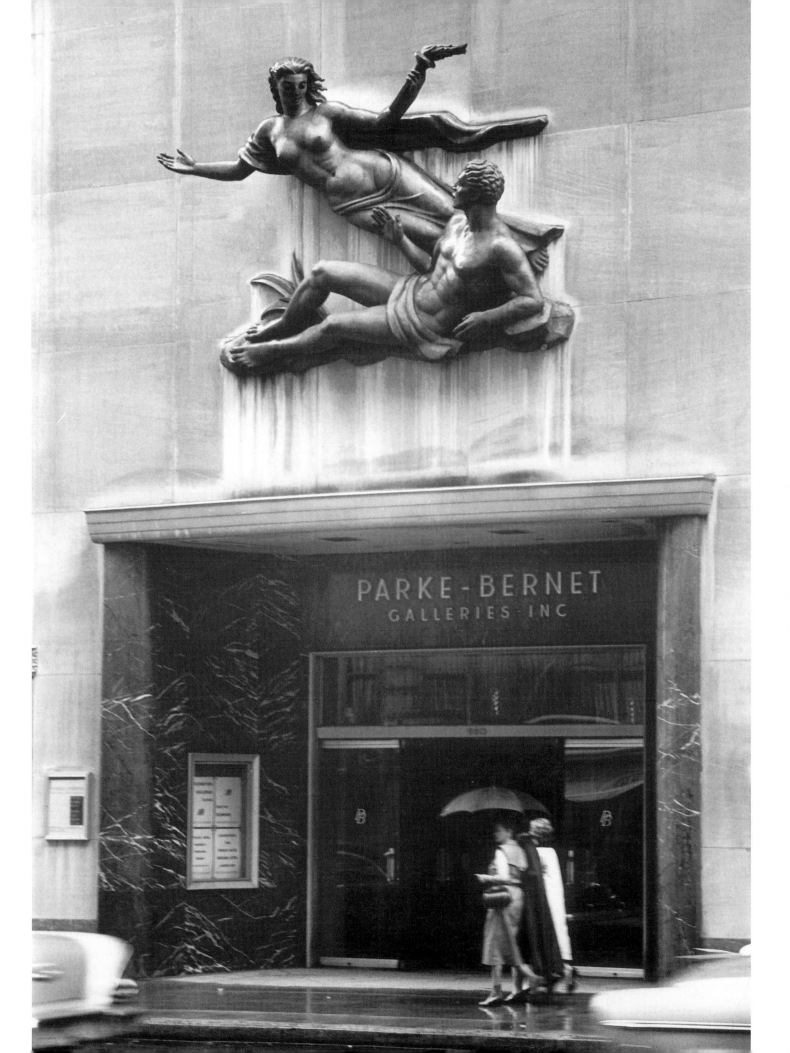

A city of steel and stone—how could it be so impermanent? The building boom following World War II had reached full momentum and would hardly weaken for another decade. Every year enough offices were going up to meet the total needs of a good-sized city, and plenty of apartments were still going up, as well. The other side of that boom was the tearing down of buildings, many of them substantial and some of such solidity that they had been expected to stand forever. What went up in their stead looked far less durable. It was disquieting to find that this most solid seeming of cities was the most transitory, but it was exciting, too. I felt a vicarious sense of power: *I tear down and I build up!*

Whole new cities were springing up where I had thought I *knew* the city. It was small comfort to be able to say: "I was here when it used to be thus." The familiar kept disappearing. The Time-Life Building rising where it could truly be seen— beyond the three- and four-story structures along old Sixth Avenue—was a new giant among midgets. It was a new and splendid thing, as the great early skyscrapers must have been, half a century before. Unfortunately, it was only a prelude to the disaster of upper Sixth Avenue, when Rockefeller Center continued its westward spillover without any of the imagination, interrelated planning, or design that had gone into the original Rockefeller Center three decades earlier. Where a new city-within-a-city might have been created, all that happened was that the Time-Life Building came to be hidden among other slabs—just one in a cemetery row.

Well, perhaps we could live with it. Perhaps New York was only a test of whether the human race could adapt itself to an environment completely removed from not only what we once knew of as Nature, but also from what we had once thought of as community. Perhaps we were on the threshold of a new stage in our evolution.

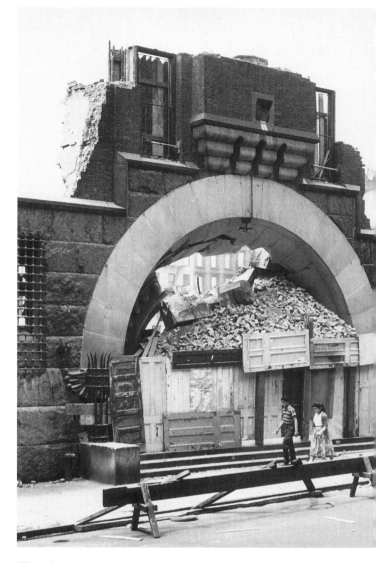

THE ARMORY DEMOLISHED, WEST 62ND STREET, MAY 1959.

TIME-LIFE BUILDING NEARING COMPLETION, SIXTH AVENUE, AUGUST 1959.

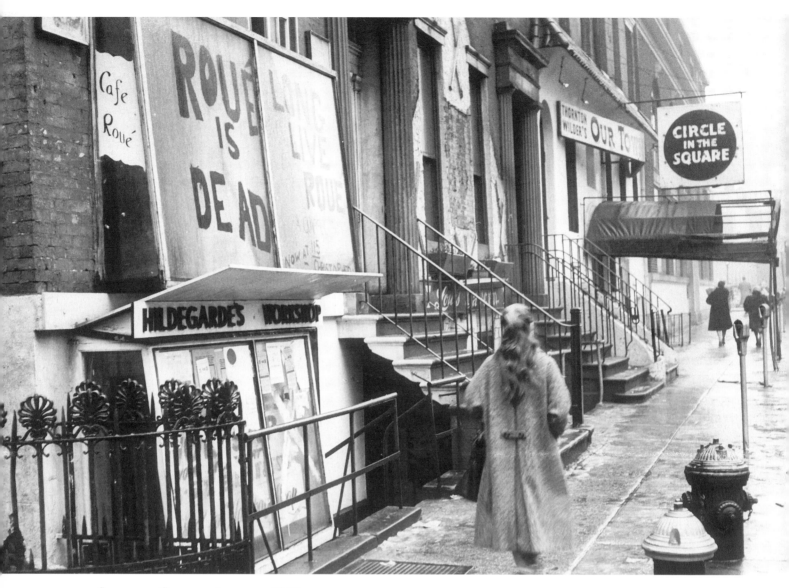

SHERIDAN SQUARE, JANUARY 1960.

And the Circle in the Square went—and, in the same block, Louis' and Roué—all for one of the uglier apartment piles in creation. It was—for my generation—the end of Greenwich Village. We could not make the scene, as it would come to be called, in that part of the Lower East Side that the real estate people were promoting as the East Village, even though I was in fact living over there—on St. Mark's Place—at the time I took the photo of what to me was the death of Sheridan Square. To be sure, the Circle in the Square moved to a new location, and I think I went there once (for Genet's *The Balcony*?), and later it moved uptown; but it was at the old Circle in Sheridan Square I had seen O'Neill's *The Iceman Cometh*—and drunk at Louis' afterwards.

As I imagine it now, perhaps it was the love of death—my marriage in any case was slowly dying—but we moved back to the Village proper, to most proper West 11th Street between Fifth and Sixth Avenues, under one of those irregular lease arrangements that permitted both landlord and tenant to derive benefit while more or less complying with the rent control law. The landlord got a little

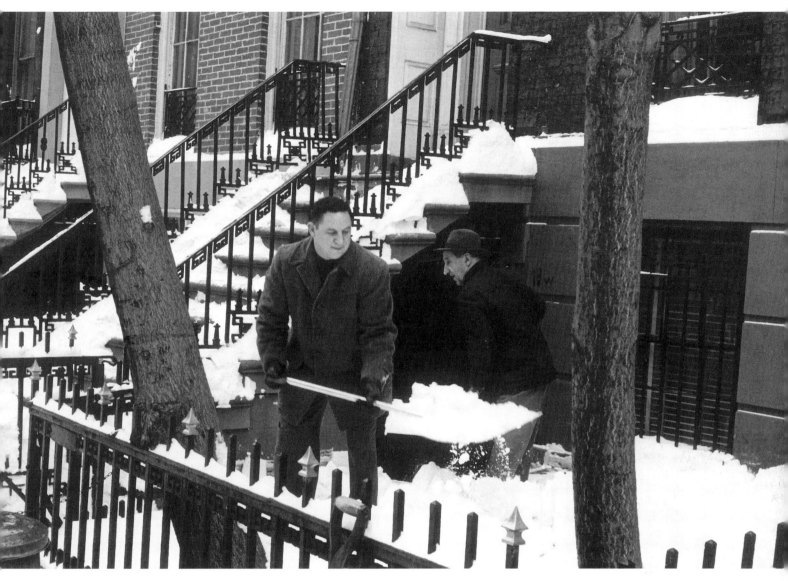

18 WEST 11TH STREET, MARCH 1960.

extra, and the apartment hunters got a place to live. It was a garden apartment, somewhat below sidewalk level, not without charm, but it was also narrow, low-ceilinged, and rather dark. I may be exaggerating the mood, superimposing a morbidity on the scene that I did not feel at the time, but I now see an ominousness in the peaceful picture of Mr. Merkel (the super for several buildings, including ours) and his son shoveling snow a number of doors down our block at 18 West 11th Street. Exactly ten years and two days later that sedate building on that quiet block would explode and vanish, killing three

young members of the Weathermen radicals who had apparently been making bombs for the revolution they envisioned. (See page 128.)

There was enough other destruction at that time—officially peaceful destruction—in the name of urban renewal. It may have unhoused more people than were subsequently housed, but political mobilization and community action against massive clearance were not yet organized enough to deflect the powers that be. That would change, but not quite yet.

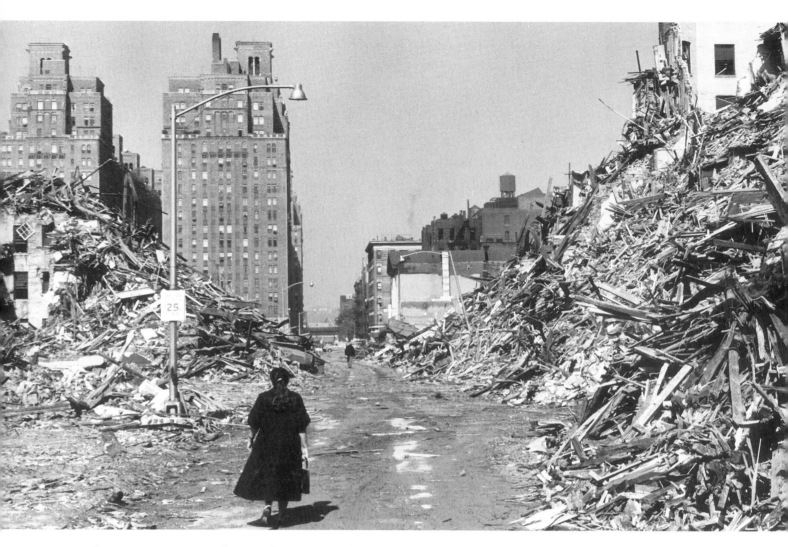

LOOKING WEST FROM EIGHTH AVENUE AND 24TH STREET, SEPTEMBER 1960.

When the area south of Penn Station to 23rd Street was leveled for a housing project of the International Ladies' Garment Workers' Union, it may have looked as if The Bomb had hit, but this was still generally viewed as a necessary stage in the carrying out of an enlightened program. And if the final result left a good deal to be desired aesthetically—if it was, in fact, a new blight upon the landscape—it provoked none of the controversy that had surrounded the Guggenheim Museum.

As buildings around town were leveled, there may at times have been some temporary, purely aesthetic benefit. I once read of a photographer who made part of his living by taking advantage of tran-

sitory views opened up by demolition to photograph various New York buildings as they had never been seen before and never would be seen again—views, in other words, that approximated those of the architects' renderings. Architects, owners, and prominent tenants reportedly paid well for his pictures. There was perhaps another value to them. Since New York doesn't bury but smashes its past, photographs must largely replace artifacts for future cultural historians—and anyone who takes pictures of the city might therefore be said to be engaged in contemporary archaeology.

As for bombs—or The Bomb, rather—we had, of course, been living through the Cold War all this time, and thoughts of nuclear bombing lent a sense

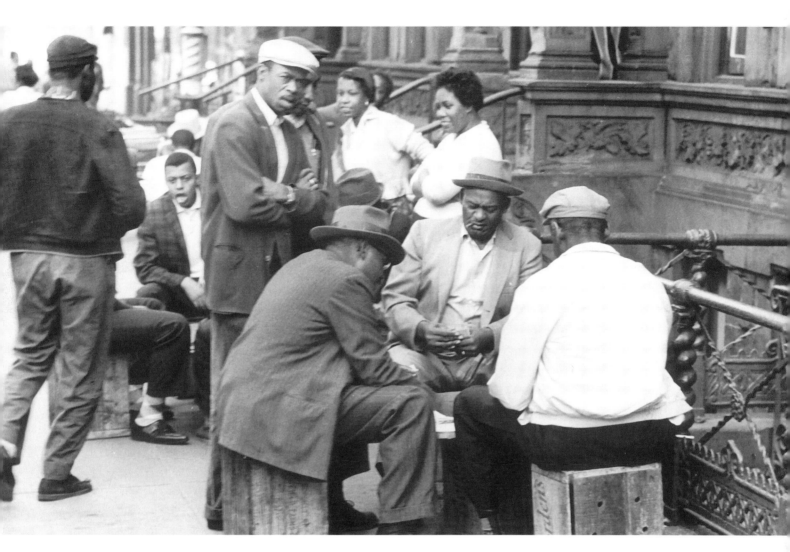

WEST 124TH STREET, SEPTEMBER 1960.

of crisis to any international disturbance. We had survived John Foster Dulles's urge to remake the world in his image, thanks to Dwight Eisenhower's restraining hand, and we had come to feel that we could live with Nikita Khrushchev—at least until Fidel Castro overthrew the Batista regime in Cuba. In September of the election year of 1960, in the midst of the Kennedy-Nixon campaign, Khrushchev came to New York ostensibly in the name of disarmament and thumped his shoes on the table at the United Nations, while Castro let chickens run loose in a Midtown hotel. Both had been restricted to Manhattan island (the State Department didn't want either one on American soil, but had to give them access to the international territory of the

U.N.), and when Castro ran afoul (afowl?) of the hotel management, he steamed up to the Theresa Hotel in Harlem—Harlem being, after all, on Manhattan island. Khrushchev went there to visit, and the two embraced in full view of the world—a gesture meant to take in all victims of imperialism and all peoples of color.

Harlem itself seemed the least impressed; it was inured to white gestures. Looking around at card players and other local residents, I wondered if they cared at all. Harlem's new consciousness of itself would have to spring from its own sources; the edge of revolt was as yet hardly evident to most of the white world downtown.

53

FROM FRANKLIN D. ROOSEVELT DRIVE, QUEENSBORO BRIDGE, OCTOBER 1960.

The United States had entered 1960 more prosperous than ever, but now the economy was sagging, and the country was increasingly apprehensive about its position in the world. Despite all the marvels of American technology, it seemed possible that the Russians had moved ahead—at least in space and missiles. And the Republicans weren't offering anyone more attractive than Richard Nixon. So, while Adlai Stevenson remained to the end the sentimental favorite of New York Democrats, in November the city went strongly for the handsome and energetic young John F. Kennedy and his promise to "get the country moving again." We looked forward to the anticipated Kennedy decade.

A new decade is likely to look very different in books written afterward, and certainly the '60s were to prove different from the '50s in ways we couldn't have imagined: in years to follow there would be multiple national traumas. But national traumas are not the same as personal traumas, and most people's lives would really not change that much. Most people's tears and laughter have little to do with the wider events of history. The man I saw lying on West 56th Street, perhaps the victim of a stroke, while a boy posed over him and a cop took notes, was part of a human drama, a tragedy even, that was playing out without reference to any greater developments or trends of the time.

Yet it was true that an undercurrent of change had begun after the mid-'50s, expressed by writers and artists. President Eisenhower had worried about a trend of deterioration in the moral quality of life. He had maintained that the increase in socialism and decrease in godliness he saw infecting America didn't make people happier in Sweden—just look at their suicide rate. On the other side were those who doubted that affluence through free enterprise was making Americans happier. In revolt against what they saw as a suburban nation that relegated its poor to live under welfare in the

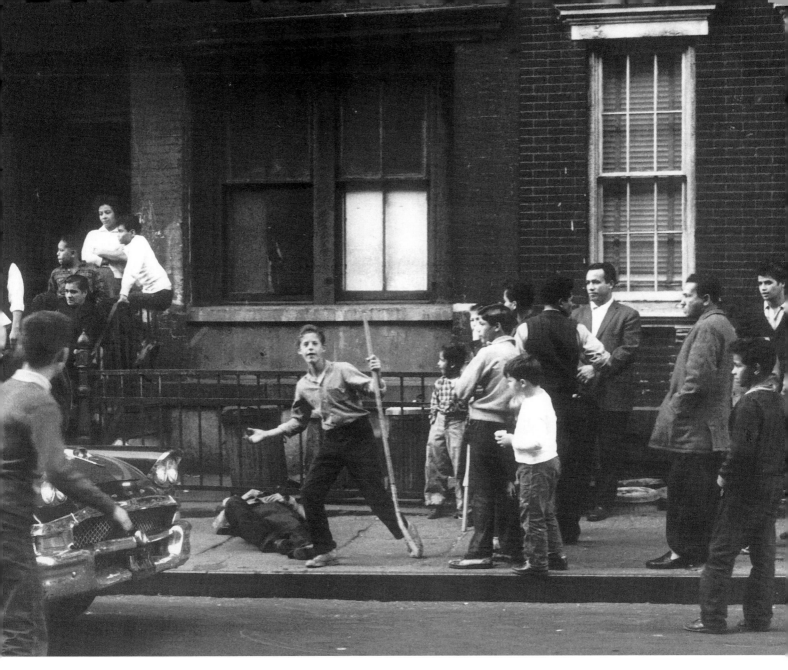

WEST 56TH STREET, OCTOBER 1960.

cities, the Beats tapped into a growing sense of unease. Kerouac and Ginsberg looked for a nonmaterialistic new American Dream; the early Albee took apart the consequences of the old, materialistic one. Discontent in America was certainly not new, but a wilder strain of it was showing. A decade earlier, Miller's *Death of a Salesman* had prescribed putting one's hand into the soil. His answer now seemed too tame, too individualistic, too at odds with reality. A new search had begun for mystical communion with others. Release. Drugs. Reality was acknowledged by trying to reject it altogether.

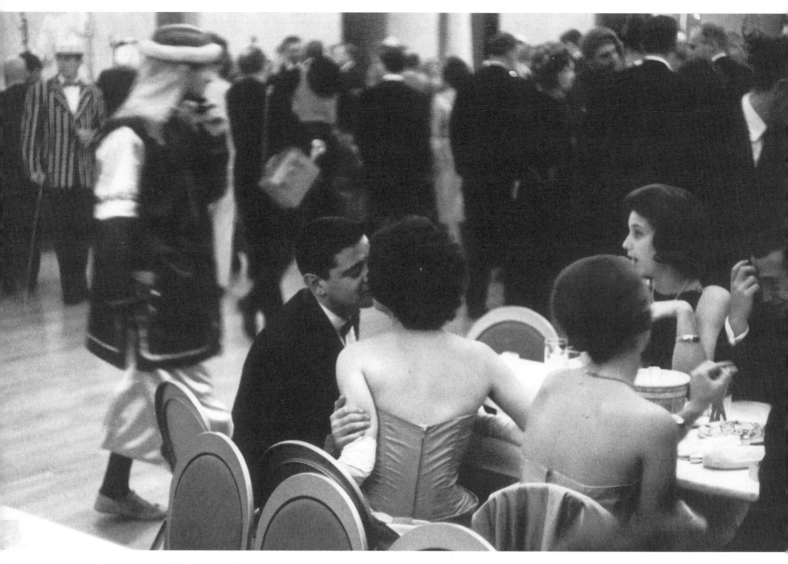

ARTISTS AND MODELS BALL, ESSEX HOUSE, CENTRAL PARK SOUTH, NOVEMBER 1960.

But still most people were interested in making it in the conventional way. The eight-cylinder pursuit was not to be sidetracked by twinges of discontent. The aspiration of New York was still F. Scott Fitzgerald's: to be rich, young, beautiful, in love, and rich. New York was ever ready to agree with Fitzgerald that the rich were different, and not to believe for a moment the rejoinder of that backwoods boor Hemingway that they merely had more money. How marvelous that we were getting as First Lady a veritable Fitzgerald heroine.

In retrospect, 1960 must seem a good and peaceful year. In a way it seems terribly long ago, when you think of it as the year a Catholic could

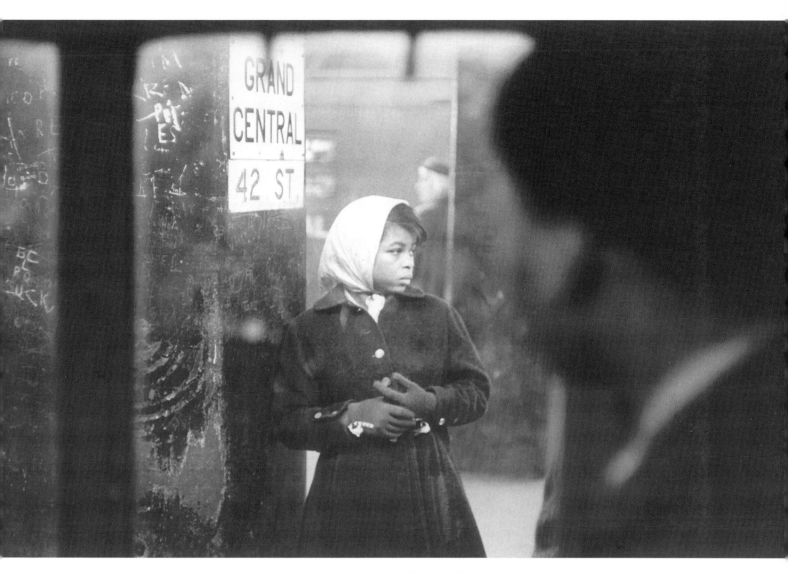

GRAND CENTRAL IRT STATION, DECEMBER 1960.

finally be elected president (how little difference his Catholicism made!), but it seems so recent when you consider that the Port Authority was under attack for aggravating the ills brought on by automobile traffic and for failing to do its share for mass transit. (We had just been going through that period of exaggerated tail fins, which finally revealed the automobile in all its grotesqueness, much as SUVs have more recently re-revealed the same.) The Port Authority, best known to most people for operating the metropolitan area airports and some bridges and tunnels, fought off an attempt by Congress that year to look into its books. Decades later, the Port Authority would still be acting much the same way, defending its right to serve its own

corporate goals rather than the needs of the community. (Or, as its executives might think, what's good for the Port Authority is what's good for New York.)

Meanwhile, the vast subway system, under a city-state management system different from the bistate (New York and New Jersey) compact that governed the Port Authority, continued to serve a very large portion of the city's population with surprising efficiency, if hardly glamorously. It served those who were not necessarily young, beautiful, and rich—though it could serve them too, even those in love.

The meaning of these times. I wonder if the ancient Egyptians pondered that question. Any *now* moment is so riddled with uncertainties that it makes the past seem simple. As 1960 ended, we obviously faced a world of uncertainty. The Cold War's intensity continued, with a steady fear that it could erupt into a deadlier one. A charismatic new president had been elected but had yet to take office. Would he really affect the nation's course? Would the economy pick up or suffer? How would race relations play out? Would the new administration be good for New York City? These were a few of the concerns that presumably wise people, ministers among them, sought to shed understanding and provide prognostications about. On a quiet, snowy evening on West 11th Street, the sign outside the Seventh Day Adventist Church that implied worry about "the meaning of these times" seemed unduly tinged with apprehension. The scene was just too peaceful.

Change often registers only slowly. Even if big developments are afoot, localities and the lives of their inhabitants go on as usual. Two women taking leave of each other at 713 Washington Street in the far West Village, one with a pastry box, the other with a baby carriage containing a grocery bag, her little boy inspecting some anomaly in the sidewalk, while a nymph chases a faun on a Greek vase painted on a window more recently defaced with scribbles, carry on as if oblivious to the decay that both evidences change that has been going on and suggests that more change is coming.

In New York in 1961, possibilities of community activism were becoming more evident. Change might, after all, be better controlled. The people of the West Village showed that the giant bulldozer of urban renewal could be stopped. In that year, the heroine of the fight to prevent wholesale demolition of the neighborhood, Jane Jacobs, published *The Death and Life of Great American Cities,* after which city planning and urban renewal could never again blithely ignore community wishes. She may have been overly sentimental, for my taste and experience in her description of the city as a collection of neighborhoods. I thought of the city more in terms of a complicated totality, but her influence on thinking about urban development was certainly to prove profound. In 1961, too, the city's Democratic party boss, Carmine de Sapio, was beaten when he ran for reelection as leader of his Greenwich Village district; his power in local and state politics did not survive the setback. As a generator of reform, the Village was turning up a new life and inspiring the rest of the city.

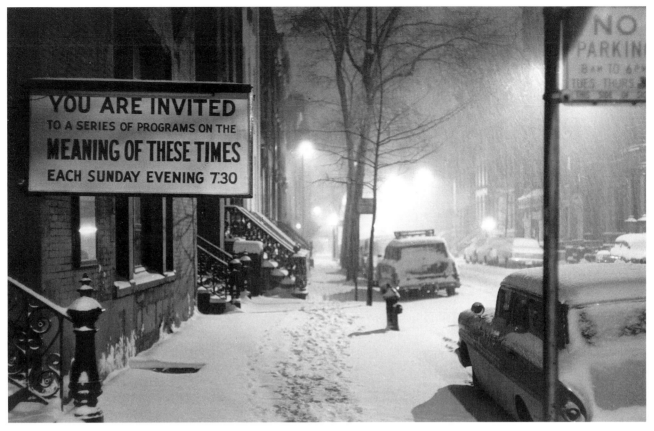

WEST 11TH STREET NEAR WAVERLY PLACE, DECEMBER 1960.

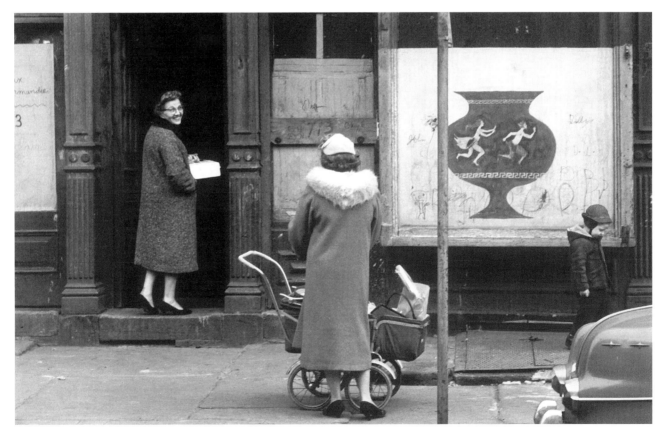

713 WASHINGTON STREET, FEBRUARY 1961.

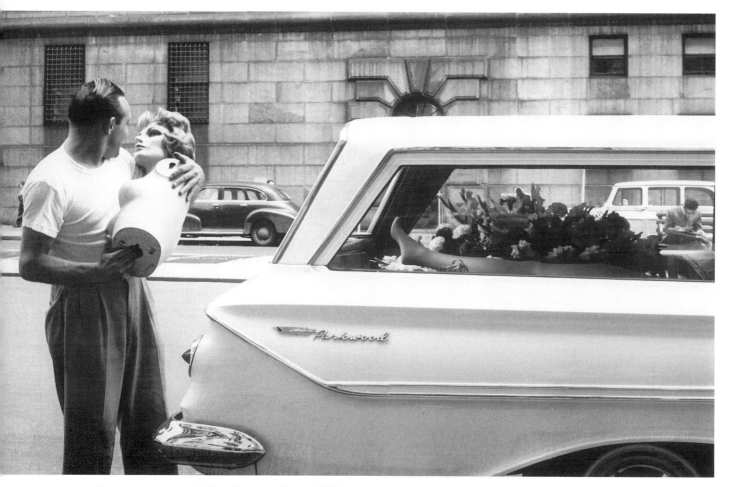

BROADWAY AND 115TH STREET, JULY 1961.

Work went on, its variety expressing the quality of a big city where everything could be had, every kind of problem attended to and usually solved. Along with work went daydreaming. A florist's employee could imagine the mannequin's head and torso he was carrying to an all-too-hearse-like station wagon on Broadway at 115th Street was a flesh-and-blood woman welcoming his embrace. Far downtown, an investment house employee in a Wall Street office might have his mind on something other than financial figures, his inward gaze turned away from a striking harbor view against which rose the phallic tower of the former City Bank Farmers Trust Building.

My own job had become quite absorbing. Because of my African travel, I was chosen by the newsreel company to produce a newsreel that had been contracted by the U.S. Information Agency to be shown in the newly independent African nations.

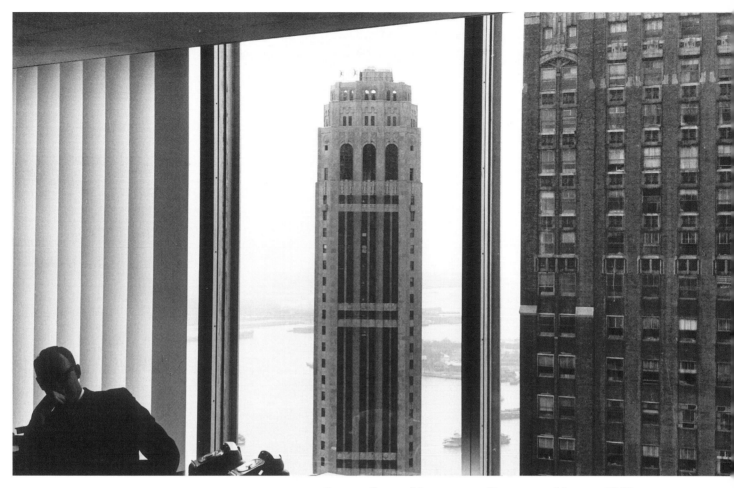

IN THE CHASE MANHATTAN BUILDING, MARCH 1962.

In a sense you could say this was a real-life application of what I had studied in the Air Force. Since, in a gesture toward encouraging active African involvement in the project, the USIA engaged a number of inexperienced locals to do the filming, I wound up writing a lengthy memo that amounted to a how-to manual for beginning cameramen.

"Hope springs eternal in the human breast." Alexander Pope, 1733. Add to that all the things that have been said and are being said, phrases of the time we have lived through ("we shall overcome," "make love not war," "turn on, tune in, drop out," "tell it like it is," "the medium is the message," "burn baby burn," "where have all the flowers gone," "put on," "right on," "bad trip," "blew my mind," "power to the people," "America love it or leave it," "you know," "it's awesome"), and you wonder who's to keep track of it all, and to what ultimate purpose. We can store it all in computers, but then what? Once there was a tradition of knowledge, and the function of the educated man (I'm afraid it was pretty much restricted to men) was to know what was known, what was worth knowing. Now there is so much to know, one doesn't know where to begin, or if it is even possible for a person to build a body of knowledge that is either coherent or valuable.

The past. It takes time to arrange a past, and New York never seems to want to become heavy with history. Throughout this account I have sprinkled dates for reference, and the photographs bear dates as well. A photograph derives from an event in time: it was now (now!) when the shutter was pressed, but the result is a *then*. Its time is fixed. And so the dates I pin on my account of New York are firm, in a way—and yet they won't quite stick. I *feel* New York as a continuing present that keeps wanting to wriggle free, to shake off these tags that would pin it down to a dead past.

The importance of a date in history is a negative one: it tells us what was not yet part of human knowledge before the event of that date took place. But the event belongs to all subsequent time. The crucifixion of Jesus could mean nothing to the world on the day before he was crucified. Ever since (or at least as soon after as his immediate followers were able to impress its significance upon a wider world), that event has been a defining one for Western civilization and beyond. As for the dates of photographs, they are not necessarily determining or limiting. It is possible, after all, to photograph something left over from an earlier time—City Hall, say. To photograph an anachronism, something not expressive of its moment. Also, photographs can seem to go forward as well as backward from the time they were taken. A photograph will not necessarily betray its date, though it may well do so. To me, many of these photographs seem younger than their dates, while there are others that seem older.

A photograph that dates itself—or does it?—is that of a man with a briefcase squeezing past handcarts on West 38th Street, a block filled with businesses dealing in wholesale millinery, textile imports and exports, and novelties. It could hardly have been taken later than its 1962 date, but then again, it looks almost too old for 1962. The always hatless Kennedy was president, the style was jauntier, vehicles didn't have windshields like the one on the truck at left center, most buildings and signs didn't look like this any more. It might almost have been the 1930s.

But there is one thing about the man with the briefcase that holds true for today, or for the New York of a hundred years earlier. He is in a great city—in one of its more central locations, in fact—but he is alone. The activity around him is quite outside his purpose, even if it physically presses in on him. For all that millions of people inhabit this place, what I've been conscious of through the years is how detached people seem from it so much of the time. I'm often reminded of Chinese scroll paintings in which a lone figure is placed against a mountain landscape, except that in New York tall buildings take the place of Guilin's slender peaks, and the figures are so often rushed or preoccupied rather than calmly contemplating. A certain shared introspection links them nonetheless. And, surprisingly in this crowded town, it is not rare to come across a city block on which only one other person is in evidence. On side streets, that is—hardly ever on Fifth Avenue in Midtown.

WEST 38TH STREET, FEBRUARY 1962.

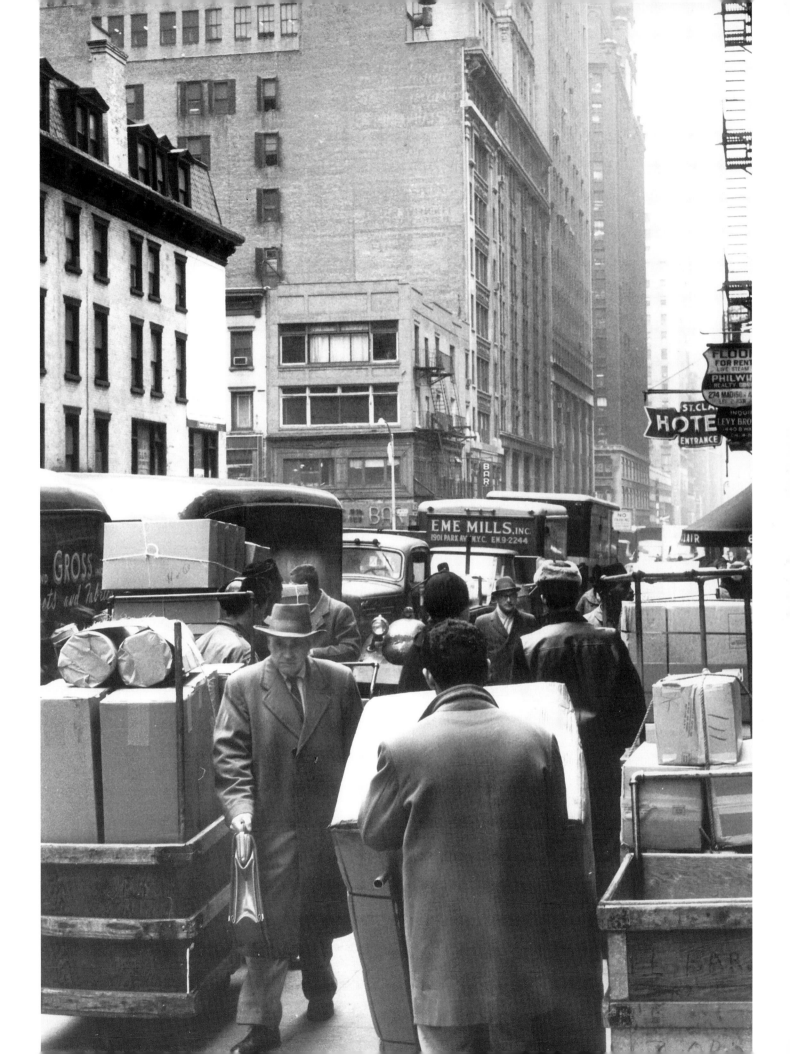

Although we now live in a world of color, I feel that New York continues to express itself in black and white—and the shades of gray in between. Stone, steel, asphalt, concrete, and glass—the building materials of the city—by and large don't demand color film. Then again, I began working in what was a still-strong tradition of black-and-white photography. Black and white was also easier and less time consuming when it came to making my own enlargements. Time was always a factor, as I held a full-time job outside of photography. So I came to think in black and white when looking at the city.

Black and white suits mourning. The Singer Building, briefly the world's tallest after its completion in 1908, was one of the city's great losses when it was demolished, beginning in August 1967, with the process lasting a year and a half. When I was a little boy in Tampere, Finland, a shop downstairs in our apartment building had a picture of that tower on its wall. Singer sewing machines were known around the world, and the building was one of the symbols of New York. The sheer rise of its tower from a single setback and its expansive windows between the two vertical strips running up each face gave it a firm place in the history of skyscraper architecture, and should have given it a firm place in Manhattan's bedrock. The day I had this good look at Ernest Flagg's gracious 47-story structure from, as it happened, the 47th floor of the much newer Chase Manhattan Building, I had no inkling that I would soon be lamenting its destruction.

Unfortunately, the landmarks preservation law that the city would enact in 1965 was for many years to be applied only to saving smaller buildings, some of them imitation Colonials. Designated landmarks came to include the "Georgian" townhouse at 124 East 80th Street, built in 1930—a century and a half after the valid period for its style. (I could never understand the American fascination with recreating the image of colonialism, a period when the country belonged to someone else. Do we still wish it did?) But the new commission was timid about challenging the big-money interests that controlled big buildings, and so the Singer was wrecked for a ponderous United States Steel Corporation slab, later to be known as One Liberty Plaza.

THE SINGER BUILDING, MARCH 1962.

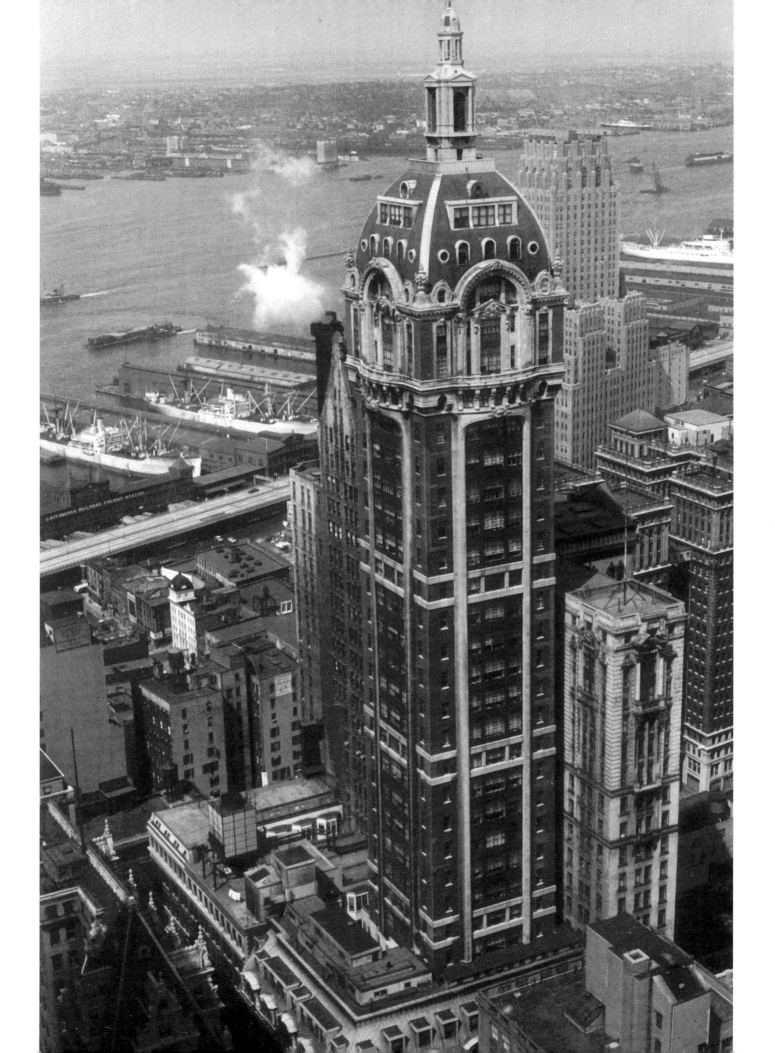

Another desecration was the blocking off of Park Avenue by the Pan Am Building (later renamed for MetLife after Pan American World Airways shockingly went out of business). I'm glad I'm old enough to remember when the spire-topped New York General Building to the north of Grand Central Terminal used to terminate the Park Avenue vistas from both south and north. Having known that time, it hurt the more to see every floor of the "Berlin Wall" that rose between Grand Central and the General Building to hem in the eye. It was perhaps an appropriate coincidence that the wall dividing Berlin was erected by the Soviets at about the time the one on Park Avenue began to rise, the difference being that the Park Avenue one employed a couple of famous architects (Walter Gropius and Pietro Belluschi) in a vain effort to lessen the monstrousness.

I could only try to comfort myself with the thought that the Pan Am and the other office building that later rose over part of what had been Penn Station would allow arriving commuters to be funneled directly into their warrens without setting foot on another inch of Manhattan, thus leaving everything worthwhile about the city to those who might have some appreciation of it. Not charitable of me, I confess.

This reminds me of another opinion I want to get off my chest: that "the verdict of history" is so much bunk. Not history itself, as old Henry Ford maintained, but the idea that there is some final judgment made a century or more after the fact. The verdict is *now*—and it's forever after arguable and subject to new interpretations.

DOWN PARK AVENUE FROM 68TH STREET, JULY 1962.

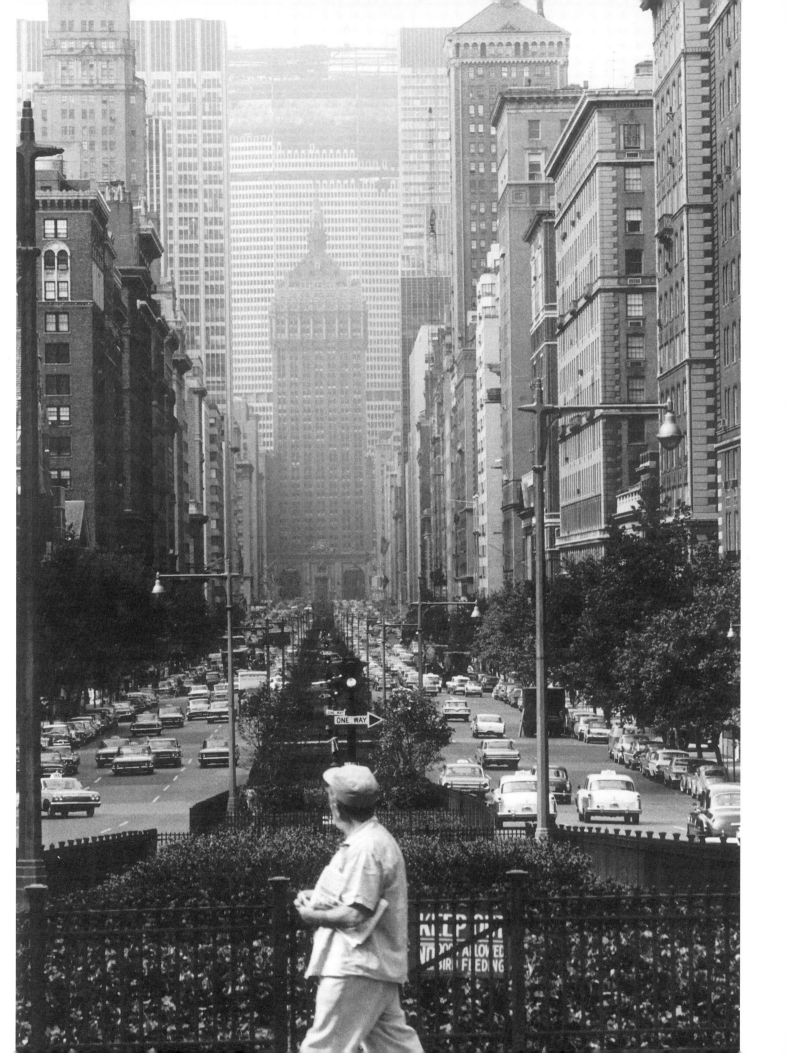

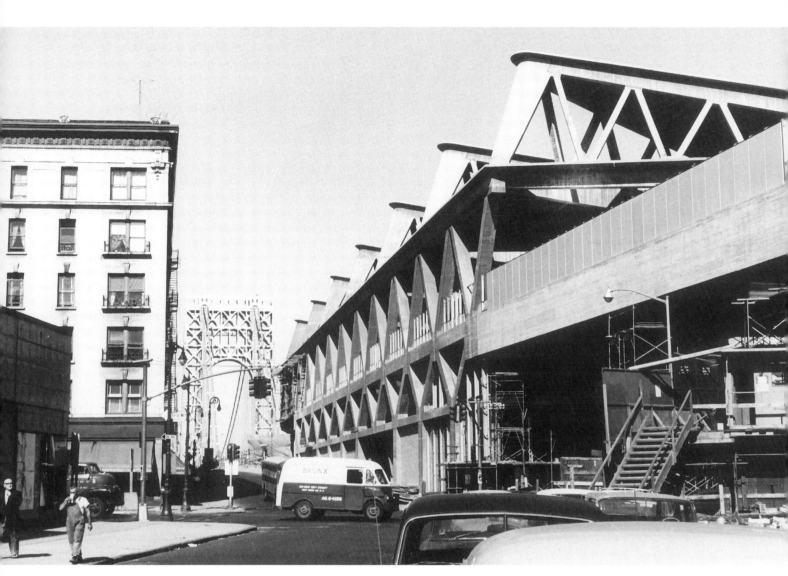

PORT AUTHORITY TERMINAL, 178TH STREET, STILL UNDER CONSTRUCTION, GEORGE WASHINGTON BRIDGE IN BACKGROUND, SEPTEMBER 1962.

New York tore to build and built to tear. Some of the results, for as long as they themselves would last, were much happier than the Pan Am Building. There was, for instance, the Port Authority's uptown bus terminal at Broadway and 178th Street, by the George Washington Bridge. This was an example of something the authority could and did do for mass transportation. To exploit his structural and aesthetic mastery of concrete—then still a fairly rare structural material in this steel-cage town—the authority engaged the Italian engineer-architect Pier Luigi Nervi; and, as an unembellished structure, the terminal turned out rather beautiful. Panels, louvers, and other finishing details unfortunately detracted from much of that beauty. But then, how often in New York hasn't that been true: the beautiful promise of building skeletons nullified by surface banalities. Dreams of rising buildings have withered as the supposed shine was added. "*Thine alabaster cities gleam, Undimmed by human tears.*" If only. The George Washington Bridge once narrowly escaped being smothered in too much "architecture." In 1962 the airiness of its span was weighted down by a second traffic level, which, to be sure, had been called for in the original design. Still, that didn't improve its looks.

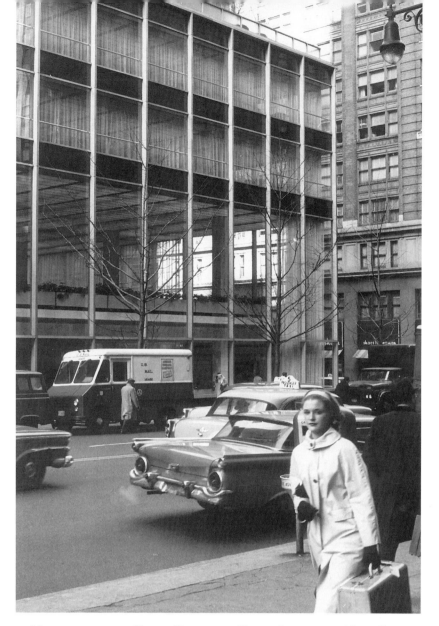

MANUFACTURERS TRUST BUILDING, FIFTH AVENUE AT 43RD STREET, JANUARY 1963.

One smallish building from the 1950s that remained beautifully skeletal as a finished product—even if deceptively so—was the Manufacturers Trust branch at Fifth Avenue and 43rd Street. An elegant cage of seeming fragility, it was supported by sufficiently substantial columns inside. Charles Evans Hughes's design for it had won an intra-firm design competition at Skidmore, Owings & Merrill, the designers also of Lever House on Park Avenue, as well as the sleek Pepsi-Cola Building a few blocks north of it, and that most suave, dark slab at 140 Broadway being designed for the Marine Midland Bank. (As the architecture firm's prestige grew, however, it was hard put to it to match the quality of these buildings.)

Here we were, approaching the final third of the 20th century, and some buildings were still going up without a floor numbered 13. They might skip from 12 to 14 or adopt a subterfuge like 12A. Not all of them; in fact, the *Times* ran a story with the headline "13TH FLOOR LOSING ITS ABSENCE HERE," and the *New Yorker* commented, "You mean it's stopped coming into nonexistence?" (I checked and found that the then three-decades-old Empire State Building did have a 13th floor, though the RCA Building—symbol of the electronic age—lacked one.)

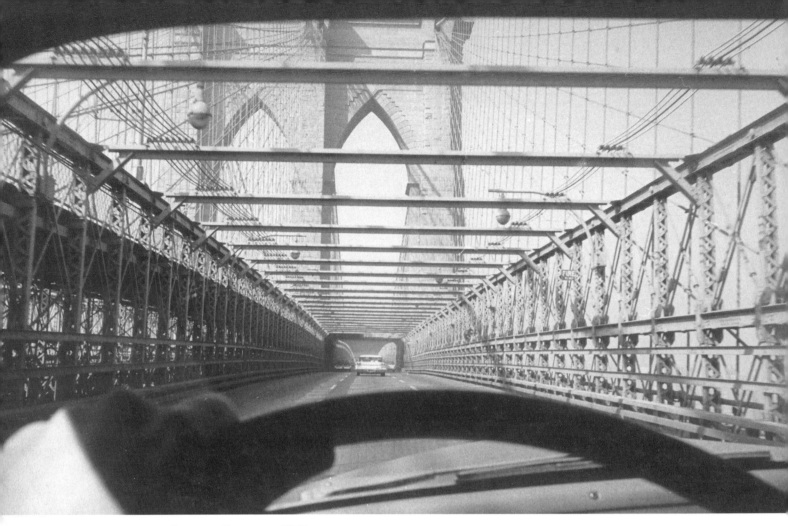

BROOKLYN BRIDGE, OCTOBER 1963.

ell, we had gotten through 1962, despite the jitters of the Cuban missile crisis that fall. (The first time I ever knew a New York cab driver to take a wrong turn out of nervousness came after President Kennedy's announcement of a blockade—officially "quarantine"—of Soviet ships carrying missiles to Cuba.) As 1963 wore on, things seemed generally promising, or would have, except for the personal matter that I was in the throes of marital breakup. At least there were no children. Once, locked out, I stayed at the Earl Hotel in the Village, and later some nights at the Albert, where I was sure I heard a man and a woman upstairs murdering each other—but the night clerk told me not to worry. I got my own apartment up on West 74th Street.

A return to freedom comes hard. I felt sorry for myself, renewed acquaintance with my shrink. I drove my old '51 Oldsmobile around a lot. I didn't have to be at work until four in the afternoon, and often felt I had the city almost to myself. Driving across the always thrilling Brooklyn Bridge and past the Verrazano Bridge a-building, I shot from the car to catch the sense of views in passing. To drive and shoot was no doubt hazardous, but the experience—and the thought that it was giving me some fresh results—answered to a need for stimulus in a time of sorrowing. Actually, my job was going well. I had moved to NBC and had serious responsibility: I was the producer of the 11 P.M. newscast and enjoyed the pressure, liked having the pictures come in and making them go out over the air, thrived on late-breaking stories. One great feature of it was that, although the tension could build very high

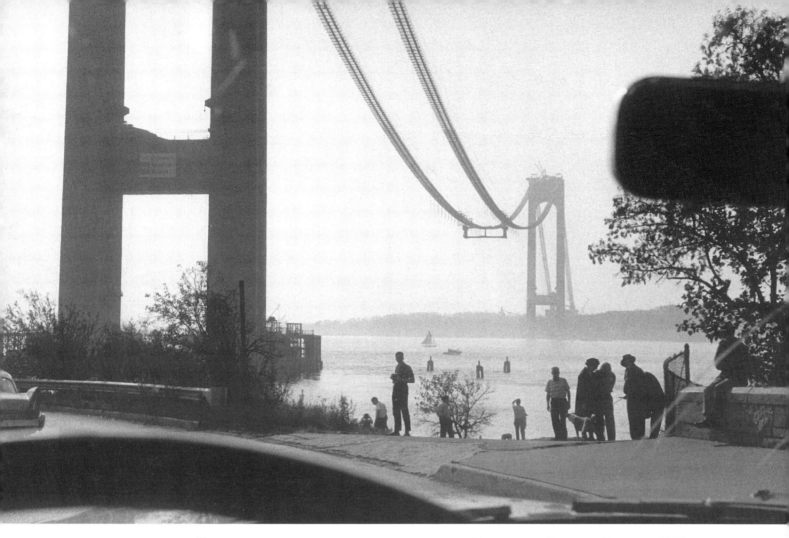

THE FIRST ROADWAY SUPPORT IN PLACE ON THE VERRAZANO BRIDGE, OCTOBER 1963.

until the broadcast was over, each evening's work ended with the sign-off and I didn't have to think about the next day until I went back to the office.

It was a very mixed year.

In retrospect I see it as a time of freedom generally, of reaching out, of possibility. Kennedy empathized with the idealism of young people. After the older-folk-dominated '50s, young people had a hopeful function in the Peace Corps and the civil rights movement. Indeed, to use a slightly later term, Kennedy may be said to have co-opted the civil rights movement by supporting the demonstration that brought 200,000 people to Washington that August, and thereby taking much of the vehemence out of the protest.

Our Cuban missile jitters were past; the Soviet Union seemed less threatening; we were, so far, cautious about getting too deeply involved in Vietnam. A growing split between Russia and China meant Communism wasn't monolithic anymore. We appeared to be in a position to turn our energies to our cities, which were deteriorating as a result of the suburban exodus, and to do something about our other social ills at home. New York was, in fact, building furiously. More than 6 million square feet of rentable office space were added in 1963, and there was a mad rush to put up the fat and ugly apartment buildings that would no longer be permitted after the deadline for compliance with the more stringent new building code of 1961. So many apartments were built that landlords offered rent concessions to lure tenants.

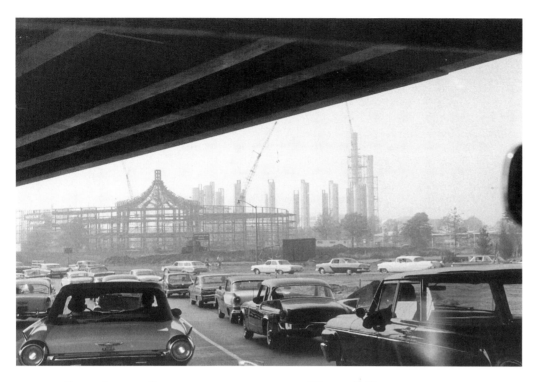

LONG ISLAND EXPRESSWAY, APPROACHING WORLD'S FAIR SITE, OCTOBER 1963.

This was the last great flowering of Robert Moses. Throwing out a proposal by a group of the city's most prominent architects for a coherent overall design of the 1964–65 World's Fair, he made it a free-for-all for the exhibitors, resulting in a carnival of unrelated forms. His lieutenant, Thomas J. Deegan Jr., explained that it all had to look "acceptable to the general public in order that we could make a financial success of the fair." Presumably the public wouldn't be drawn to good architecture. Despite predictions of a $50-million surplus, the fair would lose $21 million. For at least two years before the fair opened, the construction of approaches and overpasses kept Long Island traffic tied up. This may have proved an object lesson: stalled drivers got all too good a look at that emerging glorification of runaway commercialism and urban sprawl.

Meanwhile, New York's old perennial fair—Coney Island—was fading away. There were still rides there, rollers coasters (still the Cyclone), though there was more to fear in the creaking of

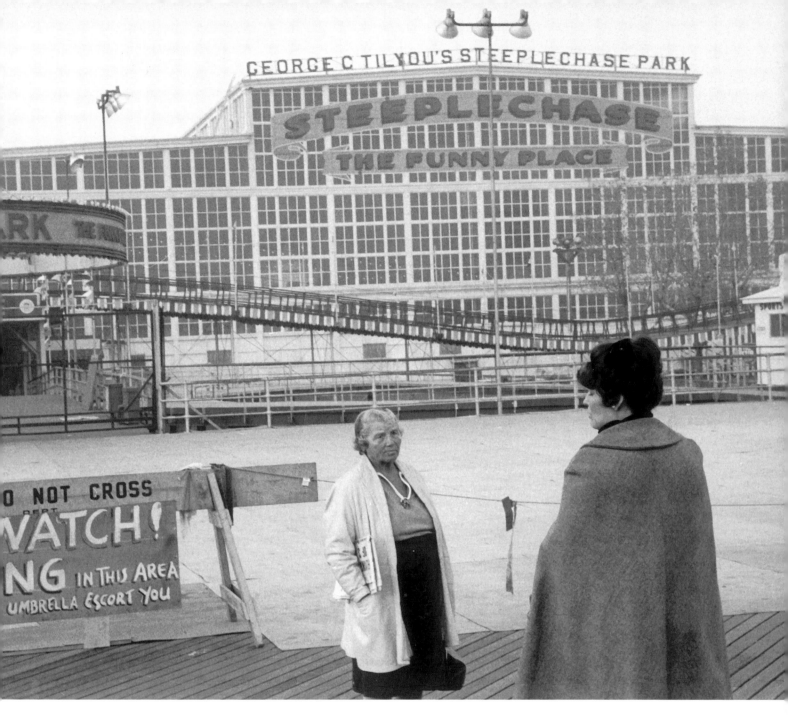

CONEY ISLAND, OCTOBER 1963.

wooden trusswork than in the hurtling of the cars. The end of the season felt more like the end of an age. Apartments were crowding out the amusements. Two springs hence Steeplechase would not reopen. Where the Parachute Jump and the Bobsled had been legacies of an earlier world's fair, the new fair had nothing to give Coney Island but competition that Coney Island could no longer stand.

But Coney Island, Robert Moses, and all of that belonged to the old order. It was a time for the passing of the old order. We had entered the new.

And it ended. MY GOD, THEY'VE KILLED HIM!

We couldn't stay stunned; all night at NBC we worked putting together obituary film. (A year before I had done some preliminary work on the film obit, and a friend outside the business had remarked, "Isn't that rather macabre?" And the project had been dropped for what seemed more pressing things, only to have much of the film left in scattered bits and very nearly unreconstructable now that it was needed.) I had invited people for a cocktail the next day, a Saturday, but I was far too busy to try to call any of them, and I wondered if anyone would show up. Except for one woman who was giving birth, they all came—and drank. People needed each other.

I don't know how much one man can change history. I can't say that in life John Kennedy had changed it very much, but I'm convinced his death changed it. His death and the deaths to follow in that decade set history back.

ONE OF THOUSANDS OF PHOTOGRAPHS OF JOHN F. KENNEDY POSTED IN WINDOWS AFTER NOVEMBER 22, 1963. THIS ONE IS AT ALAMAC LOUNGE ON BROADWAY NEAR 71ST STREET, NOVEMBER 1963.

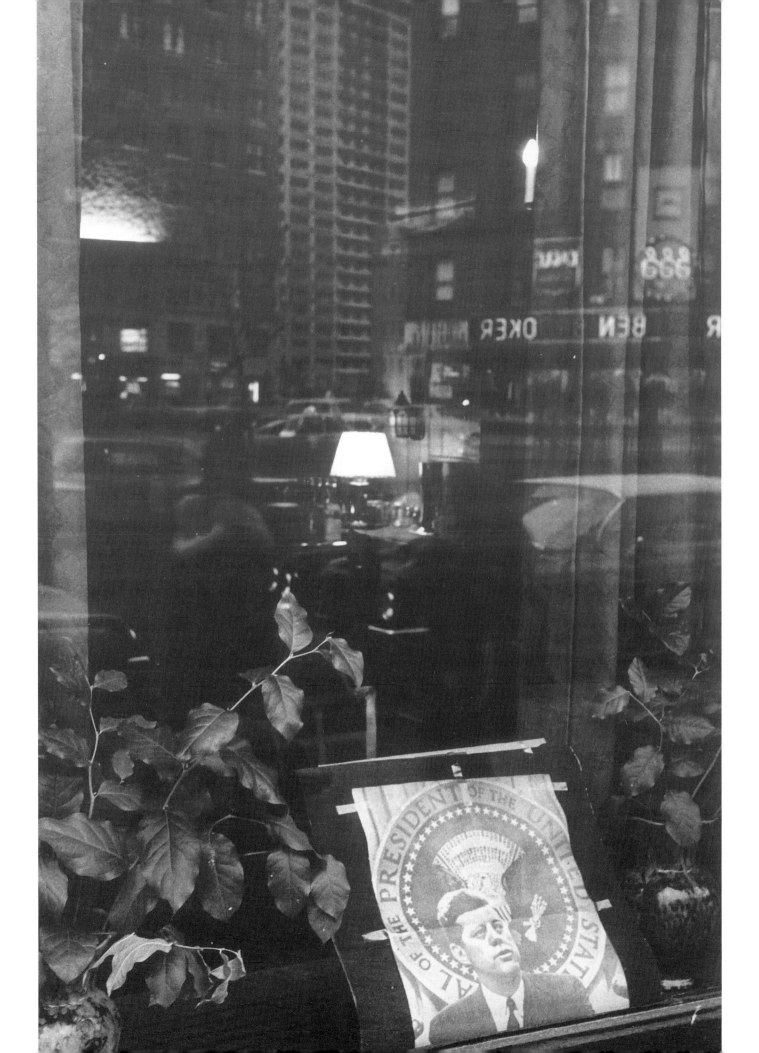

"ART STOP"
An Intermission

"We pause for this commercial message. . . ." No one says that any more. Now the game is to hit you with the commercial before you have time to silence it or turn it off.

As a producer, I often chafed at having commercial interruptions steal time from what I wanted to say and show. In reality, I couldn't have said or shown any of it without commercials to pay the freight. On a slow news night you could even argue that the commercials were the most entertaining and informative part of the program, though that's not quite the point I want to make here. Rather, it's that commercials often provided invaluable moments when I could have the attention of the control room staff and the talent (the word commonly used for the person on the air) to alert them to additions, corrections, cuts, or substitutions to be made in the remainder of the show.

We require interruptions so that we may go on. Consider sleep. So, before I go on to the next chapter, I pause to consider something I've left out. Something I meant to cover, but my thoughts about it, or the pertinent photographs, or both, didn't quite fit into the chronological sequence.

An important thing had happened in New York during the past several years. A breakthrough had occurred in the form of Abstract Expressionism, which made New York the art capital of the world in addition to its being the most powerful financial and communications center. I saw parallels to the painters' celebration of a kind of New World barbarism, akin to what Walt Whitman had celebrated in words more than a century earlier, in such things as a cracked and patched Chinatown window. It seemed to me that only New Yorkers—sufficiently aware of Europe—could have thrown off the European yoke quite so deliberately in trying to express an American essence. At last American art was dramatically freed of its European shackles—or so I felt. Today I might take a somewhat more tempered—or more nuanced, as they like to say—view of it, though I still see Abstract Expressionism as *the* important American art development of my time.

PARK STREET, CHINATOWN, JULY 1959.

SIXTH AVENUE AT 12TH STREET, MAY 1959.

SAME CORNER, JUNE 1959.

It would be too simple to say that Abstract Expressionist painting was about New York. It came less from *out there* than from within. Just the same, New York's physical presence—its lights and shadows and the power and frenzy of its postwar building boom—reverberated in those canvases.

All over town in the late '50s windows were X'ed in white to signal that their buildings were imminently to be destroyed and replaced, for profit, in the name of progress. The developers were quite

open about their intentions; only after tenants, community groups, and preservationists got more organized in the '60s did the developers develop wariness (in some instances going so far as to begin demolition suddenly on weekends before a Monday court injunction could be obtained). On a building in my neighborhood the window X'er had been particularly exuberant—it may have been a case of life imitating art. I thought it was worth a picture.

A few weeks later, passing the same window, I saw that someone with a better eye for art than

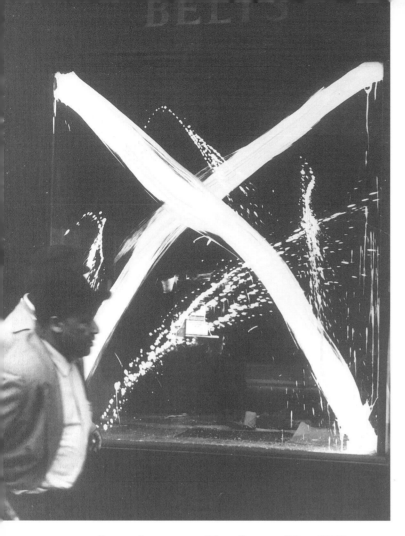

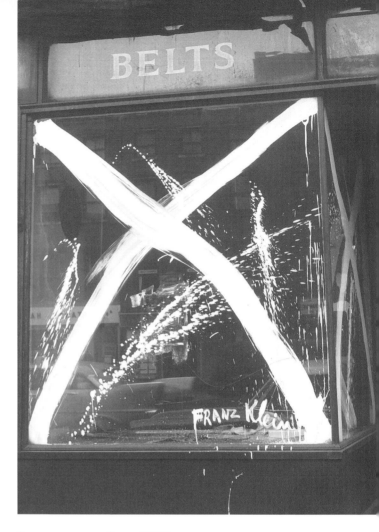

SIXTH AVENUE AT 12TH STREET, MAY 1959. SAME CORNER, JUNE 1959.

It would be too simple to say that Abstract Expressionist painting was about New York. It came less from *out there* than from within. Just the same, New York's physical presence—its lights and shadows and the power and frenzy of its postwar building boom—reverberated in those canvases.

All over town in the late '50s windows were X'ed in white to signal that their buildings were imminently to be destroyed and replaced, for profit, in the name of progress. The developers were quite open about their intentions; only after tenants, community groups, and preservationists got more organized in the '60s did the developers develop wariness (in some instances going so far as to begin demolition suddenly on weekends before a Monday court injunction could be obtained). On a building in my neighborhood the window X'er had been particularly exuberant—it may have been a case of life imitating art. I thought it was worth a picture.

A few weeks later, passing the same window, I saw that someone with a better eye for art than

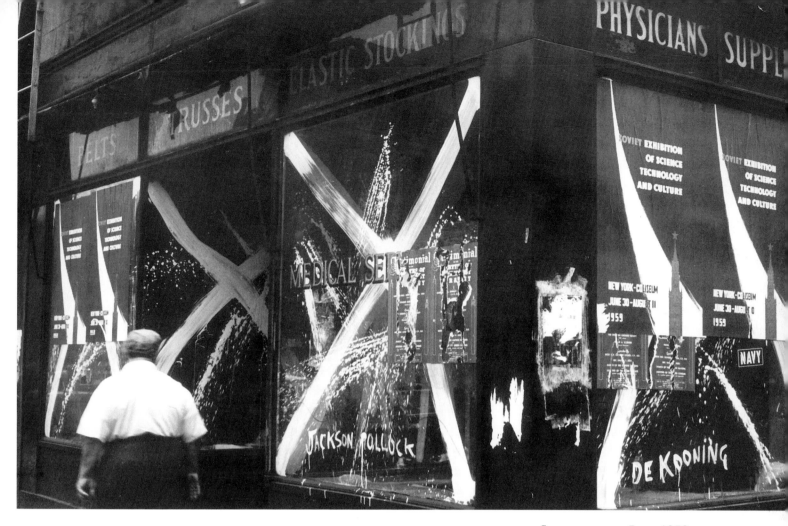

Same corner, July 1959.

spelling had had the same reaction as mine. The window had been attributed to Franz Kline (misspelled "Klein"), and two others of the same corner store had been "signed" by the other members of the period's great triumvirate, Jackson Pollock and Willem de Kooning.

But, like Abstract Expressionism itself, this celebration of it was doomed to be superseded. Even before the wreckers arrived, other kinds of art were crowding in on the scene. The field was not to be left to those who had staked the first claim.

The weeks that remained to the shell of that old building were time enough to register the triumph of Pop Art over Abstract Expressionism. What had been a new interpretation of barbarism had been forced to yield to barbarism unreconstructed. Then again, one had to think that perhaps Abstract Expressionism—which had looked so new—was really only reactionary. Perhaps it was no more than a final clinging-to of hand-painted pictures, a reaction against the commercial slickness of the airbrush and mechanical reproduction. In the years ahead, Abstract Expressionism was to be overwhelmed by all that was hard, polished, commercial, inflated, and free of the nervous shaking of the human hand.

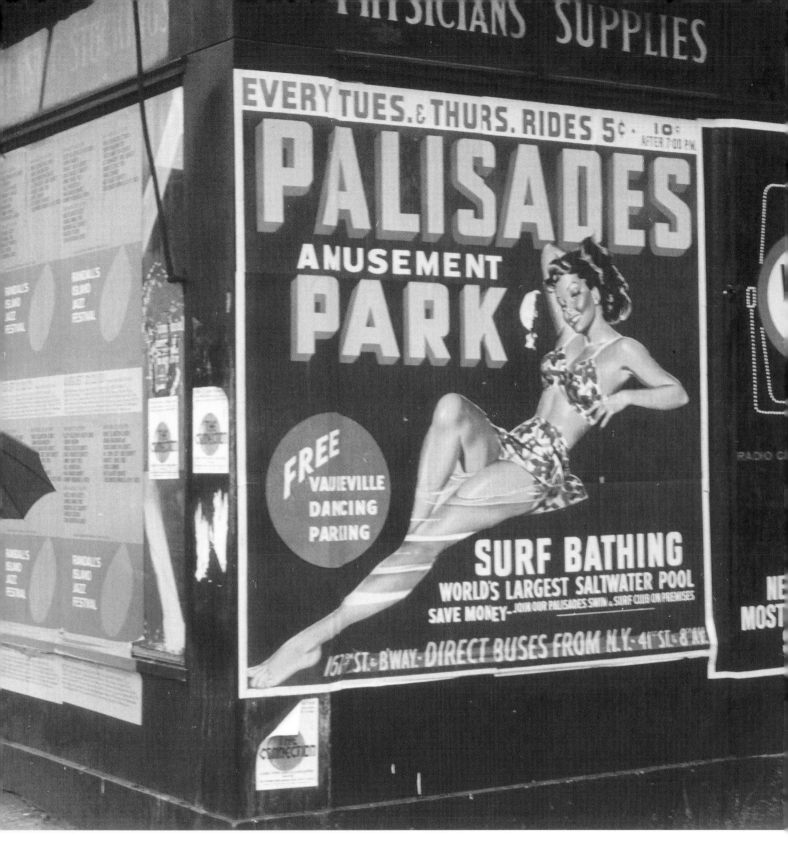

Sixth Avenue at 12th Street, August 1959.

While I dealt with more troubling matters at work—mostly from the safety of the newsroom, and occasionally out on the street with a camera crew—they hardly intruded on my private life or on my goings about town.

YEARS OF TURBULENCE

1964 to 1974

Time for a drink. After the shock of Kennedy's death (suspicions about it never entirely quieted) and with the unsought freedom of my divorce, I welcomed the all-male comfort of McSorley's Old Ale House, on East Seventh Street near Cooper Union, where the bar and the carved-into tables and the pictures on the walls never changed, only the jacket of a book by some regular now and again being found space for, and where the ale and the porter—the only beverages served—were not as strong as the limburger cheese or the cheerfully foul mouth of the waiter, Tony Stampaglia.

Once almost every week I met at McSorley's for a few suds and the limited but hearty lunch fare with my J-School classmate Dick Walton, and occasionally we were joined by other friends, such as the lovably acerbic literature professor, and later movie critic, Richard Freedman (who turned uncharacteristically benign in the latter role, since the papers he wrote for couldn't put all their movie advertising at risk). Dick's job as radio correspondent at the United Nations allowed him some flexibility in hours, and I didn't have to be in at work until 4 P.M, so we had time for leisurely bull sessions. In those days, before women finally got admitted to the place, there was only a men's room—a small space holding two of the largest urinals I'd ever seen, inverted chinaware niches reaching, at a guess, five feet from the floor. Their massiveness always made me think of Chicago—I'm not sure why ("City of the Big Shoulders"?). After protests began to grow against the war in Vietnam, a misogynist scrawl would appear above one of those urinals: "Don't bomb Hanoi, bomb Hunter." Hunter uptown, before it in turn became integrated through the admission of males, was an all-women's college.

One of our favorite writers on the city, Joseph Mitchell, had celebrated McSorley's in a *New Yorker* piece that provided the title for his collection, *McSorley's Wonderful Saloon*. Accepting the claim, later to be disputed, that it was New York's oldest bar, having been founded in 1854, Mitchell wrote that to a McSorley's regular "most other New York saloons seem feminine and fit only for college boys and women; the atmosphere in them is so tense and disquieting that he has to drink himself into a coma in order to stand it." He found the gloomy atmosphere relaxing and described the customers as "not competitive."

MCSORLEY'S, MARCH 1964.

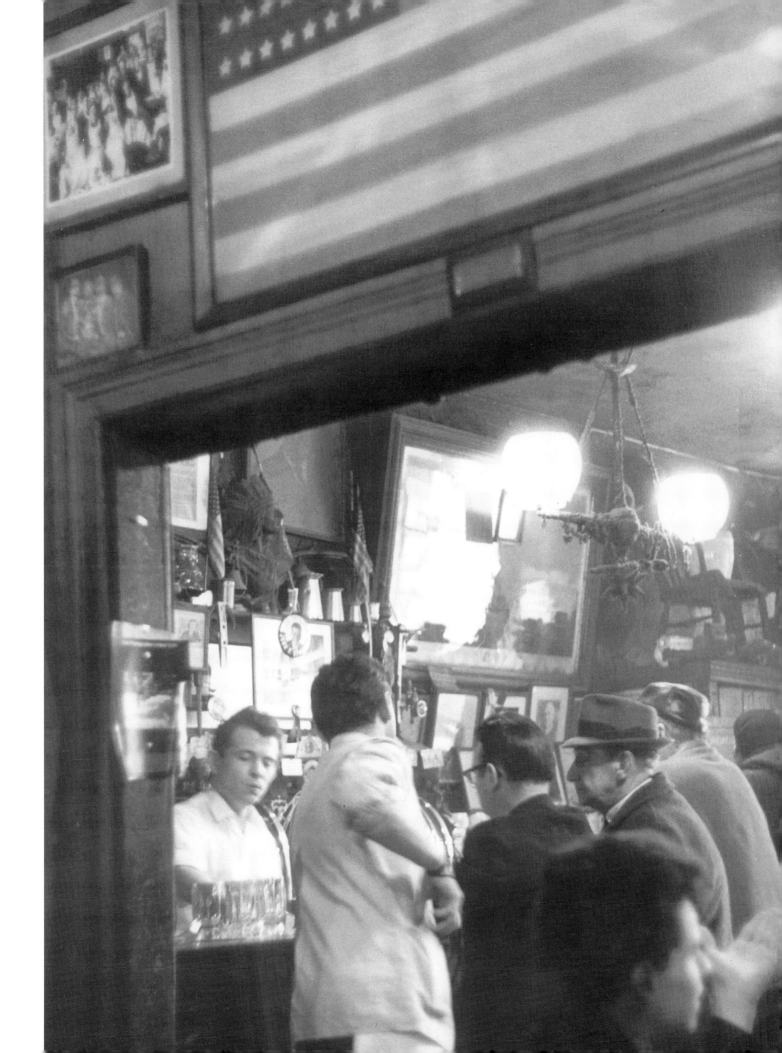

CORNER OF CHURCH AND CHAMBERS STREETS, OCTOBER 1963.

M cSorley's was fine and relaxing once a week, but most of the rest of the time I continued to face the quandary that the world was—and wasn't—full of women. Was there a woman I could desire, and speak to, who could also desire and speak to me?

I wanted a family as much as I wanted sex.

In the months I had been driving around the city in my car I had noticed so many women—as I had also on the subway or walking the streets, in restaurants, shops, wherever—for whom I could conjure up fantasies of life shared.

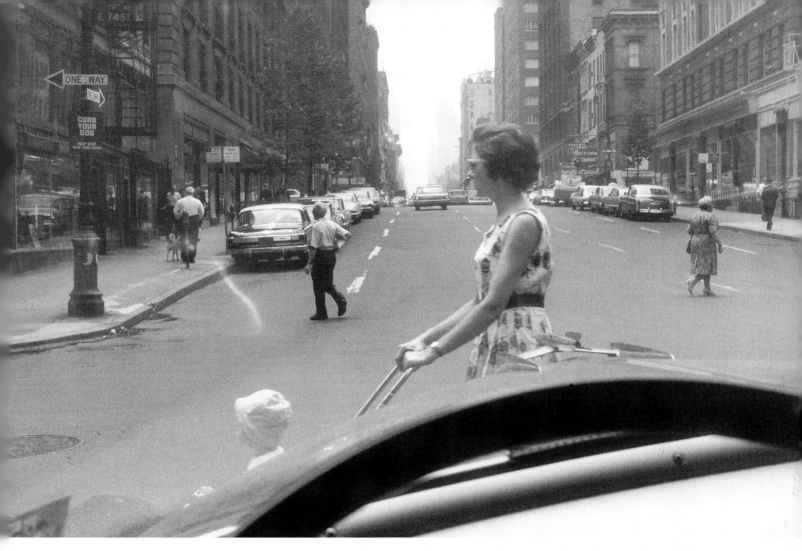

SOUTH ON LEXINGTON AVENUE AT 74TH STREET, JULY 1964.

My imaginings could be safely entertained as long as the gap of total unfamiliarity remained. In my fantasies a woman seen and desired, but not spoken to, could be what I wanted her to be. Once spoken to at a party, or introduced by some obliging friend, or otherwise actualized by something other than my eyesight, a woman became problematic. To use later terminology: where was she coming from? What was her background, her knowledge, her interests, her ambitions? Did we have anything to talk about, to share?

I wasn't precisely shy, hardly a tongue-tied teenager—I'd already been married!—but a return to dating was awkward and difficult just the same.

Once again I found that the efforts of friends to connect me with women they thought suitable never seemed to work. One such friend, Jerry Toobin (he had married Marlene Sanders, the effective all-around helper from WABD days, who was now a correspondent for ABC), did indeed steer me to a few interesting women, including the poet Sandra Hochman and the rising literary star Renata Adler, but nothing developed beyond a few polite dates.

Meanwhile, my friend, the abstract painter Bob Goodnough, gave a party at his Greenwich Village place on a Saturday afternoon, and across the Ping-Pong table in his backyard I met the dark-haired, provocative Elaine Taylor, who was studying sculpture. I didn't try to make a date with her right away. After about two weeks, though, I found she had been intruding quite lot on my thoughts, and I called her. Soon we were seeing each other almost daily. She said she had never pictured herself being married, though she had imagined living with a little dark-haired son in the south of France. When I proposed, she hesitated, but eventually said "yes," and we were married. A red-haired baby boy named Sven arrived for us near the end of 1965.

Since Elaine's floor-through above a glazier's shop on Eighth Avenue below 20th Street had more space than my West 74th Street apartment, I gave up my place and moved in with her. Dominated by the fast-flowing avenue, with its curious mixture of shops ranging from Hispanic bodegas to an Italian fish store, and China-Cuban eateries thrown in,

Chelsea was unlike any place I'd lived before, lacking the more settled residential character I had known elsewhere. The district, like the avenue, seemed in flux. But we made good friends with the Jacksons just around the corner on 19th Street, whose son Jonathan was born within days of our son Sven, and we enjoyed good relations with some of the local shopkeepers, including the warmhearted Louis Fata, who ran a liquor store a couple of blocks down and was an appreciator of wine before most of his brethren in the business caught on to it. He stocked some surprisingly good Algerian red wine for less than two dollars a bottle. (Sadly, the following year's wine from the same producer was no good at all.) We managed to live in the somewhat awkward floor-through for seven years, with a second red-haired son, Tor, following Sven two years later. When the glazier would finally sell the building to a hard-nosed plumbing supplies dealer next door, the landlord-tenant relationship would become too sour (the new owner simply wanted the tenants out), but that's getting ahead of the narrative.

ELAINE IN THE GUGGENHEIM MUSEUM, JANUARY 1965.

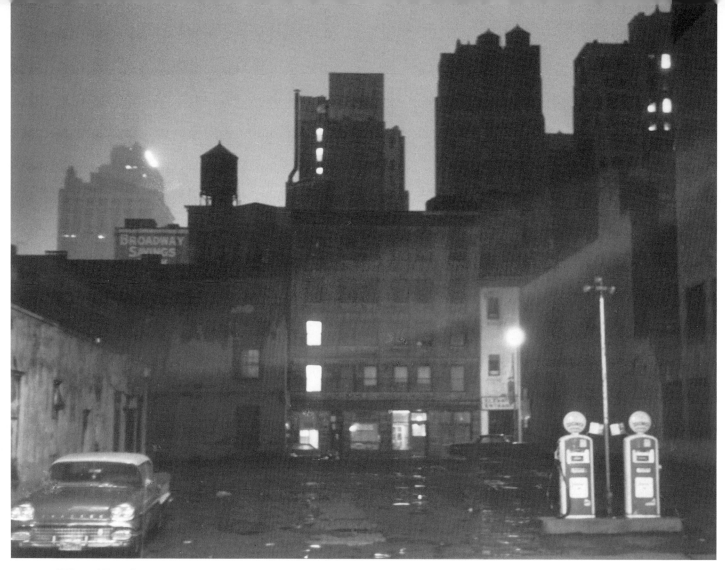

WEST 27TH STREET, DECEMBER 1965.

On November 9, 1965, just a month before Sven was born, a regional power failure blacked out New York. Leaving NBC, which was unable to broadcast locally, canceling the 11 P.M. broadcast, my colleague Peter Ochs and I walked down a Sixth Avenue whose only illumination came from the headlights of the cars moving toward us. It was about half an hour's walk home. That evening, many people managed to find they had candles somewhere in their apartments, or they managed to buy them, likely at premium prices. In the absence of television and other normal distractions, an unusually high number of babies were conceived that night. Sven, for his part, was approaching the time for emerging into this world, which he did with such dispatch when the moment came that we barely made it to the hospital for Elaine's delivery.

Electric lights. I'm just old enough to feel always a little apprehensive about machinery that is not purely mechanical but that depends on the invisible pulses of electric energy. I don't take for granted that anything electrical or electronic will work. (Even in our current millennium, those always most up-to-date people in California have had to face the rude truth of a limitation on electric supply.) On the night of the 1965 blackout I didn't think of photography. Photography without light? However, the blackout left a lingering impression, and on a damp night with a semi-blackout feeling three days after Sven was born, I took what I mentioned in my notes as "nocturnes." One of these was of a pair of outdated-looking gasoline pumps on the edge of a West 27th Street lot as a gust blew wisps of mist across darkened buildings.

I haven't checked, but I'm sure the gas pumps are long since gone, along with the vacant lot and probably some of the buildings in the picture. New York was reluctant to preserve even the still-useful picturesque. On my way to work one day, I saw a subway entrance kiosk from the early days of the century being demolished at 50th Street and Broadway. I photographed the sad event, and, since no film crew had been assigned to record it, we used a sequence of my stills on the broadcast that night. Where the kiosk had provided shelter from the weather for those on the subway station stairs, the new, more open stairway entrance that replaced it would not only look less interesting, but it would also leave subway users vulnerable to the elements at the point of transition from one environment to another. Hardly progress.

New York had begun to temper its ruthlessness toward the past. Outrage over the losing of a landmark had probably never before matched the fury over Pennsylvania Station, whose demolition began in 1963. In 1965 the city passed its landmarks preservation law. A future neighbor of ours, Otis Pearsall, was instrumental in getting Brooklyn Heights quickly designated as the first historic district under that law, although not at all other preservation actions would be as prompt or effectual, as has been noted in the case of the Singer Building. (Eventually the law would be applied to the Chrysler Building and other *real*—i.e., skyscraper—landmarks of New York.)

A building that could be designated without big-money opposition was one like the little Federal-style house on the corner of White Street and West Broadway. In the year of the landmarks law it retained a wonderful vintage New York look, if not quite the "Little Old New York" quality of the eighteenth century. Its side faced a stone-paved West Broadway, and its ground floor was occupied by a barber shop boasting not one, but two candy-striped poles, their spirals going in opposite directions. Saving a barber shop would be harder than saving a building. (By the way, I have a thing about using the word "cobblestones" to describe those rectangular stones. To me, cobblestones are strictly such rounded stones, most difficult to walk on, as are rarely found outside a few ancient city districts abroad. The brick-shaped stones are Belgian blocks.)

Well, words and phrases come and go, and I feel helpless to save the use of "Belgian blocks" if everyone else insists on calling them "cobblestones." Soon enough, nobody will know what "Belgian blocks" refer to. This is true even of expressions that have resonated with special force at a given time. I know, for instance, that "23 skidoo" was a well-nigh universal phrase in the city and nation in the 1920s, but don't ask me what it meant, and who cares very much by now? I suppose one could think of "23 skidoo" as a kind of verbal snapshot of its day. But it's interesting, is it not, how old pictures hold onto a good deal of life even as words get brittle and start to sound foreign. The word may be able to express things a picture can't, but the picture still enjoys primacy as a conveyor of the human story.

WEST BROADWAY AT WHITE STREET, JULY 1965.

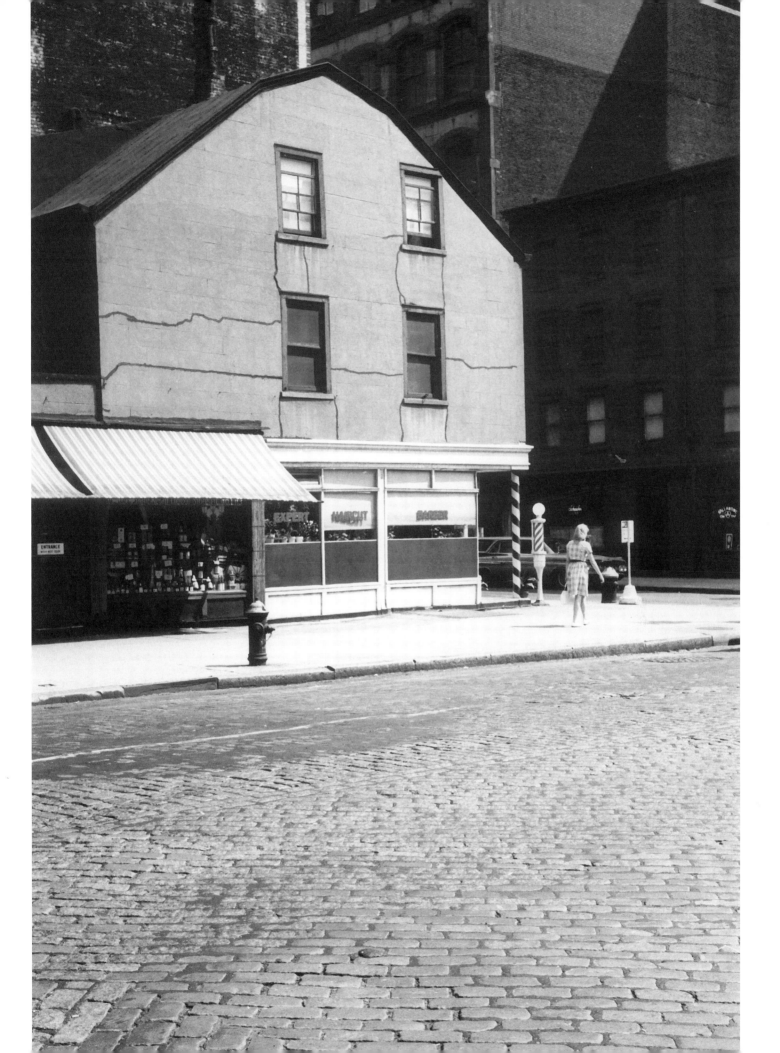

enn Station didn't come down all at once. The 1910 behemoth by McKim, Mead and White filled two entire city blocks, its columned front extending along Seventh Avenue from 31st to 33rd Street. It was still partly standing more than two years after demolition began, when, in January 1966, the subway workers greeted the new mayor, John Lindsay, with a strike. Many commuters who would ordinarily have used the subway waited in freezing weather, many with hot coffee cups in hand, to reach the concourse beneath the ruin, from which they could get onto Long Island Rail Road trains, which continued running.

In more ways than one the whole atmosphere of New York—and not just New York—was changing. We were now truly into the Sixties—a period I date from 1964 to 1974, from the year after the death of John Kennedy through the forced resignation of Richard Nixon—the time when so many premises and practices of American life came under attack.

Even Penn Station's destruction was in its way symbolic of other disaster. Demolished to save a railroad (the Pennsylvania), it failed to do that, just as American forces in Vietnam would be burning villages to save them, only in the end to lose both villages and country to the North Vietnamese enemy.

Forget "23 skidoo." Now it was "Hey hey LBJ how many kids did you kill today" that became a vivid slogan of the time. Already into my later thirties, I was well past the cutoff of the "You can't trust anyone over thirty" divide that had become a byword of the younger generation. For all that Lyndon B. Johnson embarked on a program of caring for the underdog, he suffered the disadvantage of following a leader closer in age to the myriad postwar babies coming out of their teens, and then he got disastrously bogged down in Vietnam. We'll never know what might have happened under Kennedy. In any event, the generational reaction against the smugness the nation had developed—and against its property-focused policies—panicked a great many comfortable older liberals and drove them into becoming neoconservatives. Uneasy as I felt about the youth rebellion, I was nonetheless deeply disappointed by the pusillanimous reaction of some writers and publications I had hitherto admired. Not more so than in the case of *Commentary,* a magazine that had seemed so sane and ecumenical, but whose editor, Norman Podhoretz, turned crankily dismissive of challenges to the established order and steered the publication in an uptight and parochial direction.

REMAINS OF PENNSYLVANIA STATION, JANUARY 1966.

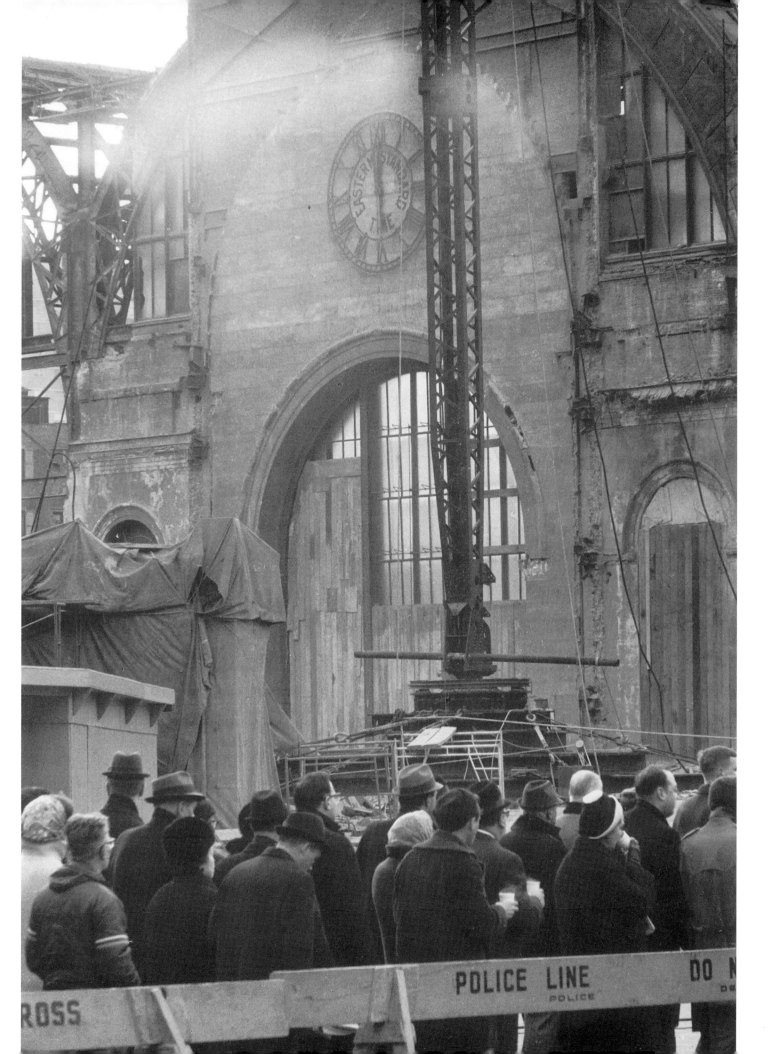

From the palely idealistic flower children to the furious Black Panthers to the violently anarchistic Weathermen, I dealt with coverage of their activities almost daily on my job. Yet these radical movements didn't touch most people's lives very much.

In some ways it was the relative trivia of the period's "revolution" that had a more penetrating, and some might say more insidious, effect. A whole vocabulary came under attack in what would become a campaign for "political correctness." People would no longer be able to use many commonplace words—fat people would become "large," cripples would become "handicapped" or "disabled," old people would become "senior citizens," people would no longer die but "pass away." Undertakers would become "funeral directors," and used car dealers would in years ahead try to pawn themselves off as sellers of "preowned" ones. Supporters of legalized abortion would become

"pro choice" in contrast to opponents who claimed to be "pro life." Euphemisms were certainly not new to American life, but those who reacted to what they saw as American materialism, soullessness, and hypocrisy, as well as those who defended the established norms, contributed to a diminished directness of language—either from sympathetic concern for the feelings of those less fortunate or from a desire to evade the unpleasant truths that the contentiousness of the period had pushed into the open.

The proud, gilt figure of an avowedly fat man catching the sunlight above Sig. Klein's shop on Third Avenue near Tenth Street was obviously a relic of a time and an outlook destined not to survive much longer. While he lasted, that fat man was glorious in defiance of an age that combined idealism, violence, and a new prudery in a most peculiar mix.

THIRD AVENUE NEAR TENTH STREET, DECEMBER 1966.

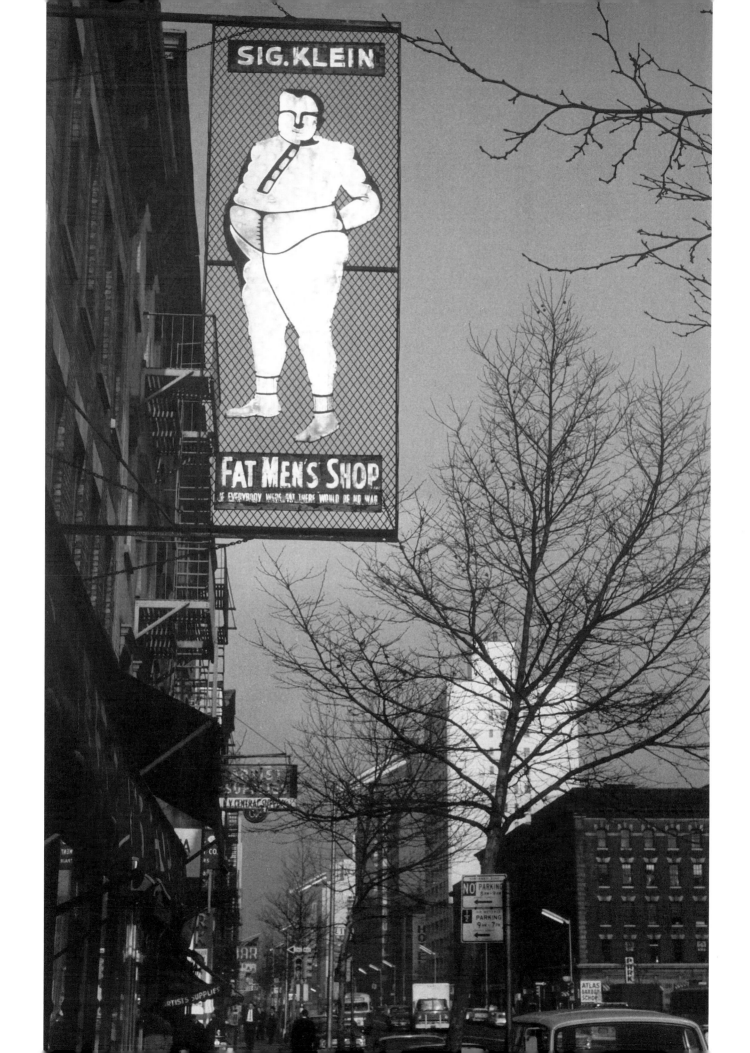

In 1965, Malcolm X had been killed; Selma, Montgomery, and Watts had become names associated with racial violence; Johnson had increased the number of U.S. troops in Vietnam to 125,000; Queen Elizabeth had made the Beatles members of the Order of the British Empire; Adlai Stevenson, the intellectuals' beloved loser of two presidential elections, had died; and John Lindsay ("he is fresh and everyone else is tired") had been elected mayor with big plans for the city—only to meet immediate obstacles.

What had all those things to do with the life of New York? Very little, it would seem, to someone strolling about many a neighborhood. One day in the Village I noticed the art of sport and the sport of art going on as if nothing more serious in the world were happening, or as if nothing more serious mattered. While passers-by paused to watch a skillfully contested basketball game in a playground at Sixth Avenue below West Fourth Street, a sidewalk portraitist was giving a more decisive appearance to a less than pretty girl. Beyond the basketball game, others were playing handball. If not quite a melting-pot scene—the basketball players were black, the handball players white, the spectators mainly white—it was nonetheless a scene of harmonious coexistence such as one could only wish would have characterized the world at large.

Another day I saw a bass player, his great musical instrument on his back, waiting to cross Columbus Avenue to the recently completed Lincoln Center, New York's new forum for the performing arts—a satisfying, even self-satisfied, oasis from the mundane aspects of life.

While I dealt with more troubling matters at work—mostly from the safety of the newsroom, and occasionally out on the street with a camera crew—they hardly intruded on my private life or on my goings about town. True, I was more wary about venturing into certain parts of town; I was on guard against pickpockets in crowded places; I scanned doorways and listened for footfalls on lonely streets after dark; but these precautions had more to do with my awareness of the general danger of crime in a very large city than with any particular menace of the time. I was never directly confronted or threatened. In fact, it was a time when business was booming; lots of construction was going on; more people were well off than ever before—even as the exodus to the suburbs continued.

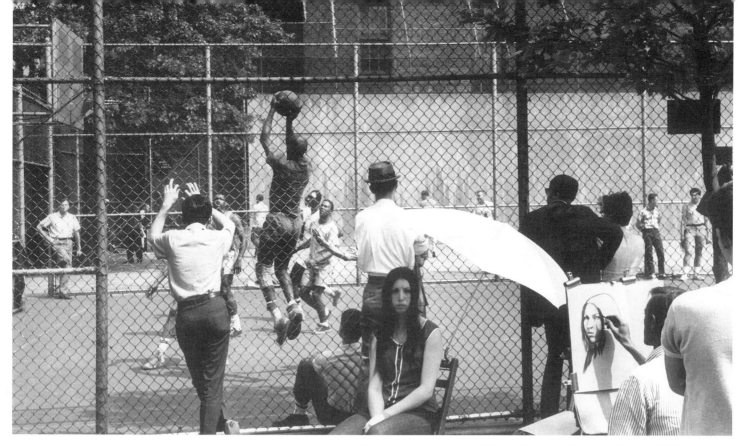

SIXTH AVENUE NEAR WEST FOURTH STREET, JUNE 1966.

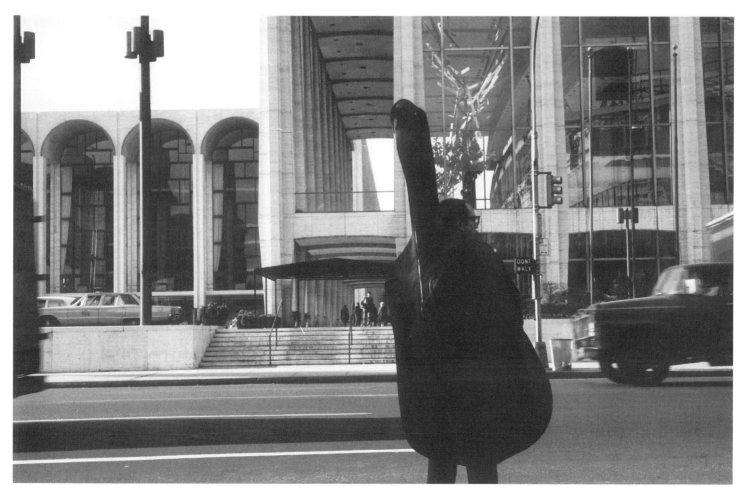

OUTSIDE LINCOLN CENTER, OCTOBER 1966.

If Lindsay had achieved his dream, we would have been living in what he called "fun city." Labor troubles, crime, racial and generational tensions, conflict over Vietnam interfered. Still, there were signs of a new spirit invigorating the place. Lindsay promoted "happenings" in Central Park—impromptu performances that drew people back into a space that had lately been perceived as ominous and even life threatening. He talked the city up at a parlous time. He also presided over the most permissive years in New York's history. What was billed as a sexual revolution was much in the air; an increasing explicitness was creeping into movies, and old censorship rules were under attack. Movie houses showing what would earlier have been banned as pornography went now undisturbed by the police. Prostitutes seemed quite free to solicit within a wide radius of Times Square. A convention-eering Lion from out of town might encounter a "friend" on the very doorstep of Rockefeller Center at Sixth Avenue and 49th Street.

The musical *Hair* arrived to celebrate what was known as the "summer of love," when antiwar and antiracist sentiments were combined with affirmations of peace, love, and sexual liberty. In Mike Nichols' movie *The Graduate,* a young Dustin Hoffman was introduced to sex by Anne Bancroft, as the mother of his girlfriend (a movie also remembered for a businessman's one-word career advice: "Plastics"). Not that sex was the all-dominant theme at that time; two other notable movies, Antonioni's *Blow-up* and Bergman's *Persona,* delved into ambiguities of identification and identity. The Antonioni film's concern with the limitation of a photograph as evidence struck a special chord with the photographer in me. Another tour de force, one that expressed sex in the guise of violence, was Arthur Penn's *Bonnie and Clyde,* in which the slow-motion heaving of the outlaw couple's car and their bodies as it and they were riddled by bullets suggested intercourse coming to climax. It was at the time a fresh and shocking use of slow motion, a device that would soon be overused.

SIXTH AVENUE AT 49TH STREET, JULY 1966.

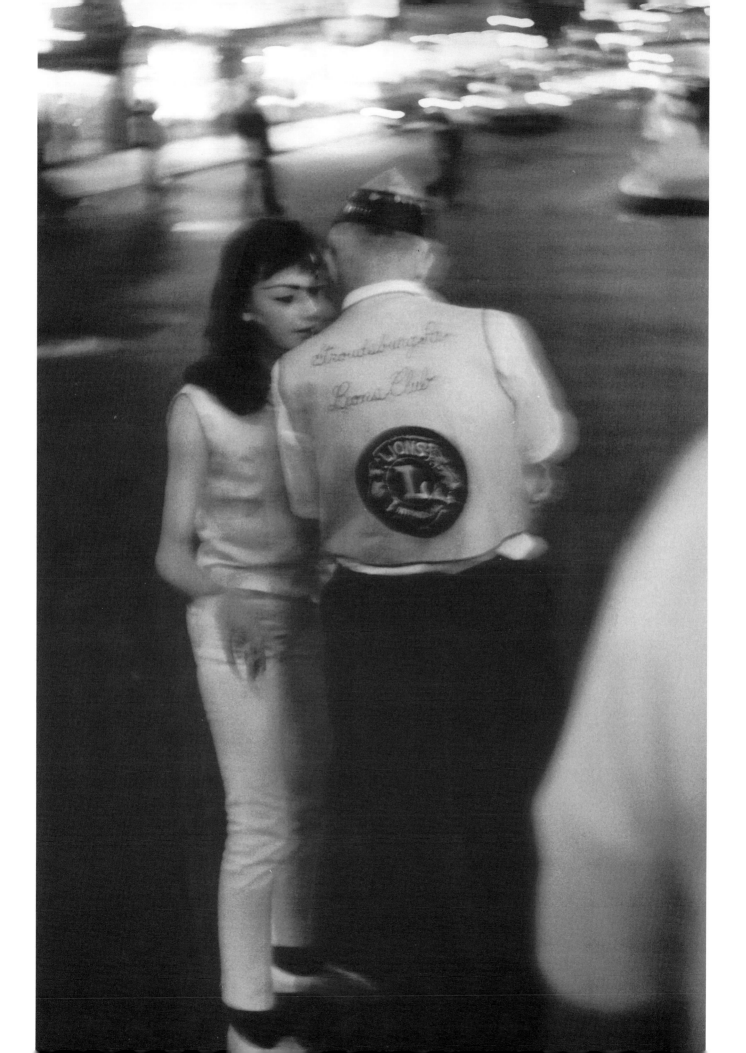

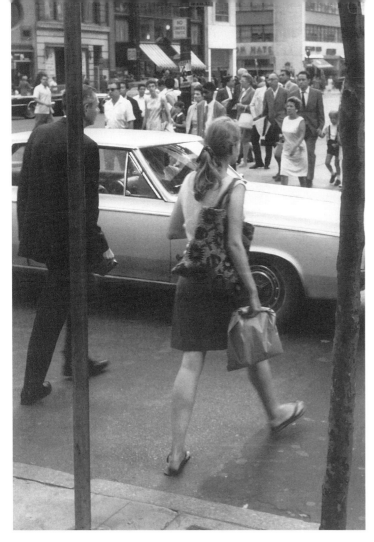

Fifth Avenue and 49th Street, September 1966.

nd the miniskirt arrived! The backs of a girl's knees—one of the first miniskirts I saw—the first one I photographed—appeared on Fifth Avenue at 49th Street in early September of 1966. Evidently I did not yet know the term, as I jotted down in my camera notes only *short skirt*. I think it was Andy Rooney on *60 Minutes* who commented that the miniskirt revealed to the world that the knee was not the upper part of the lower leg but the lower part of the upper leg. Be that as it may, the miniskirt was truly revolutionary, in the way it both altered the conventional image of the clothed female and challenged the authority of the fashion establishment. Ever since the start of the postwar recovery, the high-fashion houses had been trying to saddle women with Dior's "New Look" and other encumbrances of excessive dress. An occasional American designer, like Claire McCardell in

AT THE CHEETAH, WEST 53RD STREET, FEBRUARY 1967.

New York, had pushed for easier, sportier clothing. Now younger women were demanding even more—which is to say less—in the way of unencumbered street wear. The fashion establishment soon mounted a counterattack against this popular development by decreeing floor-length maxiskirts—but those fizzled. From now on, the fashion moguls would take their cue from the street at least as much as the street took its cue from them. Later, the fashion world would reassert its power largely through the heavy marketing of cosmetics and accessory products, but it could not dictate to women growing more confident about dressing—whether in miniskirts, jeans, trim suits, army fatigues, long dresses, or whatever—to fit their own shapes and styles of life.

By and large, the scene of the day was quite free to exist without my being part of it. That continued to be the great virtue of New York. Its various facets did not demand one's involvement. As E. B. White had written a quarter of a century earlier in *Here Is New York*: "New York blends the gift of privacy with the excitement of participation; and better than most communities it succeeds in insulating the individual (if he wants it, and almost everybody wants or needs it) against the enormous and wonderful events that are taking place every minute." What this privacy is not proof against, however, is visits by relatives from elsewhere—and almost every New Yorker gets them. So it happened that through the visit of relatives from Finland I went to my first disco. They had heard of a place called Cheetah on West 53rd Street. We went there and experienced the closely milling but non-touching dancers, the beat, the flashing strobe lights. I didn't regret the visit.

24TH STREET AT EIGHTH AVENUE, JANUARY 1967.

The gift of privacy—could one say loneliness?—might be had, night or day, on any block in the city. This was not a lonely time of my life. Nonetheless, an image evocative of loneliness could jump out at me, like the sight of a group of manhole covers illuminated against the dark asphalt by a corner store and a streetlight. They might have been oversized stars fallen down from a distant sky. A subway entrance, but no one in sight. I find comfort in such an image.

MADISON AVENUE, LOOKING NORTH FROM 47TH STREET, SEPTEMBER 1967.

BY THE PLAZA FOUNTAIN, AUGUST 1967.

In the summer of 1967 John Lindsay enjoyed a moment of glory when he walked the streets of Harlem in his shirtsleeves, cooling the racial tensions that had erupted into violence in a number of other cities. Besides that show of courage and empathy, he seriously attempted to give more voice to minorities, and diffused control of public education through the creation of community school boards—an experiment vitiated by small-time power grabbing and corruption. Lindsay is better remembered today for his aspirations and the handsome figure he cut than for his achievements. On the aesthetic side, too, what seemed like good ideas led to some unfortunate results. He pressed for better architecture in New York, but the effort

was undercut by a tired Modernism that led to too many flat-top slabs. Through a new "transfer of air rights" zoning device, some of these got put next to landmark buildings, overshadowing them. In return for allowing developers to build higher, they were required to put in little plazas at the bases of their buildings—another seemingly good idea that in practice resulted in too many uninviting spaces, which, at the same time, broke up the reassuring and orderly sense of Manhattan's street grid. What ultimately would hurt Lindsay the most, however, was his perceived failure, not uncommon to Manhattan-based mayors, to give enough attention to the "outer boroughs" (Brooklyn, the Bronx, Queens, and Staten Island). The city's inability to

Chock full o'Nuts, 50th Street and Broadway, August 1967.

clear Queens streets following a big snow in February of 1969 would haunt his administration forever after. A nominal Republican who then switched to the Democratic party, he managed to squeeze in for a second term in that year's election, but essentially his luck had run out.

Not to underestimate the effect of a dashing image—a quality he shared with John Kennedy and that much earlier (corrupt) Mayor Jimmy Walker—Lindsay set the model for a level of stylishness that coexisted with the scruffier aspects of hippiedom. A pair of attractive women conversing at the Plaza fountain off Fifth Avenue with some carefully groomed young men seemed to reflect a Lindsay, or even an F. Scott Fitzgerald, idea of New York.

I doubted, though, that the males were New Yorkers; their apparent diffidence and trimmed hair suggested out-of-towners. The women looked more nearly New York, as did the clearly self-possessed blonde sharing a Chock full o'Nuts counter with less prepossessing neighbors at the end of a day's work. Her proud posture and the others slumping identified them all in their differing ways as belonging to the metropolitan area. (That fast-food eatery at 50th Street and Broadway is long gone, as is the popular restaurant of onetime heavyweight champion Jack Dempsey whose sign is partly visible through the window at right.)

As a parent I was quite content to think of Sven and his newly arrived brother Tor growing up in New York. I never felt the least temptation to move to the suburbs. The stimulation, the learning opportunities, were so much greater in the city. There was neighborhood; there was no need to ferry the children around by motor vehicle.

At the same time there were some sanitary problems. Elaine was furious over a young woman who let her dog urinate in the Abingdon Square playground she took Sven to. She said none of the other mothers ever said anything to the woman. A lack of civic sense was too often encountered. I remember being upset when I saw a man spitting on the marble floor of the RCA (now General Electric) Building, where I worked. It wasn't just the fact that the floor was marble. As I thought about it, his act suggested a difference between city and country. The country, true country, it struck me, absorbs many things that in the city become blemishes. I could spit, or throw away an apple core

in the country, and feel I was even doing something for Nature, but I felt angered to see this man casually spitting on the floor of the RCA Building. An act that would have nothing to do with society in the country had become directly antisocial in the city, where Nature could not absorb and transmute the product of his act. His was an anticity act, as, more seriously, was that of the woman with the urinating dog.

The city exacts a price, it seems, both of those who hate it enough to spit or let their dogs urinate where they shouldn't, and of those who have to endure their actions. The man would hardly spit on his own floor, nor would the woman let her dog defile her own apartment. It may not even have been hate that was involved, but simply a lack of value accorded to property in the public realm. I had assumed the man was expressing hate, which had exacted a price of me, but it may simply have been that we were living in a society—still living in it— that hadn't developed respect for public property, that hadn't yet learned to live in this or any city.

ABINGDON SQUARE PLAYGROUND, APRIL 1968.

108

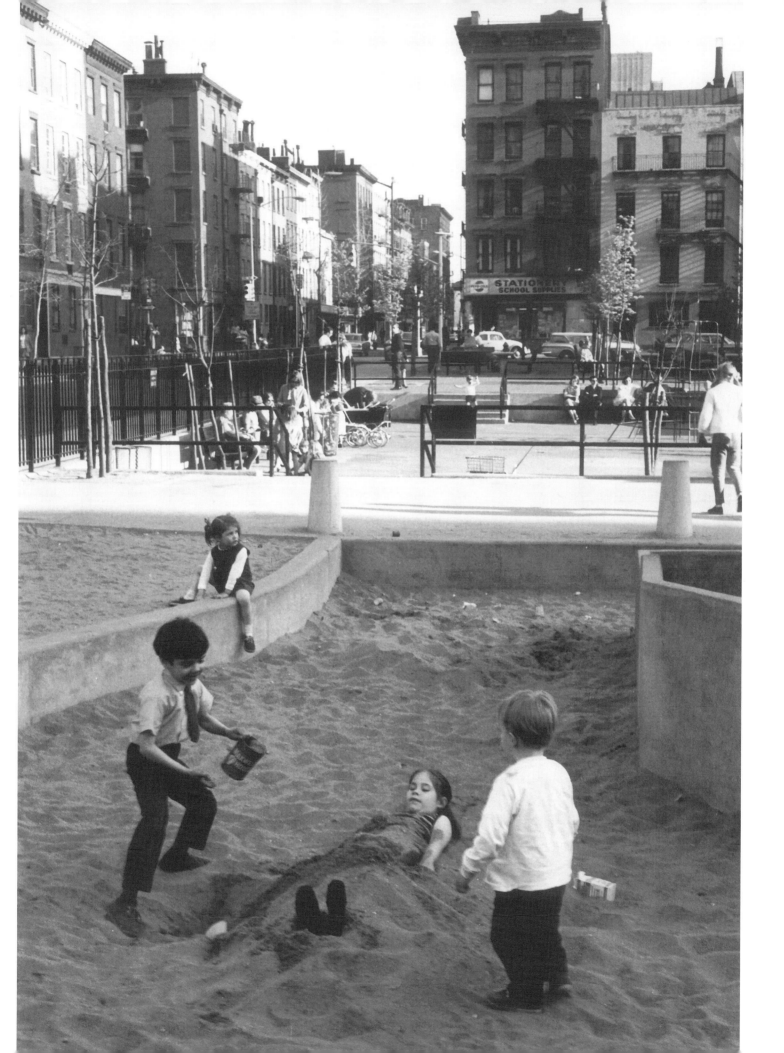

In truth, those small irritations of daily life tended to press more immediately on me than the cataclysmic events of the day—even in that terrible year of 1968. Martin Luther King Jr. and Robert Kennedy were murdered that year. In New York, student radicals shut down Columbia University. I wasn't around for the Columbia uprising that spring, having been sent to Paris as a *Today* show coordinator for what was scheduled to be the start of Vietnam peace talks. Unexpectedly, demonstrations by Paris students became the bigger story. My colleagues working for the network's main Huntley-Brinkley evening news were frustrated when their New York bosses failed to regard the students' actions seriously—they'd had a surfeit of civil rights, anti–Vietnam War, and other demonstrations—but I found the *Today* producers more receptive, with the result that NBC's more lightweight morning show scooped its more self-important evening show on a story that would culminate in the downfall of the de Gaulle government.

In Paris, too, ordinary life went on. In off-duty hours I walked through miles of streets that to all appearances were entirely untouched by the demonstrations. I took pictures and sent an article about those walks to the *New York Times* travel section. The longtime travel editor, Paul J. C. Friedlander, wrote me an irate rejection, saying I must have been faking—didn't I know Paris was in an uproar? It was, at least, better than getting the usual, bland, boilerplate rejection.

Later, near the end of August, I was sent overseas again, this time to London, a relay point for the then still-new transmission of pictures via satellite, to help gather, edit, and forward the visual record of Soviet tanks crushing the "Prague Spring" of political and cultural flowering in Czechoslovakia. This assignment took me away from another contentious event on the domestic front—the Democratic convention in Chicago, where Vice President Hubert Humphrey, crippled by his loyal support of Johnson's war policy, gained the presidential nomination amid rioting and a retaliatory police crackdown. I had begun to grow a beard that I would keep until the day after Nixon's forced resignation in 1974. The beard didn't start as a political statement, but it became one.

Once back in New York I did witness a November demonstration beginning to form outside City Hall by mainly minority students, who chanted "Forty-five minutes must go" in protest against a public school teachers' strike settlement that provided for forty-five minutes of added daily class time, with overtime pay for the teachers. It was pretty tame stuff by comparison with everything else that was happening.

OUTSIDE CITY HALL, NOVEMBER 1968.

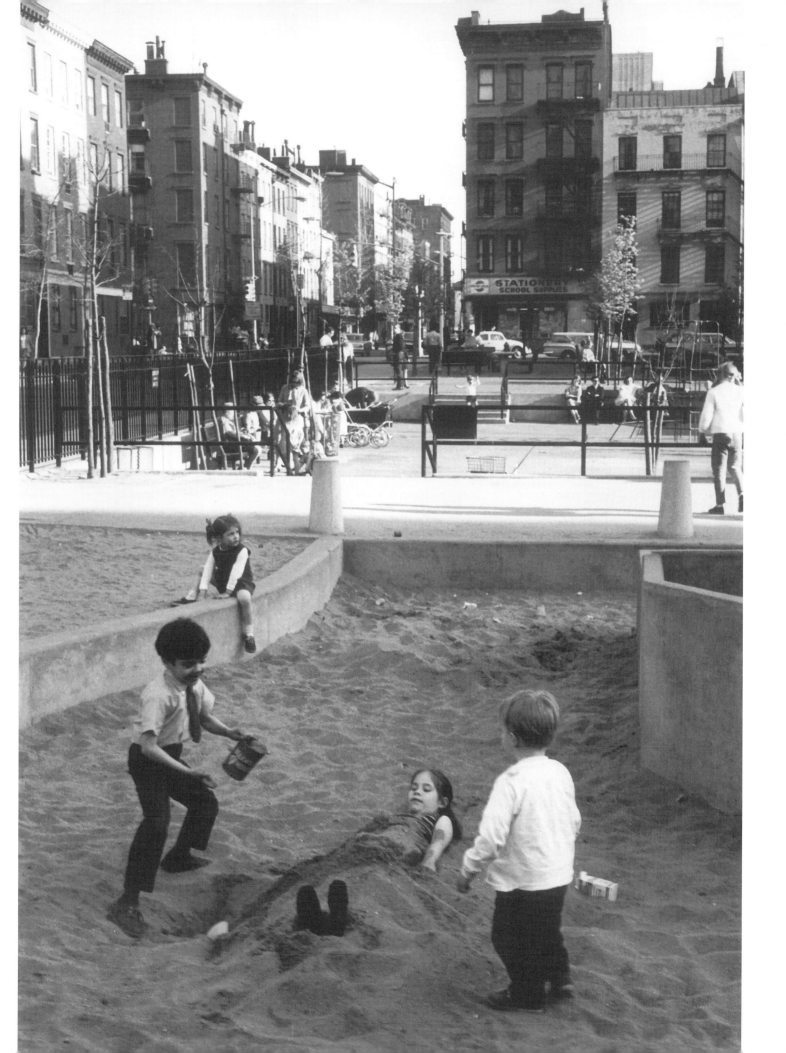

In truth, those small irritations of daily life tended to press more immediately on me than the cataclysmic events of the day—even in that terrible year of 1968. Martin Luther King Jr. and Robert Kennedy were murdered that year. In New York, student radicals shut down Columbia University. I wasn't around for the Columbia uprising that spring, having been sent to Paris as a *Today* show coordinator for what was scheduled to be the start of Vietnam peace talks. Unexpectedly, demonstrations by Paris students became the bigger story. My colleagues working for the network's main Huntley-Brinkley evening news were frustrated when their New York bosses failed to regard the students' actions seriously—they'd had a surfeit of civil rights, anti–Vietnam War, and other demonstrations—but I found the *Today* producers more receptive, with the result that NBC's more lightweight morning show scooped its more self-important evening show on a story that would culminate in the downfall of the de Gaulle government.

In Paris, too, ordinary life went on. In off-duty hours I walked through miles of streets that to all appearances were entirely untouched by the demonstrations. I took pictures and sent an article about those walks to the *New York Times* travel section. The longtime travel editor, Paul J. C. Friedlander, wrote me an irate rejection, saying I must have been faking—didn't I know Paris was in an uproar? It was, at least, better than getting the usual, bland, boilerplate rejection.

Later, near the end of August, I was sent overseas again, this time to London, a relay point for the then still-new transmission of pictures via satellite, to help gather, edit, and forward the visual record of Soviet tanks crushing the "Prague Spring" of political and cultural flowering in Czechoslovakia. This assignment took me away from another contentious event on the domestic front—the Democratic convention in Chicago, where Vice President Hubert Humphrey, crippled by his loyal support of Johnson's war policy, gained the presidential nomination amid rioting and a retaliatory police crackdown. I had begun to grow a beard that I would keep until the day after Nixon's forced resignation in 1974. The beard didn't start as a political statement, but it became one.

Once back in New York I did witness a November demonstration beginning to form outside City Hall by mainly minority students, who chanted "Forty-five minutes must go" in protest against a public school teachers' strike settlement that provided for forty-five minutes of added daily class time, with overtime pay for the teachers. It was pretty tame stuff by comparison with everything else that was happening.

OUTSIDE CITY HALL, NOVEMBER 1968.

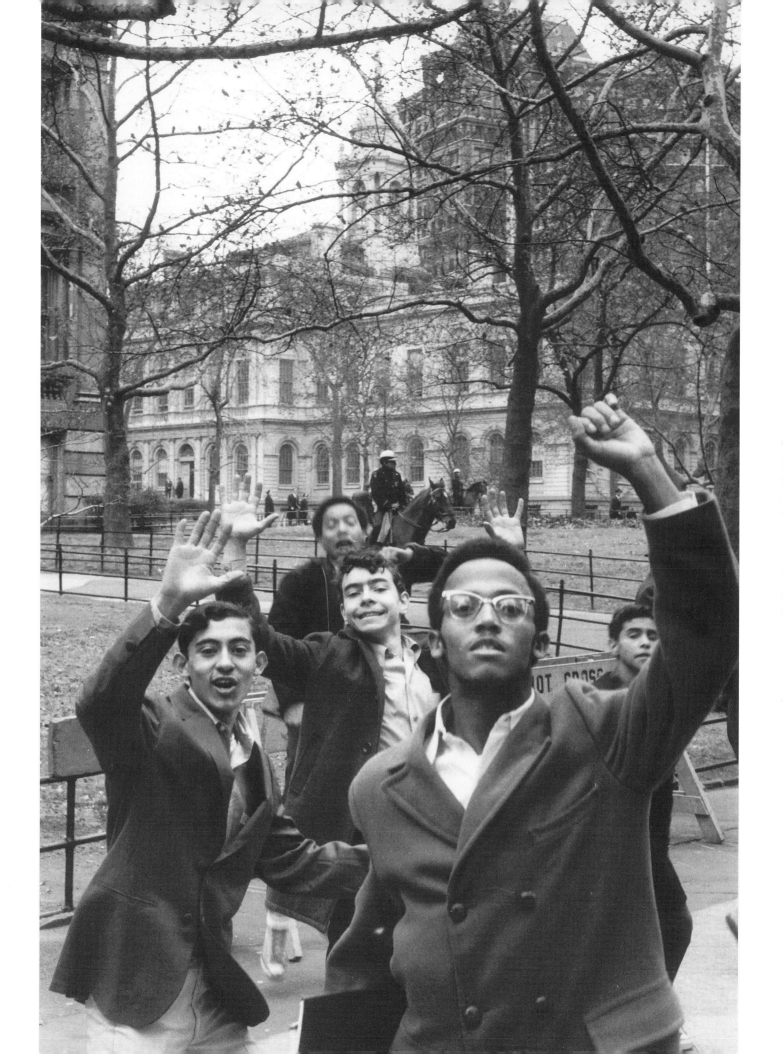

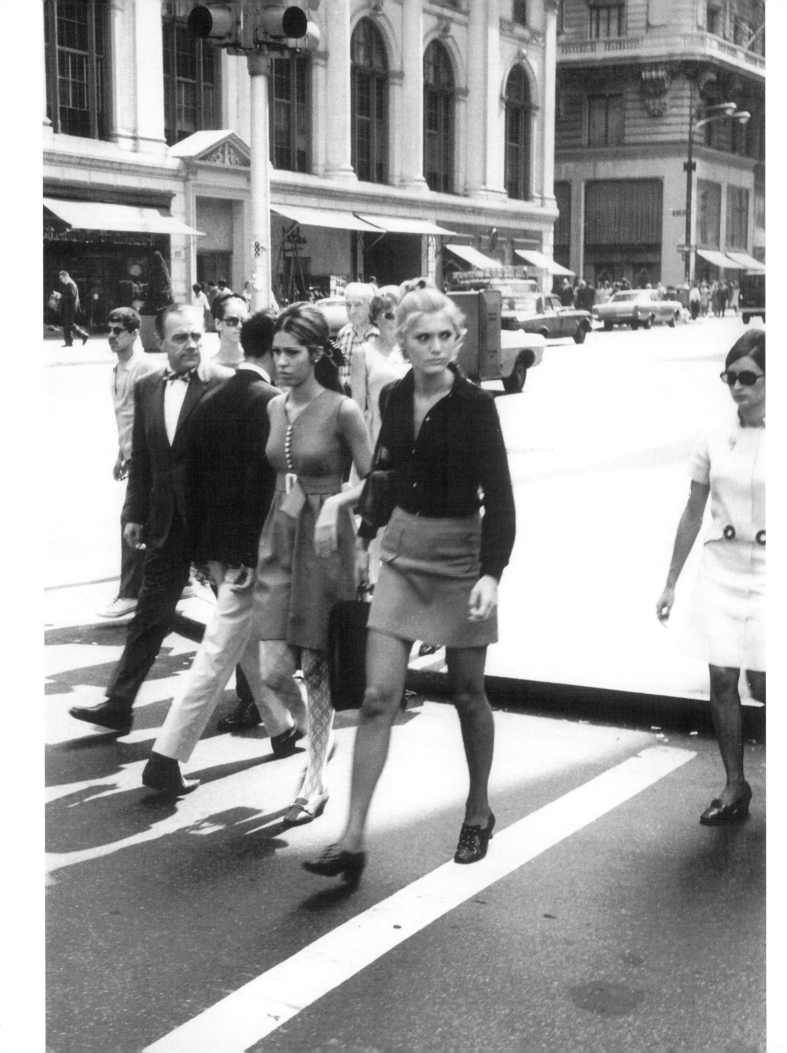

In the interval between my Paris and London assignments I enjoyed a less pressured, daytime schedule at NBC. With a change in local news executives I had been replaced as producer of the 11 P.M. show—another producer and I would play musical chairs with this position for several years, alternating in the role with alterations in management. Since my current "demotion" actually resulted in a softer job on the network side, where redundant staffing spread the work out, I was able to have unhurried lunches out and also be home in the evening with the family. After one lunch, as I was returning down a sun-blanched Fifth Avenue with a pair of colleagues, my eye—and camera—caught a miniskirt in the midst of an interesting little group crossing 56th Street. After an agreeable meal, it was an agreeable sight. Life seemed pretty good.

For all I knew, we might get back to the office to learn that some cataclysmic event had happened somewhere. But, for the moment, a sense of well-being ruled. It's a common reaction on hearing of a disaster or serious disturbance in a faraway place to imagine that an entire region is engulfed—an earthquake in India devastates the whole subcontinent—whereas what happens locally may go unnoticed a block or two away. The same is true of events removed from us in time. In my files I find a telling review by a William Marshall, in the January 1, 1995, *New York Times Book Review,* of a book titled *Scenes from the Life of a City* by Eric Homberger, in which Marshall notes that any then contemporary account of New York City as a violent place would "be almost unrecognizable to the millions of ordinary, middle-class people who work and live in it every day—so Mr. Homberger's simplistic descriptions and divisions of New York in the 19th century probably would have been unrecognizable to the majority of residents who were neither nabobs nor Neanderthals, but ordinary, decent people intent only on making good in the New World."

Fifth Avenue at 56th Street, August 1968.

In 1969, I celebrated—if that's the word—my fortieth birthday. It feels very old when you're forty; it doesn't seem so old later on. For the first time, you begin to feel that your body doesn't obey you quite the way it used to, and you feel some twinges and occasional aches.

At the Museum of Modern Art, visiting a retrospective of paintings by Willem de Kooning, I was amused—slightly disturbed, too—by the sight of a moderately hippie-looking pair inspecting what by now was rather old-hat art. This was the de Kooning who, together with Jackson Pollock and Franz Kline, had been called to mind by a window-X'ing painter on a building about to be demolished (see pages 78 and 79), when Abstract Expressionism still retained its shattering freshness. Who were these people looking at the paintings? Were they of the present moment, or were they throwbacks to an earlier Beat generation? What did they see in de Kooning—excitement, or a style that was passé? Were they artists, serious art lovers, or just poseurs? What was the woman carrying in what looked like an airline flight bag? Then again, how was de Kooning standing up? A hundred years hence would he still be regarded as an artist whose work commanded continuing respect and admiration, rather than simply representing an anomalous development in the history of art?

We were living through a period obsessed with the perpetually new. I was growing older—I wasn't new—and I wasn't at all sure that any works of my time period, beyond its undoubted technological advances, would be remembered with the continuing awe and affection we accorded to the old masters or to Shakespeare.

THE MUSEUM OF MODERN ART, MARCH 1969.

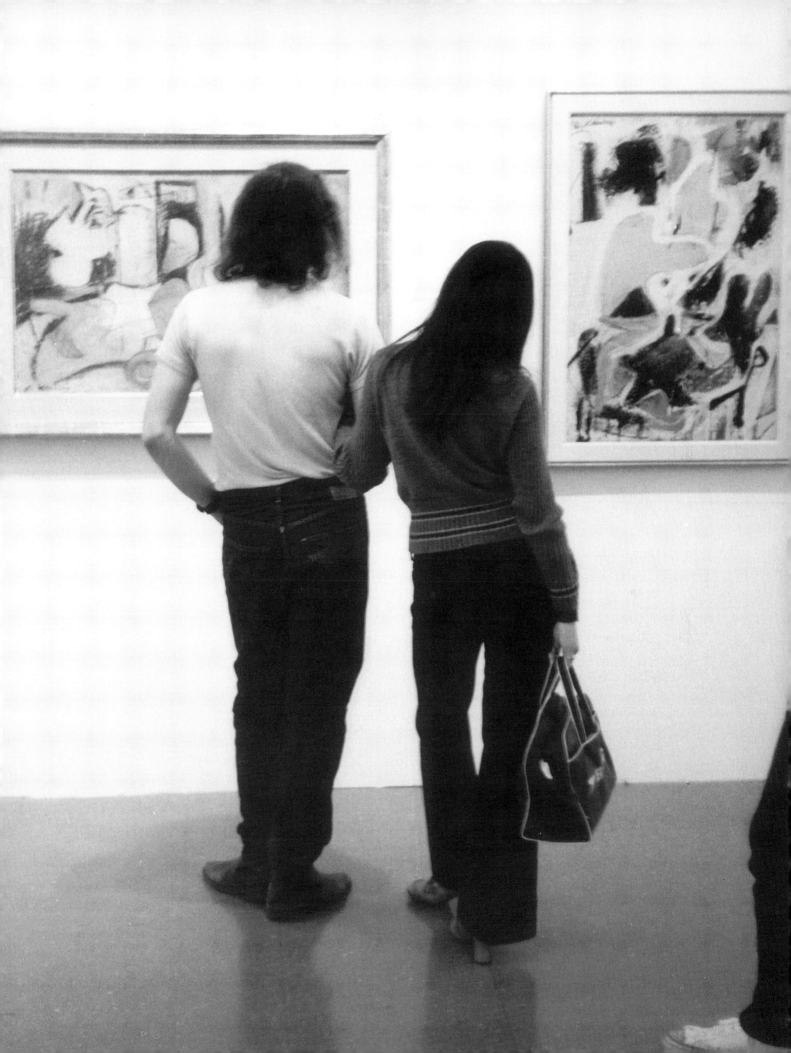

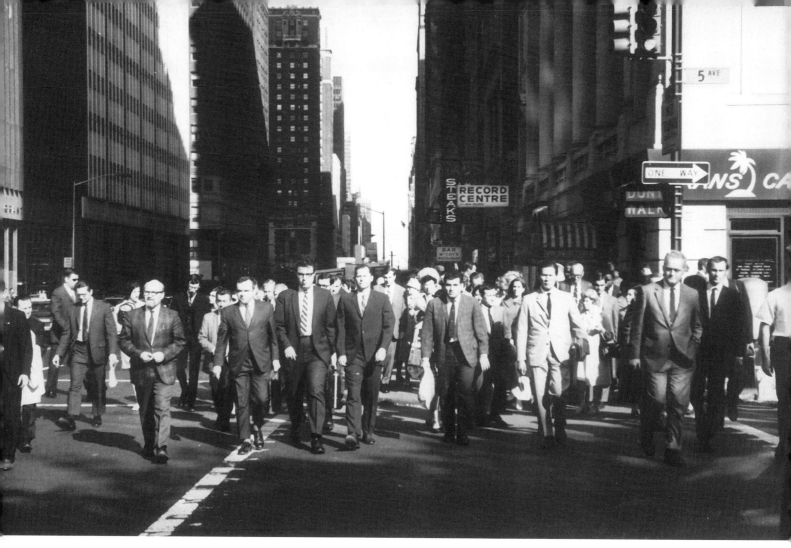

AT FIFTH AVENUE AND 42ND STREET, MAY 1969.

New York is waves, has long been waves. In his 1856 "Crossing Brooklyn Ferry," Walt Whitman wrote:

> Flow on river! flow with the flood-tide, and ebb
> with the ebb-tide!
> Frolic on, crested and scallop-edg'd waves!
> Gorgeous clouds of the sunset! drench with your
> splendor me, or the men
> and women generations after me!
> Cross from shore to shore, countless crowds of
> passengers!

Whitman was overly optimistic that "A hundred years hence, or ever so many hundred years hence" travelers on the ferry would see the shipping of

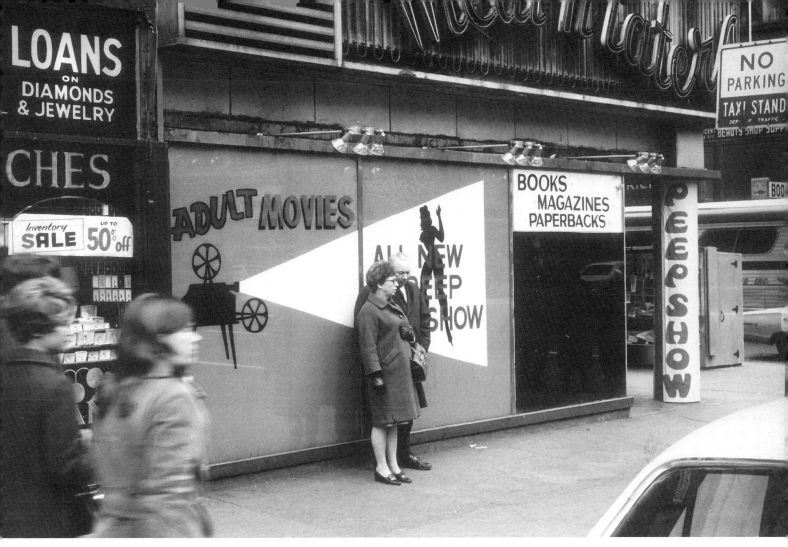

AT SIXTH AVENUE AND 42ND STREET, MARCH 1969.

Manhattan and the heights of Brooklyn—or was he? Not too long after the opening of the Brooklyn Bridge in 1883, the ferry from Fulton Landing in Brooklyn to Lower Manhattan stopped running, and in a little over two decades after the opening commuters would begin tunneling by subway. However, some things come back. Today, in the first years of the new millennium, I see clusters of small, fast ferries and water taxis converging on Wall Street weekday mornings and fanning out to Brooklyn and New Jersey in late afternoon and evening. But it isn't just the literal waves of commuters across the water that I had been thinking about. Rather, it's the everyday waves of people walking to and from work and traveling by whatever other means of transportation. The nonthreatening army advancing toward me across Fifth Avenue

at 42nd Street, as the May evening sun caught their faces, provided a striking example of a wave.

The waves are not slow. They can unnerve the out-of-town visitor as they sweep by. The bewildered visitor often doesn't know which way to turn and may be too intimidated by the impatiently rushing hordes to ask directions. It's in this respect that New York never seems to change. There's much more to confuse and disturb the visitor. I was struck one day by the sight of a not-young couple, obviously not New Yorkers, standing uncertainly on Sixth Avenue at 42nd Street, their backs (intentionally perhaps) to a seedy pornography emporium as they seemed to ponder where to venture next—or should they just flee this inhospitable place?

Inhospitable? As a fond New Yorker it grieves me to think that some might find this city as such. The same people also find Paris inhospitable. Even with limited French I've never found Paris unfriendly. This may have to do with having learned to sense the rhythms and preoccupations of big city inhabitants. People in Paris, like those in New York, may not be eager to take you in or devote much time to you if you are one of the too many strangers landing at their door, but in both places I've found the locals helpful and kind when there was a problem to be solved.

New York's weather can certainly at times be inhospitable, sometimes freezing and windy in winter, stifling in summer, and always subject to some form of precipitation. (My younger brother and his large family were happy to have ensconced themselves in southern California years ago.) But there are many more delightful, temperate, mild, glorious days in a year in New York than there are uncomfortable ones. A decidedly wet but ameliorating July rain like the one through which I caught a woman scurrying in Greenwich Village can also be some people's idea of a great day. While the scene may have been set in a film studio, with a manufactured downpour, Gene Kelly's singing and dancing in the rain could have been imagined on a Village street.

The wetness of the street, though it would soon be dry again, stays fixed in my photograph. Susan Sontag once wrote, if I remember correctly, that photography is a form of murder. That struck me as extreme. Theft, perhaps. When photography is not a gift, as it can be, it is a form of appropriation. A photograph can "steal" a person's image, can steal someone's privacy, but more profoundly it steals from Time. That which Time would wash away—as Time washes everything away—the photograph, by preserving it for at least a while, steals it back from Time. While I wouldn't quite equate this with Robin Hood stealing from the rich to give to the poor, still, to the extent that photography foils Time even a little, it has its special virtue.

GREENWICH AVENUE AT BANK STREET, JULY 1969.

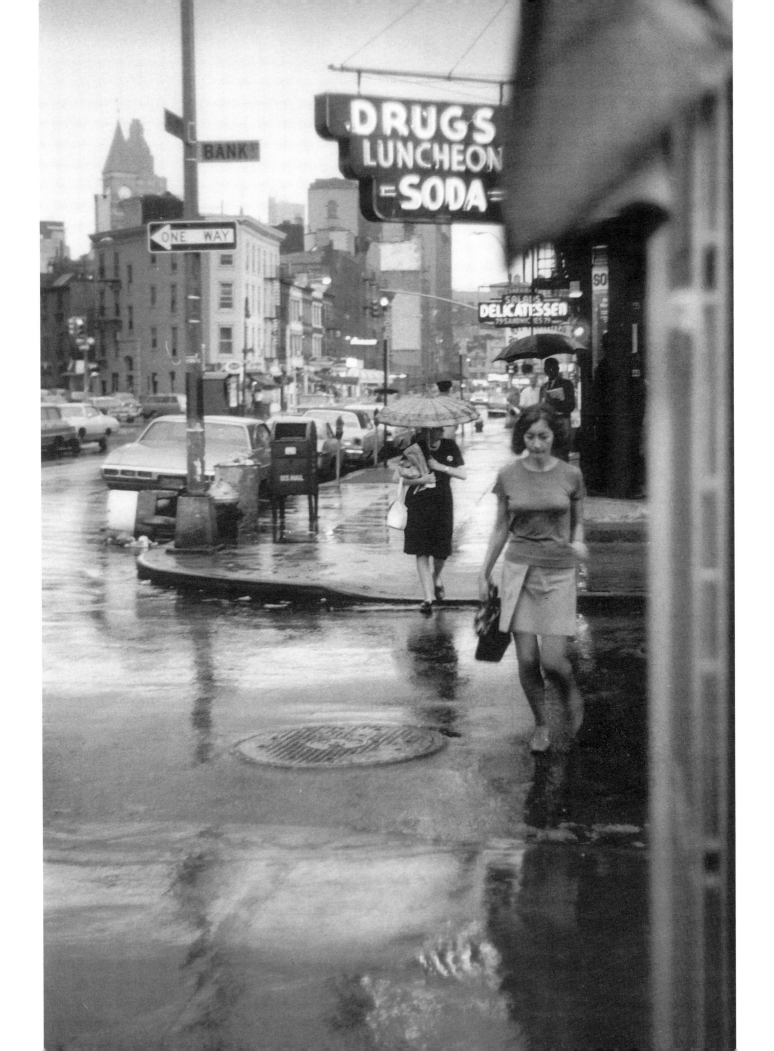

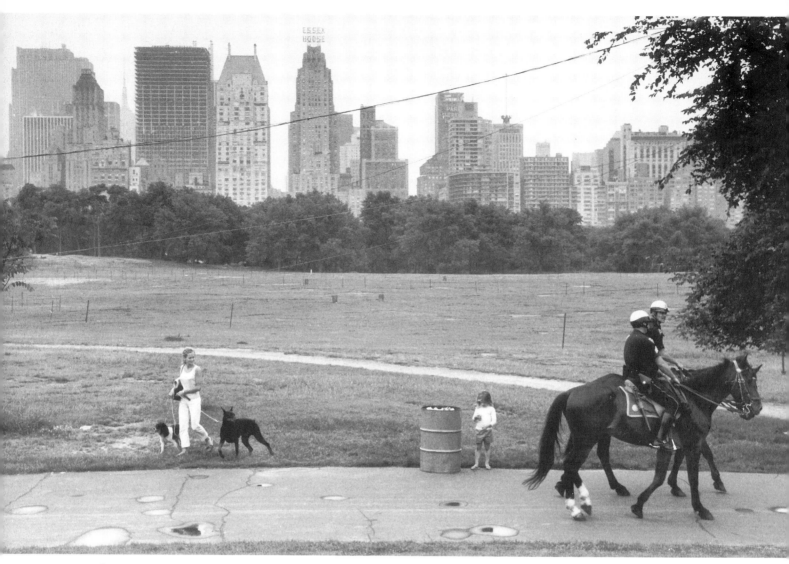

CENTRAL PARK, JULY 1968.

It's hard to believe these were such times of tension when I look back at my Time-defying frozen frames of the period. A young mother strolling with a pair of dogs and her little girl in Central Park no doubt felt more secure for seeing a pair of mounted police riding by, but she couldn't have counted on encountering them, so she must have felt it was safe enough to stroll there. The lovers, apparently Hispanic, who waited in a drizzle to cross Fifth Avenue at the park's 72nd Street traffic entrance as I drove past, might have been imagined as figures from *West Side Story*—except that there was nothing necessarily tragic in their touching attitude.

FIFTH AVENUE AT 72ND STREET, JUNE 1970.

Through all the preceding years (including the McCarthyite witch hunt of the late '40s and early '50s) a generally liberal trend had been in ascendance. Even the Catholic Church under Pope John XXIII had become so liberal and reasonable that I could almost have considered belonging to it. Now, there was a shifting away from liberalism. I do believe that human social development goes through many lesser and greater pendulum swings (some can take centuries), and I've generally been optimistic enough to believe that in the long run the trend is toward greater freedom and equality and less oppression by dogma. But I also believe that all good movements, like bad ones, develop their own excesses that inevitably provoke reaction. The movements for civil rights, feminism, recognition of gays, and against consumerism, environmental degradation, and corporatism that were still strong—and in some respects are still gaining strength today—were also developing, or had already developed, extreme factions that hampered their cohesiveness and even turned off some of their sympathizers. Conservatism was becoming more confident of itself, while most people seemed just happy to be able to turn away from the unsettling emphasis on social change that had been so dominant in the news for so long.

Not that all of the news was worrisome or depressing. We had gone to the moon. To the moon! After having suffered blows to America's sense of superiority from the Soviet Sputnik satellite in 1957 and Yuri Gagarin's first earth orbit in 1961, the race to catch up had progressed amazingly. We hadn't yet matched the Soviets in the size of the payloads we sent into space, but we outdid them in other ways. In August of 1969 New York celebrated the first human landing on the moon with a ticker tape parade for Apollo 11 astronauts Neil Armstrong, Edwin "Buzz" Aldrin, and Michael Collins. Broadway was littered with paper after the parade, and some of the spectators continued to seem euphoric well after it had passed by.

A downside to this remarkable achievement was that for some years thereafter—and perhaps nowhere more so than in New York—any kind of failure of government or technological systems was met with the complaint: "How come they can put men on the moon, but they can't . . ." Astounding as it was, the moon landing was in years to come relegated to the status of an experiment not worth repeating or following up. We would seem to lose interest in the moon from a scientific or technologically exploitative point of view, which was all right with those who felt we had somehow violated the moon by diminishing its mystery, erasing its romance.

BROADWAY NEAR PINE STREET, AUGUST 1969.

Another glorious moment came the following year, on April 22, 1970—the first Earth Day! It was an occasion of joyous celebration for thousands of New Yorkers. Lindsay had both Fifth Avenue and 14th Street, a major crosstown artery, closed to vehicular traffic for the day. People happily crowded these thoroughfares on foot, on roller skates, and on bicycles. There was an exhilarating sense of what a car-free and pollution-free New York might be like.

Unfortunately, unlike the thrush of Robert Browning's poem, the city (and the nation) would never recapture the "first fine careless rapture" of that moment, and succeeding Earth Days would fall into ever darkening obscurity. In so many ways Lindsay pointed to what the city could be like; he deserves to be remembered for that, even if in the end he could deliver on so little of the promise. If we are ever to progress, we need to be reminded that things don't have to be quite the way they are.

On West 14th Street near Sixth Avenue, April 1970.

New York was by no means uniformly liberal, nor has it ever been. If one segment of the city turned out en masse for Earth Day, it was undoubtedly a predominantly different segment that paraded down Broadway the following month in support of America's continuing involvement in the Vietnam War. To this crowd it was above all important to show solidarity with American troops wherever and for whatever reason they were fighting. About one hundred thousand construction workers and office workers marched past City Hall to express backing for Nixon's war policy. They called Lindsay "the Red mayor" for his opposition to it.

What a curious mix of things going on! Some of the ferment of the time, events we associate with "the Sixties"—the affirmations, the celebrations, the protests, the violence—first occurred in the years 1969–70: Woodstock; the gay revolt against a police raid on the Stonewall Inn in Greenwich Village; the march on the Pentagon; and the fatal shooting of four war protesters at Kent State University by Ohio National Guardsmen.

BROADWAY NEAR CITY HALL, MAY 1970.

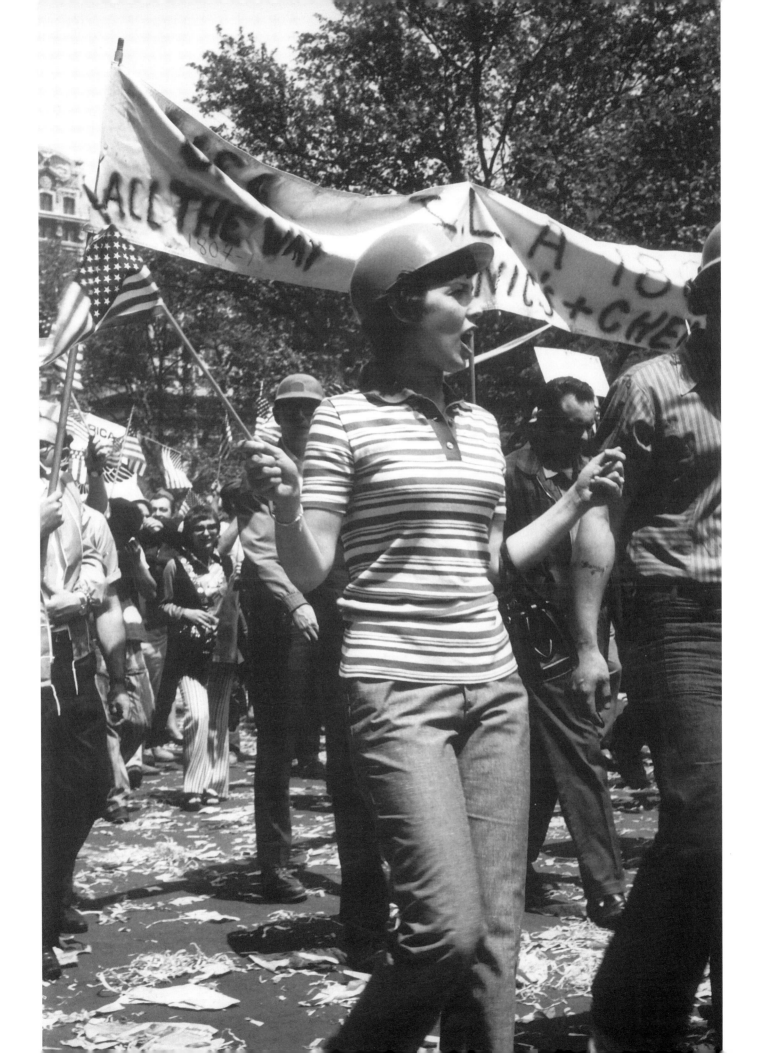

On an unusually mild day, March 6, 1970, Elaine had just picked Sven up from nursery school, and as they were starting for our Eighth Avenue home a thundering blast shook the neighborhood. They were on West 12th Street just west of Fifth Avenue. A block away the house at 18 West 11th Street had just blown up. The explosion killed three young Weathermen who had evidently been making bombs in the basement. That was the same building whose yard was being cleared of snow by Mr. Merkel and his son when I photographed them ten years earlier. (See page 51.)

Passing by there two months after the blast, I photographed a built-in bookcase still adhering to the wall of the adjacent building at 20 West 11th Street.

On May 7, three days after the Kent State shootings (Nixon had just promised eight university presidents he would tone down his anti-youth remarks), I was driving a visitor from a troubled foreign country through the streets of Manhattan, on a beautiful evening when all that was evident to the senses was the scented sweetness of spring, and New Yorkers were calmly going about business as usual. I remarked that the country seemed on the verge of revolution. The foreign visitor thought I was crazy.

WALL OF 20 WEST 11TH STREET, MAY 1970.

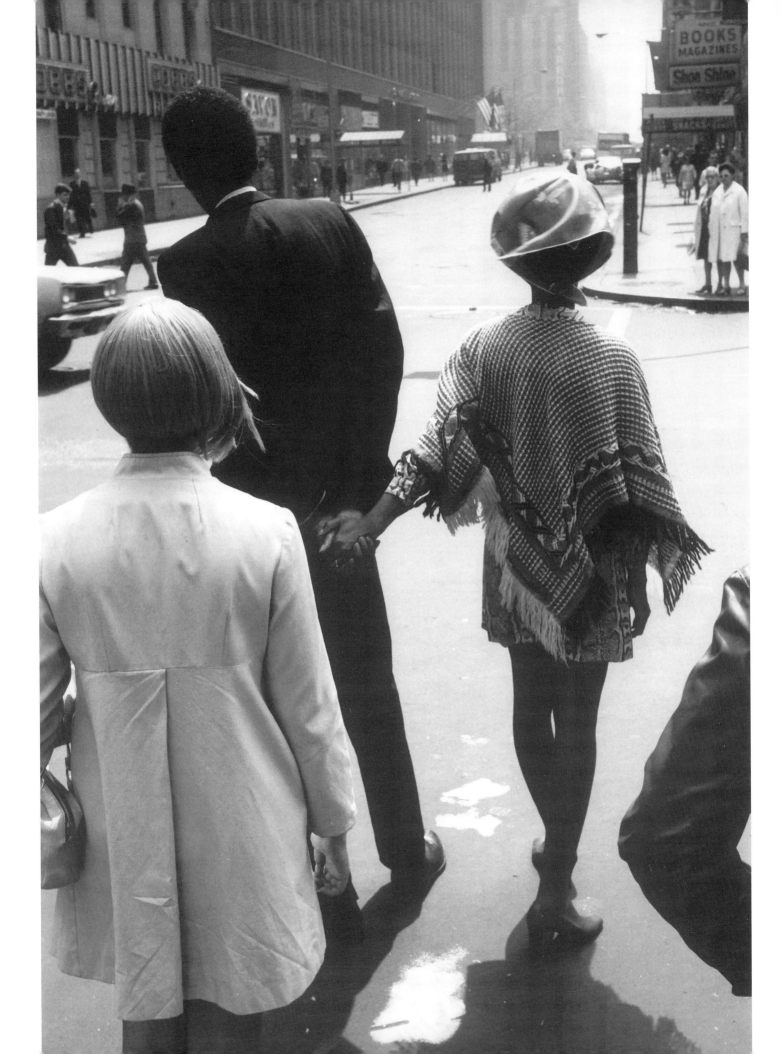

Although an economic recession was coming on, you couldn't tell it from the look of the city. Some corporate headquarters were moving to the suburbs or out of state, but skyscrapers seemed to be going up faster than ever. In 1970 Manhattan was to see sixteen office buildings completed for a total of 8,659,000 square feet, with twenty-one more scheduled for completion in the following years, for a further total of 20,755,500 square feet. The biggest previous postwar year—1959—had seen twenty-one office buildings completed for 6,874,000 square feet. New York was building the equivalent of entire cities yearly, even as its residential population was diminishing.

Worries about the effect of corporate power were not new. Sloan Wilson's *The Man in the Gray Flannel Suit* and William H. Whyte's *The Organization Man* had warned about it years earlier, but in his 1970 book, *The Greening of America,* Yale law professor Charles A. Reich celebrated the counterculture as an answer to it. Like any ambitious social theorist, he established his own categories, dividing Americans into Consciousness I, II, and III. He said that Consciousness I (the unsophisticated, self-interested, "rugged individualist" outlook) "could not grasp, or could not accept, the reality that the individual was no longer competing against the success of other individuals, but against a system."

Reich saw Consciousness II as the individual who favored reforms as long as they did not require him to go against his organization or society, and who was therefore "schizophrenic." Consciousness III was the liberated and spontaneous person who placed his or her own needs for personal integrity, love, and fellowship above organizational loyalty or dehumanizing notions, such as grading people by standards of merit or achievement. "No one judges anyone else" was a commandment—like all commandments, unfortunately observed largely in the breach. He was criticized from both right and left for a too easy optimism. Critics said he made older teenagers' rebelliousness seem unrealistically tame in order to reassure conventional middle-class parents. Nevertheless, a couple of his points still resonate.

Reich's was, to be sure, a white person's book that tried to provide a happy solution to dissatisfactions felt by a large white population that had grown increasingly comfortable economically but was troubled by the superficiality and inequities of the general culture. Aspiring blacks, Hispanics, and other minority group members, who were encountering somewhat growing opportunities, would have felt less concern about disparity between organizational demands and personal integrity. For those who rose to it, their challenge was first of all to make it; to get the money.

SEVENTH AVENUE AND 50TH STREET, MAY 1970.

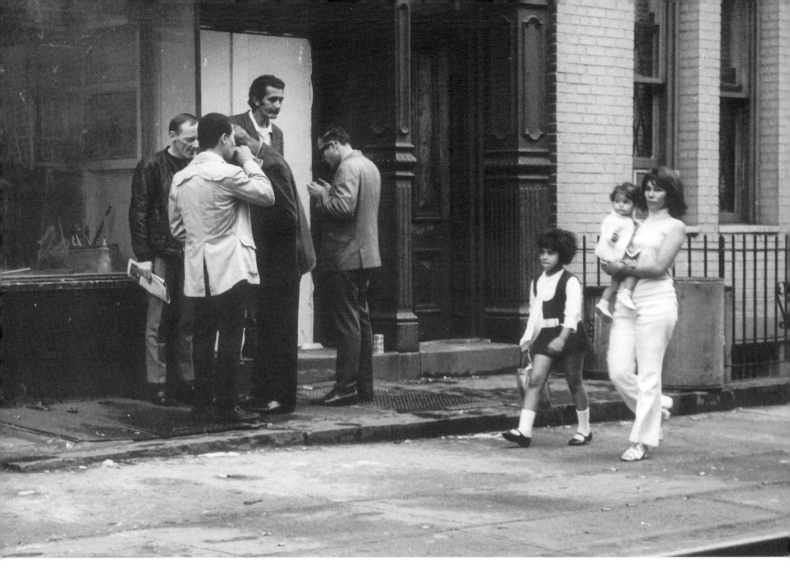

Chelsea area, June 1970.

"It's easy to see why kids are laying *Greening* on their parents: Reich can explain, as they never could, that dope, sex and goofing off are attributes of a revolutionary culture that is beautiful, valuable and inevitable— and does not entail any messy business about Angela Davis, the Vietnamese, the Hell's Angels or Fidel Castro," the journalist Andrew Kopkind wrote in the March 1971 issue of *Ramparts* magazine. With his ironic tone Kopkind was reminding readers that radicals and groups associated with them were not necessarily nice people easily welcomed into white middle-class living rooms, and that a hedonistic drug culture might not be a universal joy.

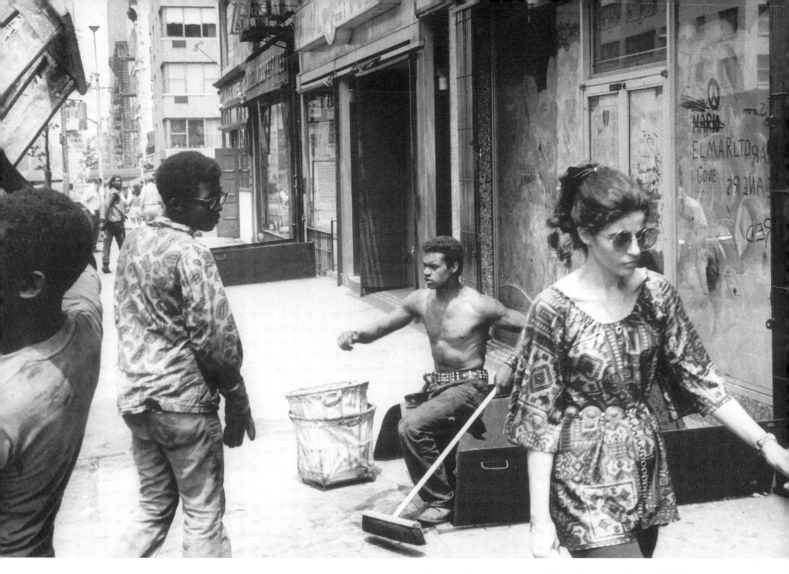

FIRST AVENUE NEAR 71ST STREET, JUNE 1970.

One day, presumably after parking the car (the two preceding exposures on the film are from the car; the next shot is of our baby son falling asleep on a couch), I passed a dissolute scene on what was probably a street in the West 20s. This is one of the very rare instances in which I failed to note down something I had photographed. The men may have just been drinking wine, though it looks as if the man to the right may have been preparing to ingest something else. The woman passing by, as well as her older daughter, appeared to be deliberately avoiding looking at the scene, anxious to get beyond it. I did note down the location of another scene from that same month—a white woman passing a group of black workers, one of whom is casting a glance after her—on First Avenue near 71st Street. In neither case was there any imminent or even likely physical threat to the woman in the picture, but in each instance a sense of discomfort could be felt. For that matter, the woman on First Avenue might have felt even more uncomfortable passing a group of white male workers, who would likely feel less inhibition about expressing some kind of sentiment to her. We were still a considerable ways away from having reached a revolutionary and beautiful world.

As a person past forty, I felt that the world I had known was under siege, that I wasn't part of the future. At the same time the old, familiar world was still hanging on, as if oblivious to the winds that were blowing. What was real? Was the counterculture really going to change our lives, or was the counterculture just a dream, a phantom?

On a warm December day in 1970 I passed a group of what I presumed were midlevel managers taking in a bit of sun on East 23rd Street outside Metropolitan Life. They looked like escapees from a pre-1960s time, or like characters from a Rod Serling *Twilight Zone* episode who had been transported into the present. They looked so anachronistic in their business suits and with their carefully trimmed hair. Curiously their like would survive after the hippies were little more than a memory.

Curious also is the fact that this seems to have been one of the very few pictures I've taken on 23rd Street, even though I paid special homage to that important crosstown street in my jottings of 1971:

I must say I'm with Jane Jacobs when it comes to the beauty and variety of uses, of living quarters, shops, light manufacturing, restaurants, movies, etc. all mixed together. She may almost be said to have discovered the esthetics of rampant but small-scale commercialism. By these lights the area of Lexington and Third Avenue from 23rd to 34th Streets may well be the greatest place to live in all of New York. Come to think of it, 23rd Street has a lot to say for itself as the greatest single street in New York. It has apartment buildings of all ages, brownstones, hotels, office supply and stationery shops, piano stores, undertakers, florists, liquor stores—in short, it has nearly every kind of place of every age that makes the city worthwhile. Why it even has Madison Square Park and, diagonally across from it, the Flatiron Building—New York's greatest early skyscraper landmark! It also has some drab stretches between Eighth and Tenth Avenues to keep one reminded of urban decay. Yes, for the city lover it's 23rd Street from river to river—a street whose beauty only a city lover can fully appreciate.

And yet I never tried to get a good shot of the association-rich Chelsea Hotel on West 23rd Street. As for the Flatiron Building, although I've photographed it a few times, I leave it to remain celebrated by Edward Steichen's iconic 1906 photograph, *The Flatiron—Evening*.

On 23rd Street east of Madison Avenue, December 1970.

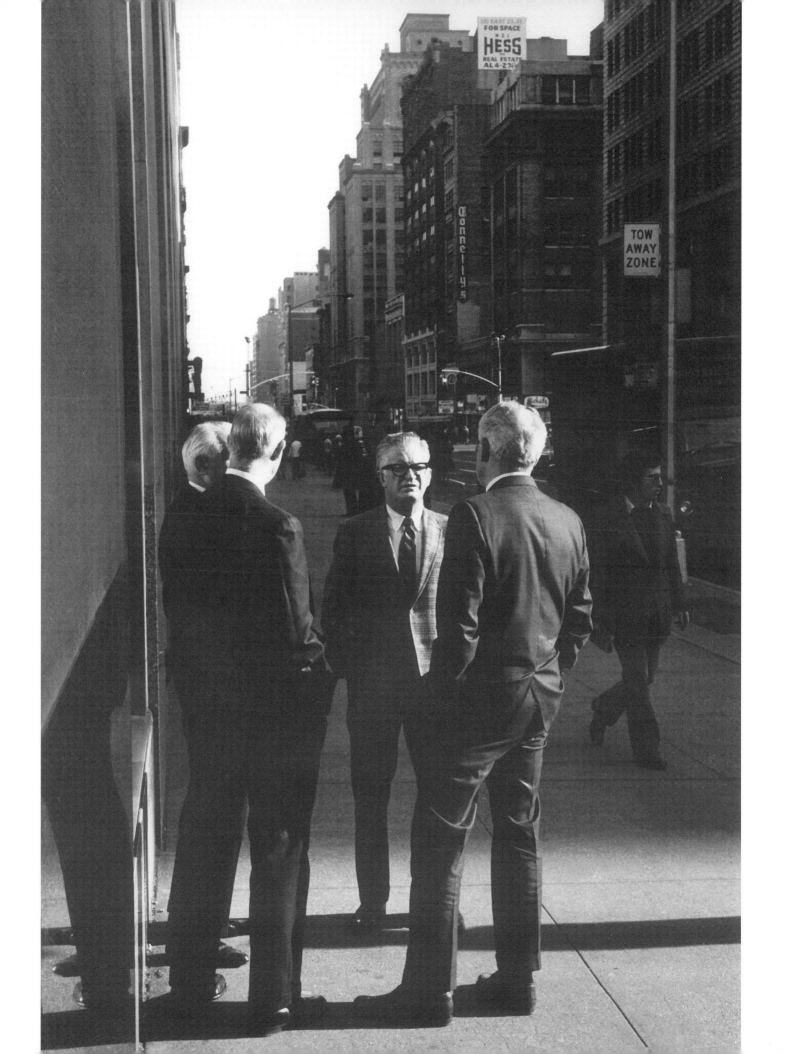

Ah, but what a time it was! Miniskirts rising to new heights, microskirts, hot pants—legs revealed in their variety and glory.

Who could really worry about politics and the dire potentialities of revolution when there was this lovely revolution? Short hair, long hair, petite, tall, skinny, buxom—pulchritude in all shapes and sizes.
What's a city for!

ON 51ST STREET EAST OF FIFTH AVENUE, JUNE 1971.

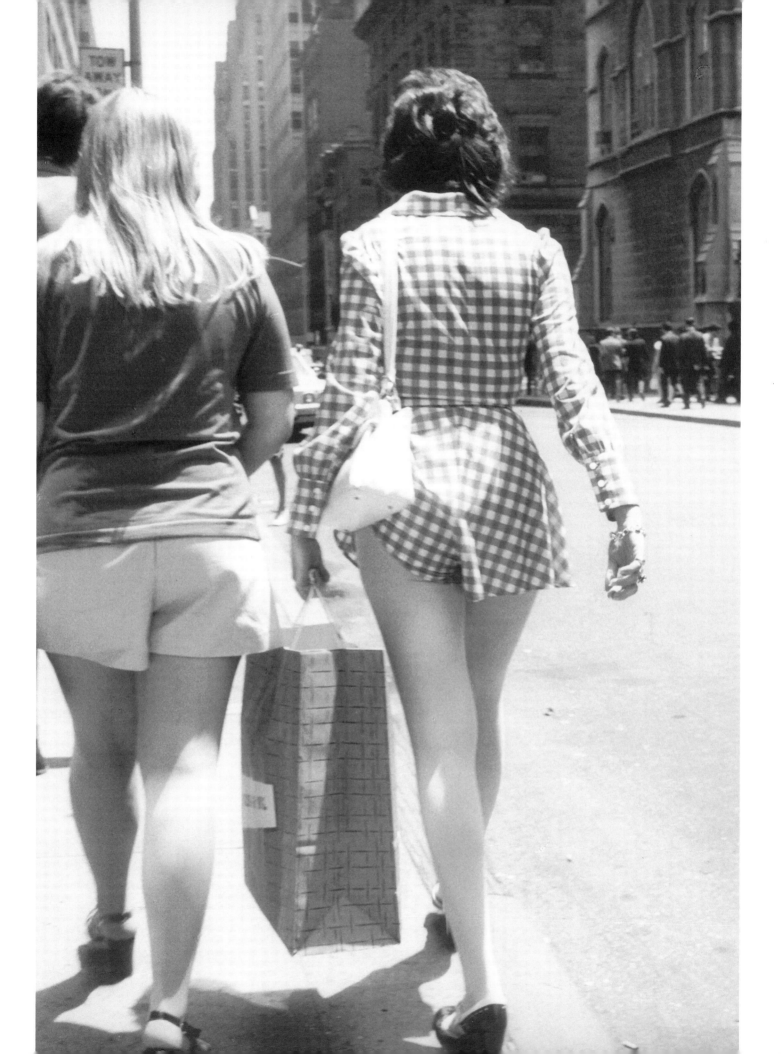

Tennis in Central Park continued to be an inexpensive way to enjoy the game. Also to enjoy an idyllic setting; courts set among trees, with an imposing cityscape looming beyond. If you got there at the right morning time you might get on a court with hardly any wait.

During one period, while I was producing the 11 P.M. news show on WNBC, I played regularly with an old colleague from my Telenews days, Ozzie Segerberg, who was my counterpart, producing the 11 P.M. news for WCBS. At the time, our ratings were much better than theirs, and he felt a pressure from management that I rarely felt. (The difference in ratings had much less to do with how good a job either of us did than with the overall performance and popularity just then of the two networks and the relative popularity of the news anchors. For one thing, we had stronger "lead-ins"—i.e., shows with better ratings immediately preceding our broadcasts.) As we met one morning, Ozzie's first words were: "When did you get the first word of last night's fire?" A bad fire at Union Square had cost a pair of firemen their lives. "I saw the first bulletin when I came down after the show," I said. "Oh, thank god!" Ozzie exhaled. He had worried all night that we had gotten the story on our air, and he would have to explain why he hadn't gotten it on. My recollection is that he was too exhausted to play very well that day.

CENTRAL PARK, OCTOBER 1971.

138

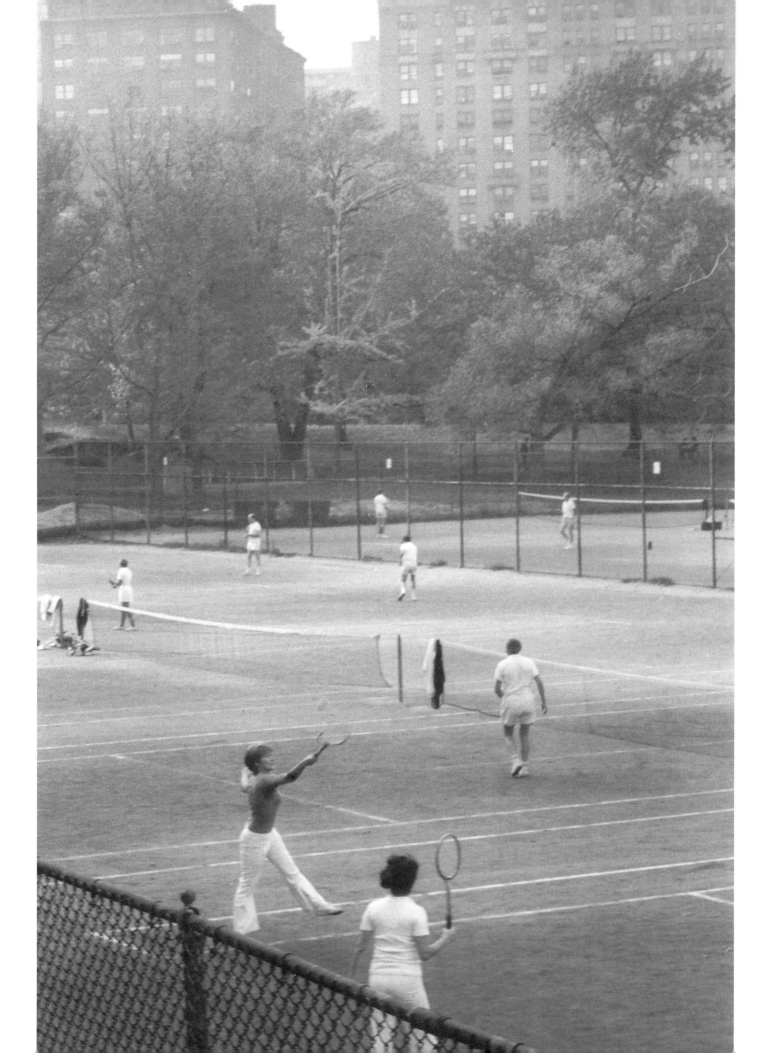

TEENAGE FOOTBALL GAME, BAY RIDGE, BROOKLYN, VERRAZANO BRIDGE IN BACKGROUND, NOVEMBER 1972.

My father died in October 1969. He had joined us in Brooklyn Heights in 1946 after living through the wartime period in Finland. It couldn't have been an easy choice for him: to leave a place where he was at home and established and to start over in middle age in a country whose language he did not speak well, where his professional specialty, as a chemical engineer, was not in demand, and where he had to accept a secondary place in a household containing two financially quite successful bachelor brothers-in-law. He made the best of the situation, familiarizing himself with paint chemistry and working, first for a small paint company on Staten Island, then for another one in Long Island City, Queens, on improving the quality of latex paints, which were gaining favor for use on interior walls. He also found an outlet for his long-held journalistic ambition by writing weekly dispatches to two papers in Finland about life in America—extolling, among other things, martinis and ice water.

My mother was running the household, in the apartment I had known in my late teens, for the two brothers and a maiden sister (who at sixty-five would break away and marry). In 1971, when the new landlord in Chelsea, eager to reclaim our space, was giving Elaine and me a hard time, my mother learned of a rent-controlled apartment we could get near her in Brooklyn Heights. I can't say Elaine was ever delighted by the move or by the apartment we obtained, but move we did, barely ahead of the enactment of vacancy decontrol.

In Manhattan, no neighborhood, however special its quality, feels isolated from the surrounding

MONTAGUE STREET, BROOKLYN HEIGHTS, JUNE 1973.

city. But Brooklyn Heights was, and still is, something of a separate small town. Across a wide band of water (called a river though in reality it is a strait connecting Long Island Sound with New York Harbor), the Heights looks upon a great city but does not seem quite part of it. At its back, the Heights is separated by a slightly dreary civic center park and straggly downtown fringe (today in the process of change) from a low-lying expanse of the borough to the east and south. To be a Brooklyn Heights resident, as I knew from the past, was to be neither quite a Brooklynite nor precisely a New Yorker (i.e., Manhattanite). Many Heights residents self-consciously gave their address as "Brooklyn Heights, NY" rather than "Brooklyn, NY," as if "Heights" could erase a felt cultural stigma. If Manhattanites rarely ventured as far as Brooklyn

Heights, many Heights residents seldom ventured into the borough's hinterland.

We didn't become total Brooklynites all at once, but we enrolled Sven in the local public school, PS 8—as well as Tor when he became old enough—and we took part in some excursions farther into the borough. We took Sven down to Bay Ridge to see if he would like to play little boys' football in what was called the Knute Rockne League. He showed he could run very fast out of bounds to avoid being tackled. (Later he would become adept at squash and tennis and develop enthusiasm for basketball.) Football may not have been Sven's cup of tea, but Elaine and I enjoyed the almost rural aspect of those playing fields by the Narrows, with the great span of the Verrazano Bridge in the background.

AT THE CHAMBERS STREET STATION, JANUARY 1973.

I generally traveled into Manhattan, to work, on a subway commute that added ten or fifteen minutes to the time it had taken me from Chelsea. This was not a good period in New York's subway history. The trains still got you to where you were going on the whole dependably, but the cars and the stations were filling up with graffiti, doors went out of order, as did lights, and if you noticed a car with many empty seats available, it was usually because a "stinker" was occupying one or more seats. The subway had become a refuge for many an unwashed homeless person riding trains all day and night. Fear of crime was also high. Still, relatively speaking, the subway remained a safe and efficient way to get about town. As the scale of the graffiti got bigger, "grand graffiti" entirely covering some cars inside and out, it was even celebrated by the art world—though not by much of the riding public—

and found its way into the design of some department store window displays, among other places.

I admit to a fondness for some of the graffiti I saw. Trains and so many stations were otherwise drab. From my point of view as observer and photographer, this was in fact a most interesting time to travel the subways. At the Chambers Street station of the Seventh Avenue line one day, I was amused by the sight of two women wearing similar knitted hats, very likely twins, engaged in a tête-à-tête behind the window of a car whose outside was adorned with large, carefully outlined initials and a numeral. While some of the graffiti one saw had a calligraphic elegance, much of it was nevertheless crudely scribbled and—may one say it?—devoid of aesthetic value. Later the city and the subway authorities would crack down on graffiti, chase out homeless riders, improve maintenance and securi-

SEVENTH AVENUE SUBWAY, MAY 1973.

ty, and embark on a program of making stations more attractive.

Taking pictures in the subway was something I had done from time to time, and in this period I took more of them. In earlier years Walker Evans, whose documentation of America had established a standard for so-called straight photography, had recorded people on the subway by not shooting directly at them but by using a sideways-pointing camera that allowed him to seem to be looking the other way. I shot directly, but very quickly, often pointing the camera without any careful framing of the image and counting on a faster lens and faster film than Evans had had at his disposal. The results were hit or miss, but I got some decent images.

Subway photography is a particularly intrusive practice, though, and I've never felt entirely comfortable doing it. "Candid" pictures and the use of them can trouble even practitioners. When I read that a very great photographer, of all people, had protested the theft of his image by another prominent photographer, I wasn't sure how to react. The notoriously camera-shy Henri Cartier-Bresson (I feel diffident about even mentioning his name in a book of my own photographs) had tried unsuccessfully to stop David Douglas Duncan from publishing *Faceless,* a collection of snapshots of Cartier-Bresson he had taken while the two photographers had a friendly snack together. Although Cartier-Bresson, then ninety-two, had stopped photographing professionally in favor of making drawings, he had always guarded the anonymity of his appearance to help him catch his subjects at instants of private absorption and unselfconsciousness. He didn't want, even so late in life, his face to become recognized.

143

Duncan, known as much for his enterprise as for his photography, defended the charge of thievery by throwing it back at Cartier-Bresson. "How can he object when he has made his fame and fortune out of taking photographs of people without their permission?" Duncan was quoted as complaining in the *New York Times* of February 8, 2001.

Would we rather do without Cartier-Bresson's memorable pictures? Would we rather do without Duncan's snapshots of Cartier-Bresson, unexceptional as they might be? On the scale of ethical justice, how do we weigh the art of Cartier-Bresson? Is such a scale even applicable? How do we value having a record of what this artist himself looked like?

Often I've had the feeling I was transgressing, and many a time I've refrained from taking a picture that a more aggressive or determined person might have taken, but at other times I've gone ahead, apprehensive though I might have felt. Not long ago, when an old friend and former television news colleague was in town, we had lunch together—and I snapped a quick shot of people at a nearby table. My friend seemed a bit shocked that I didn't ask their permission, which surprised me somewhat, but it did demonstrate that some news types in fact possess finer feelings. (The picture turned out uninteresting.)

On the whole my sympathy was with Cartier-Bresson on both scores: his own photography and his anger at Duncan. I couldn't imagine that many people had been offended by Cartier-Bresson's images of them: his thefts were gifts. His continuing importance to us lies in the pictures *by* him, not *of* him. Duncan knowingly violated a trust to bring us something of secondary importance, pandering to the cult of celebrity.

As one might guess, I owe a great deal to Cartier-Bresson, whom I admire beyond measure, especially his books *The Decisive Moment* and *The Europeans*. I leave it to the reader to say if my efforts add anything of value to the period's pictorial record. There have also been so many good photographers who worked in New York around the mid-twentieth century or after whose work greatly impressed me: Roy DeCarava, Robert Frank, Elliot Erwitt, Bruce Davidson, Louis Faurer, Fred McDarrah, Helen Levitt, Walter Silver, Garry Winogrand—to take them in no particular order, and not exhausting the list. There have also been many outstanding newspaper photographers who haven't gotten their full due. I once stood in line behind Davidson at a camera repair shop, but the only photographers on my list that I met, however briefly, were Silver and Winogrand. Once I watched, unobserved but unfortunately without my own camera at hand, as Winogrand stalked a subject on a Midtown street corner only to give up, visibly frustrated, when she suddenly changed direction and veered off.

Unposed pictures in the city were the main interest of these photographers. Another one I had deep admiration for, though his photographs were mostly of a somewhat different sort, was Ernst Haas—he found extraordinary color patterns in the city.

TIMES SQUARE SUBWAY STATION, SEPTEMBER 1973.

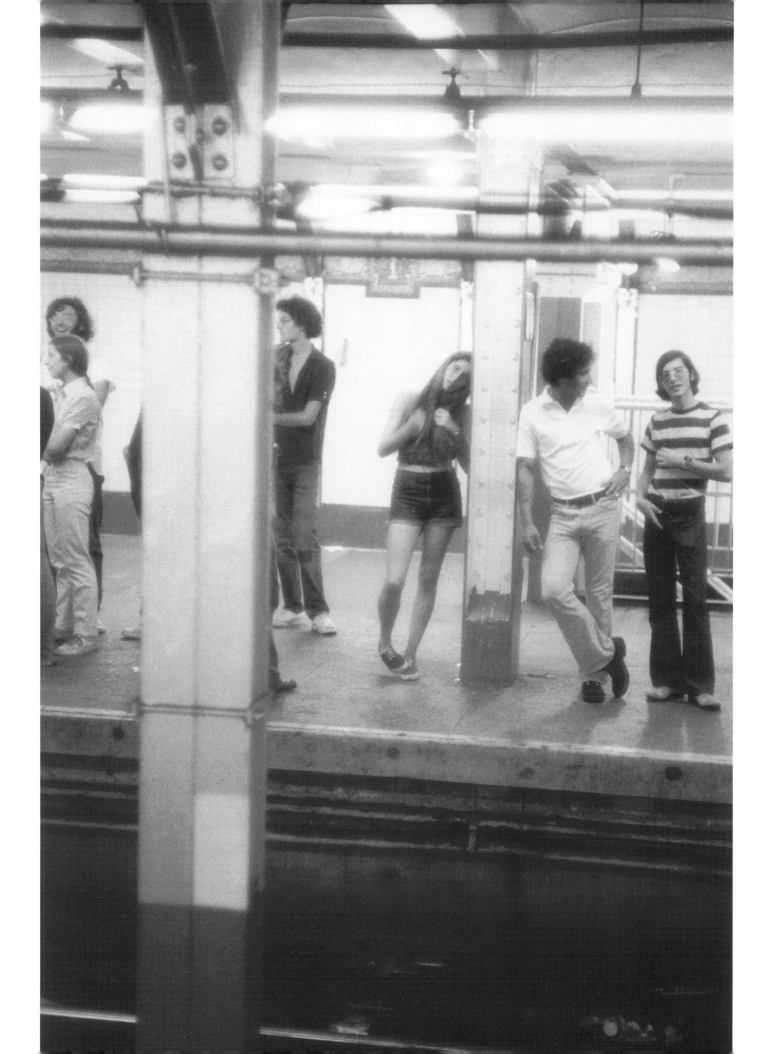

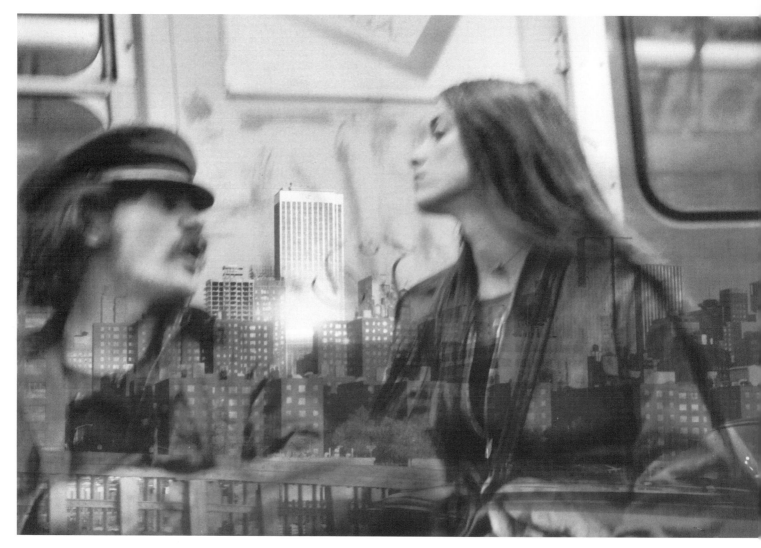

A NEW YORK COMPOSITE, MAY 1973.

Unposed pictures, undoctored, printed from the full negative, were always my main goal. Once in a great while I would be tempted to seek the effect of combining images, or otherwise playing in the darkroom, but this never really fascinated me for very long. One of the very few experiments along those lines that I felt any satisfaction with was combining a picture of a couple on the subway with an image recorded from my passing car of the Gulf+Western building at Columbus Circle, as seen from the old West Side Highway. (The elevated highway has since been torn down and the Gulf+Western transformed into a Trump hotel.)

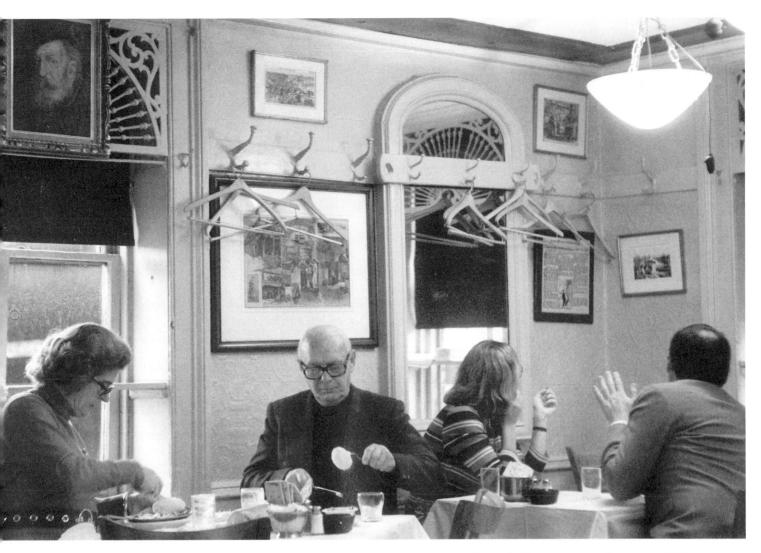

SWEET'S RESTAURANT, OCTOBER 1973.

The combined image in this case seemed to give me something neither of the individual ones did.

There were times I was envious of the big-camera photographers, and for some years I harbored an unspoken desire to own a Linhof Teknika view camera. An earlier photographer who was to me inimitable was Paul Strand, who seemed to capture light emanating from within people or objects rather than light reflected or refracted by them. I was also captivated by Edward Weston's *Daybooks* and *My Camera on Point Lobos*. Other, later photographers, like Diane Arbus, Cindy Sherman, and Chuck Close were doing quite wonderful things

without my wishing to emulate them. Maybe it finally came down to my no longer wanting to handle anything heavier than a 35-millimeter.

And so I continued snapping what was new and what was passing around me. A boiled potato at Sweet's marvelous fish restaurant in Schermerhorn Row down by the Fulton Fish Market was something to capture, along with the man eating it, before that landmark eating place fell victim to the South Street Seaport development's wrong turn toward the ersatz picturesqueness favored by the shopping mall mentality.

147

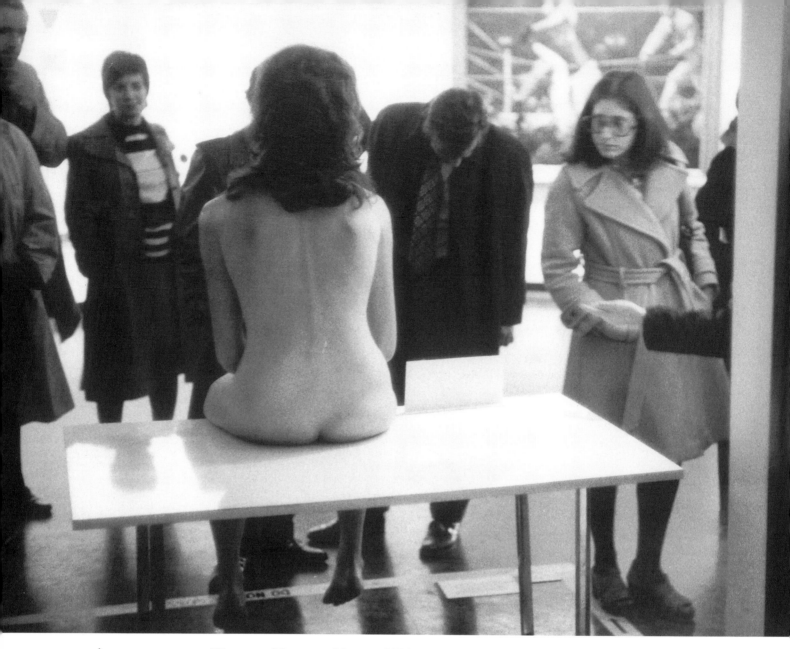

AT THE DOWNTOWN WHITNEY MUSEUM, MARCH 1974.

As for art other than photography, a new extreme realism had followed movements like Abstract Expressionism, Pop Art, Op Art, Color Field, and Minimalism. The new realism in sculpture all but broke down the boundary between the observer and the observed. John De Andrea's polyester and fiberglass *Brunette Woman Sitting on Table,* shown at the branch the Whitney Museum had established downtown, was one of the lifelike nudes that provoked initial gasps of surprise from museum and gallery goers who, on the first sighting, thought they had come upon an actual person. Shock was almost mandatory.

Surprise, not quite at the level of shock but enough to cause a twinge of envy, could be felt on seeing younger men—and not necessarily *only* younger ones—squiring one or more lovelies about. Was that a hairpiece on the man entwined in the arms of two younger women at Seventh Avenue and 44th Street? What was his secret? Extraordinary charm—or a bundle of money?

This was how the '60s were ending—the '60s

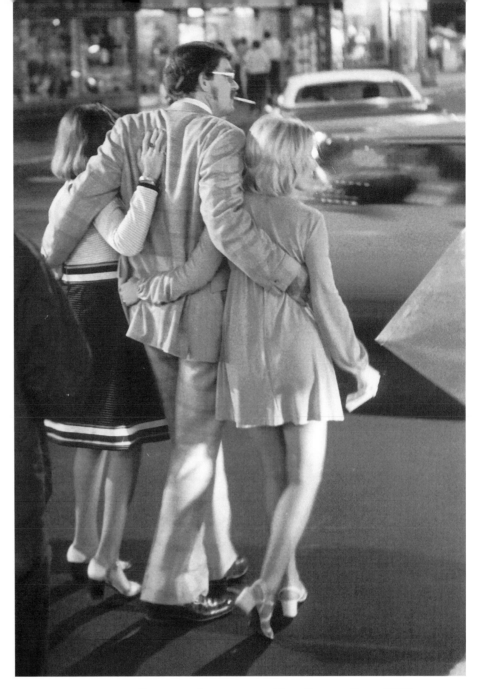

SEVENTH AVENUE AND 44TH STREET, JULY 1974.

I count as running up to the forced resignation of Richard Nixon on August 9, 1974. The Vietnam War was at last approaching its end, and the ferment of the past years had begun to quiet down. The nation had been treated to the inexorable unfolding of the Watergate story, as the administration's "stonewalling" about its involvement in what Nixon's press secretary had called "a third rate burglary" of files from a Democratic party office became impossible to maintain in the face of evidence. But the nation was listening to a story rather than feeling caught up in social and political upheaval.

Truth be told, Nixon's tenure hadn't been all bad. He had shown some concern for the needs of the less privileged and for the environment, and, in opening relations with China, he accomplished what no Democratic president could have done (just as it had taken the rightist Charles de Gaulle to get France out of Algeria).

149

Although a long period of anti-sixties reaction would now set in, some gains were not to be lost. The nation could not return to a blatant pre-'60s racism; the advances made by women and gays could not be pushed all the way back (although the anti-abortion movement would not abate), and considerable tolerance had been established for sexual relationships not formalized by marriage. How women dressed and wore their hair stayed largely a matter of personal preference. Fashion's tyrannical hold remained broken. Clothes could be loose or formfitting, now moving toward the tailored, then again shifting toward the haphazard. Not that fashion died—fashion magazines seemed only to proliferate, and a particular trend like many-layered styles or shoes with excessively thick soles or heels might win favor for a time—but a right to personal choice had been established.

Central Park was still a refuge where you could contemplate "the meaning of these times" amid the relaxing forms of nature. There one could imagine a return to the previous century alongside Simon Morley, the protagonist of Jack Finney's enchanting time-travel novel, *Time and Again,* which had been published not long before. Not that Finney presented a picture of 1882 New York that was uncomplicated. It was certainly crowded enough with people. Finney's description of the congestion of horse-drawn vehicles Simon encounters at the 23rd Street intersection of Broadway and Fifth Avenue suggested that the worst traffic jams a century later were no harder on a pedestrian.

We couldn't quite say good-bye to agitation, however. The city was about to face the threat of bankruptcy.

OFF CENTRAL PARK WEST AT 77TH STREET, NOVEMBER 1974.

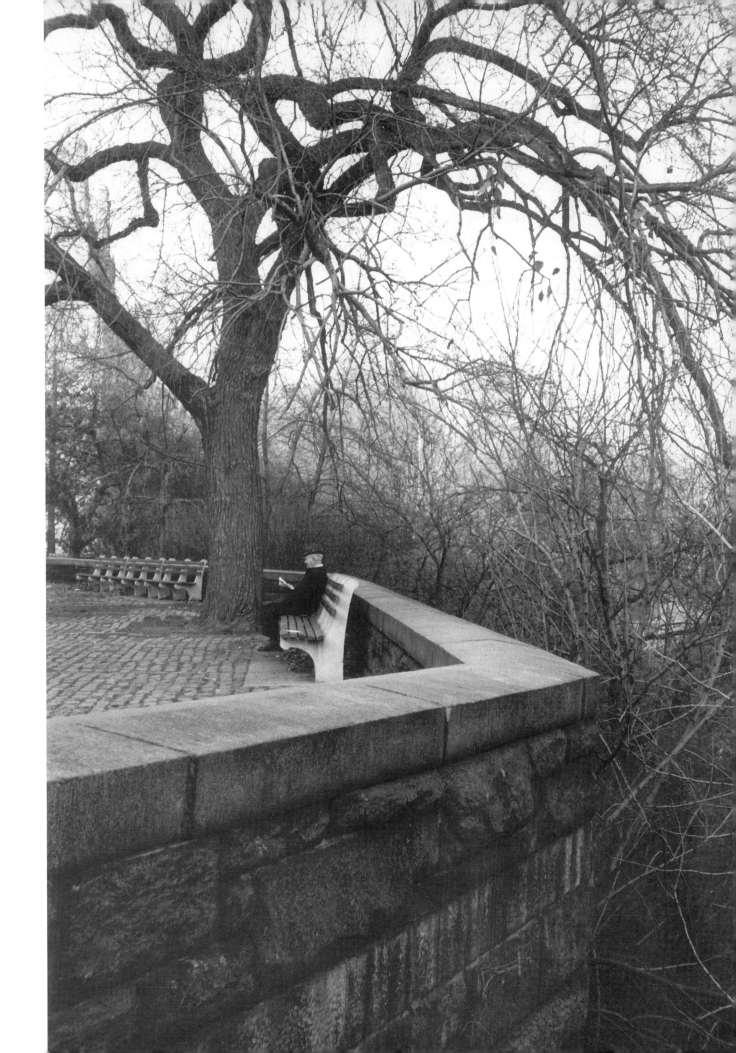

Neither good news nor bad news kept New York from the process of refashioning itself. Tall buildings in Midtown that had largely been confined to the strips between Lexington Avenue and Sixth Avenue were sprouting on either side of those borders, a spillover to Third Avenue having begun already some time earlier.

THE LATER YEARS
1975 and After

As I move now into the final decades of one millennium and the start of another, both the fragility of the city and my own mortality hover in my awareness. Looking back for a moment to a picture taken in 1970, when the World Trade Center was still under construction, I see an omen of the ruin that would stand there briefly after a morning of unimaginable horror. Time and events alter what we see in a picture. There had been a moment during the Cuban missile crisis of 1962 when the possibility of nuclear devastation felt real. Sometimes, as when a subway train was halted in midpassage under the East River, I would imagine the tunnel collapsing and a wall of water cascading in, but soon again I would become confident of the city's durability. Unimaginable? E. B. White, writing a few years after World War II, could imagine cataclysm:

> The city, for the first time in its long history, is destructible. A single flight of planes no bigger than a wedge of geese can quickly end this island fantasy, burn the towers, crumble the bridges, turn the underground passages into lethal chambers, cremate the millions.

Those disquieting words had appeared in his *Here Is New York* of 1949, but, like the dreadful possibility itself, their message was blocked out from my memory and consciousness. But now in that 1970 photograph I see a morbidly premonitory image in the second World Trade Center's incomplete facade ascending to match the misty first tower behind it, with a puff of steam rising behind a rag-dotted wire fence.

The immediate threat New York was facing in 1975 was not, however, that of physical destruction. It was bankruptcy. A loss of too much middle-class population to the suburbs, pushing mayors, governors, and legislatures to juggle books and spend money that wasn't being taken in, had brought the city to the brink of fiscal disaster. As we slipped into the late fall, the *Daily News* ran its famous headline: FORD TO CITY: DROP DEAD. Gerald Ford, the generally amiable congressman who had been elevated to serve out Nixon's unexpired term (Vice President Spiro Agnew having meanwhile been found guilty of tax evasion in connection with a Maryland bribery), never used those actual words, but he made it clear the federal government would not bail out the city. His stance was not unwelcome to a nation whose conservative direction was largely at odds with New York's liberal tradition.

THE WORLD TRADE CENTER UNDER CONSTRUCTION, MAY 1970.

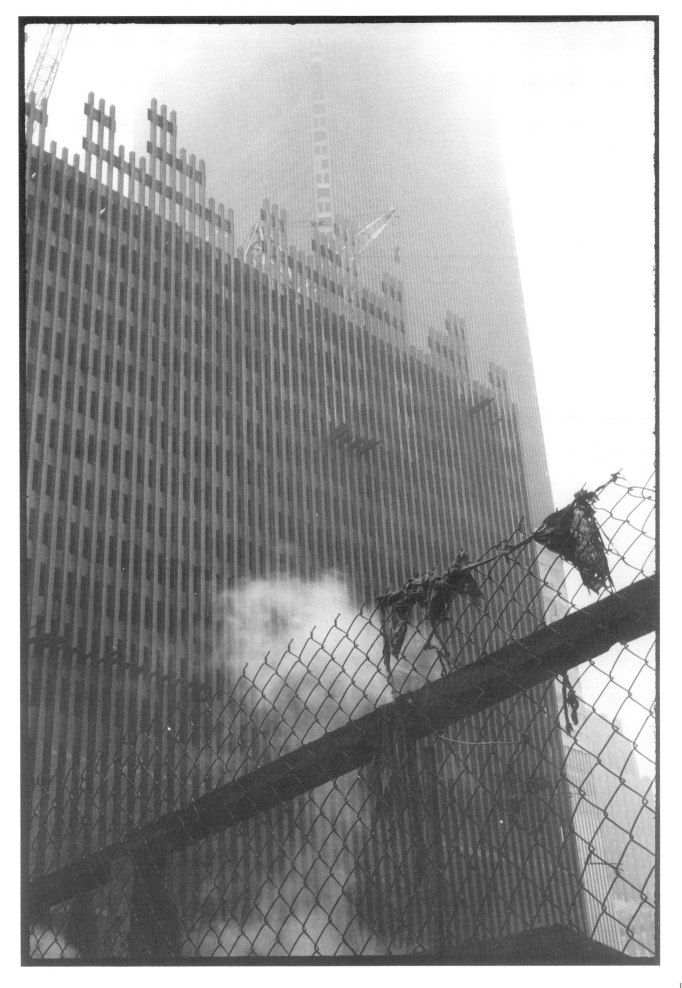

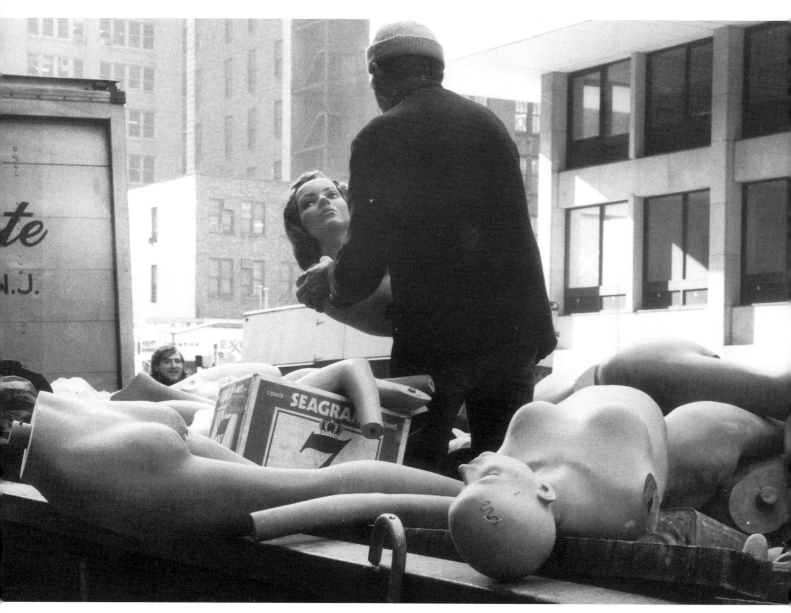

On Seventh Avenue at 27th Streeet, November 1974.

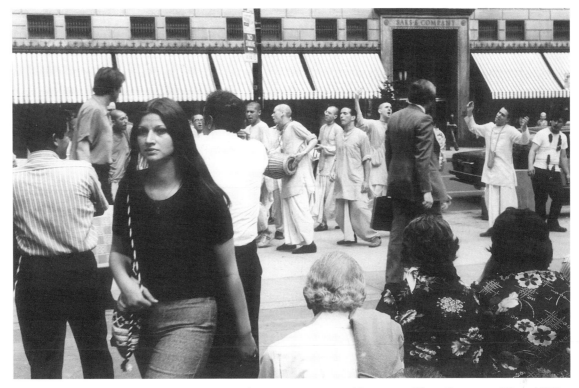

FIFTH AVENUE BETWEEN 49TH AND 50TH STREETS, MAY 1975.

In a store window I saw what I thought might be a hidden economic message, and I jotted down this thought:

In a high fashion store it might have meant something else, but here in the window of Plymouth—a chain of budget-priced women's wear—was a manikin whose décolletage revealed evidence of a bony rib cage and a hint of pendulousness in her modestly sized breasts. Did this portend a new austerity—a popular equivalent of the lean times that had befallen the city? It was almost as if we could not longer afford the more rounded models lying discarded in a curbside debris container on Seventh Avenue across from the Fashion Institute of Technology (what a name! Institute of Fashion Technology?—hardly much better), where an ever-hopeful scavenger was looking for any part he might squeeze a few cents out of.

Lean times, like other conditions described in crisis terms, did not have an immediate effect on the look of more affluent neighborhoods. Disciples of poverty, like members of the Hare Krishna sect, one of the simplicity-seeking groups spawned in the '60s, could still be seen around town, but, as they chanted and undulated across from Saks Fifth Avenue, they must have struck the tourists seated at the head of Rockefeller Center's Channel Gardens as a spectacle of curiosity rather than a reflection of the city's economy.

Through the intervention of the state's then governor, Hugh Carey, and a smart financier named Felix Rohatyn, a Municipal Assistance Corporation was set up, and what were known as MAC bonds were issued to tide the city over, while at the same time spending controls were imposed on City Hall. Still, there were large areas of the city, in the South Bronx and the center of Brooklyn (if sprawling Brooklyn can be said to have a center), that had become scenes of devastation. Many landlords in those areas chose to "let" their buildings burn down and collect some insurance rather than struggling to maintain them in the face of marginal rent income.

BRUCKNER BOULEVARD UNDERPASS, THE BRONX, FEBRUARY 1976.

The city had its dismal undersides. It also had some impressive ones. Although New York may not have the sewers of Paris (just think of sewers as a tourist attraction!), and while its subway tunnels and stations may have been more utilitarian than grand, it could show us some wonderful bridge and highway-support structures. Where Bruckner Boulevard in the Bronx dives beneath an overhead roadway before leading up to an elevated expressway—a section I've passed through numberless times en route to New England—I've always been fascinated by the successive rectangles of concrete. And there's a majesty to the arched undercroft of the Manhattan Bridge on its Brooklyn side that surely influenced the artists being drawn there to give the neighborhood the name by which it has since become known, DUMBO—for Down Under Manhattan Bridge Overpass.

How much our appreciation of the aesthetic of such urban structures owes to Piranesi! Yet it's curious to learn how little general appreciation was accorded him (Giovanni Piranesi, born 1720, died 1778) until fairly recently. I was surprised to find no entry for him in *The Random House Encyclopedia*. Yet his art prefigured a range of futuristic visions of the city, such as may be found in Moses King's *Dream of New York* (1908), in the pre–World War I drawings of Antonio Sant'Elia's *Citta Nuova* (New City), in the many renderings by Hugh Ferriss in the 1930s, in Fritz Lang's film *Metropolis* (1927), and on down to Rintaro's Japanese anime *Metropolis* of 2001 (whose images, undeniably spectacular, seemed by then old-fashioned, all the same). Whether drawing ruins or dungeons, Piranesi filled space with massive piers,

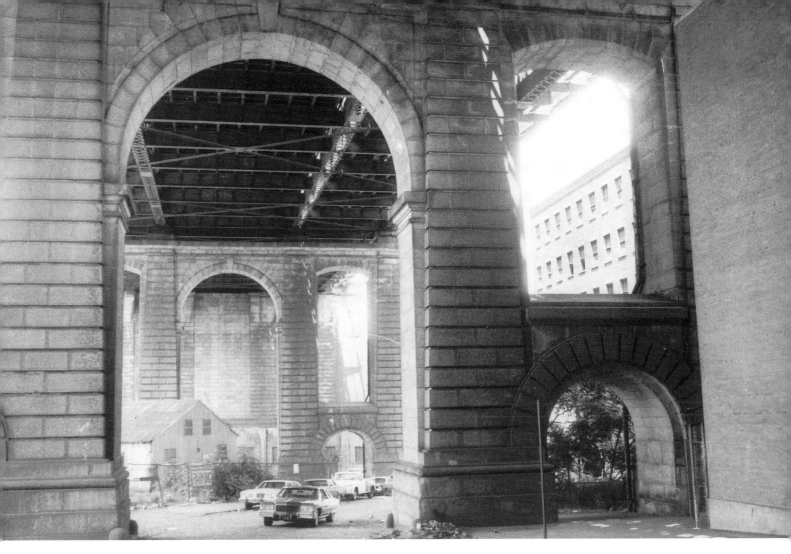

UNDER THE MANHATTAN BRIDGE, BROOKLYN, JUNE 1977.

soaring arches, floating skywalks, and a whole panoply of structural forms. I don't know if it's the architect manqué in me that finds all this so fascinating. There was a time when I seemed to keep running into other former architecture students who had gone into other fields. Maybe there are more of us than one thinks.

Knowing my interest in architecture, the local news director of the moment had urged me to do a story on the new Sixth Avenue, where the Exxon, the relocated McGraw-Hill, and Celanese buildings had been lined up alongside the Time-Life building. Until recently a science reporter, the news director was more comfortable with things than people, and he was much taken with the powerful simplicity of these vertically striped buildings. Not sharing his enthusiasm—I've already mentioned that I felt they

looked like slabs in a cemetery row—I should perhaps have begged off the assignment. But I went ahead, persuading the celebrated architect Philip Johnson to do an interview on location. He wasn't enthusiastic about those buildings either, though he seemed to take something of a shine to me. I also interviewed several passersby, including two boys of about ten or eleven, expecting they might feel the news director's thrill over these starkly new structures. To my surprise they said they hated them. When I included a sound bite from them in the story, the news director was indignant. He could accept Johnson's legitimacy, but he was convinced I had put the youngsters up to it. The story never aired.

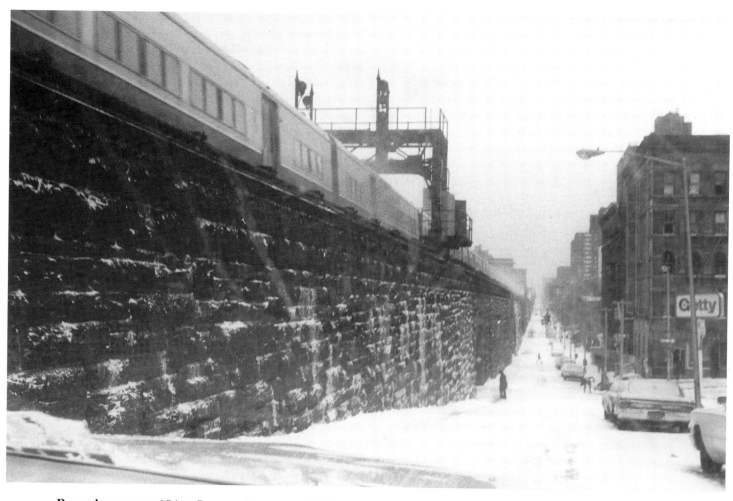

PARK AVENUE AT 101ST STREET, FEBRUARY 1976.

What was built in New York to serve transportation proved in its way quite as striking as the skyscrapers: the bridges, viaducts, elevated tracks, parkways, and expressways. Not all of them were a boon, and if Robert Moses had had his way entirely the city would have been strangled by such construction. Yet much of it was impressive. There was power and dynamism in the sight of a train on a snowy day speeding atop the heavy stonework erected along upper Park Avenue for the New York Central (that railroad itself, once so mighty, became one of the big enterprises not to survive the second half of the century, yielding its tracks to lines named Penn Central, Conrail, and later, Amtrak).

Remarkably also not surviving was the elevated West Side (or Julius Miller) Highway, the granddaddy of motorways on stilts, whose first section

had been opened to traffic in 1930. Its doom was signaled by a truck falling through its deteriorating roadway at Gansevoort Street in late 1974. To replace it, a grandiose project called Westway had been proposed even before that collapse. Westway, with parks to be built over multiple lanes of traffic, was to prove undoubtedly the most ambitious almost-built project in the city's history. Proponents of the project were bitterly opposed by environmentalists and several neighborhood groups, and Westway would finally die in 1985 when a federal judge determined that it threatened a vital Hudson River breeding ground for striped bass. "A fishy story in more ways that one," Jimmy Breslin's column in the *Daily News* was headlined—words that might have been construed as faulting the judge's ruling, but in fact Breslin was for the fish and against the fishiness of the "big guys," among them his

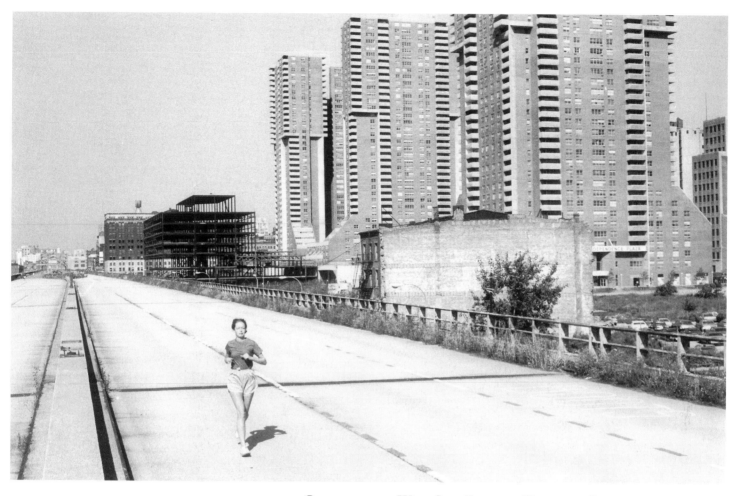

ON THE CLOSED WEST SIDE ELEVATED HIGHWAY, OCTOBER 1978.

publishers, who had pushed for Westway against the need of *Daily News* readers for better subways.

A runner who had the closed West Side Highway all to herself in 1978—vehicular traffic having long since ended—was passing an area in the process of transformation. The voluminous Independence Plaza houses had just been built on the inland side of the defunct road, and an entire new district called Battery Park City would rise on landfill along the Hudson River side.

While nothing seemed ever quite to stop construction and plans for construction, the city's close brush with bankruptcy cost the hapless Mayor Abe Beame a chance for a second term. Congressman Ed Koch was elected in 1977 on the strength of having ended more than a century and a half of corrupting Tammany Hall influence on city politics when he became the reform Democratic district leader in Greenwich Village. Koch got wide attention as he stood outside subway stations and asked potential voters, "How'm I doing?" The very model of a wisecracking New Yorker, Koch as mayor was constrained by the city's straitened circumstances, and he stressed fiscal conservatism. In contrast to Lindsay, he made no great plans for the city, leaving it to developers to build as they wished and could. On the strength of personality more than policy he would be elected to three straight four-year terms. To his everlasting credit, Koch left one memorable achievement: the so-called "pooper-scooper law" that required people to clean up after their dogs. The city's sidewalks and streets have been cleaner since.

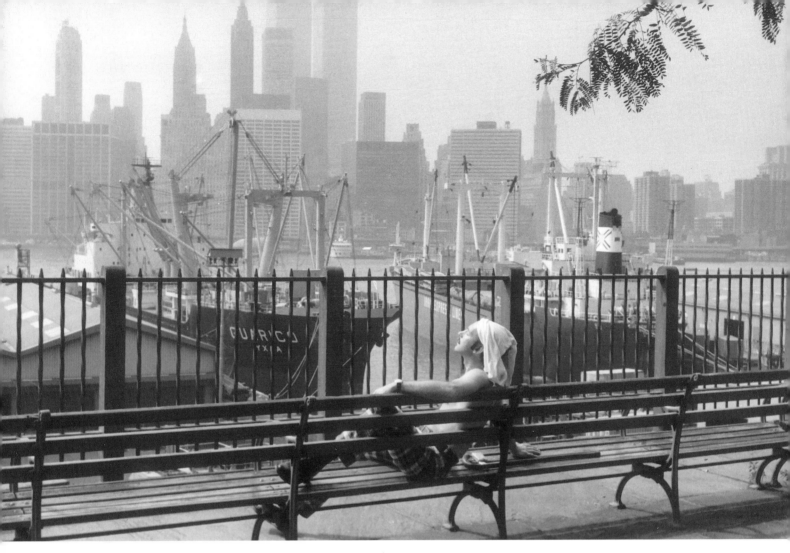

BROOKLYN HEIGHTS PROMENADE, JULY 1977.

If an unvaryingly comfortable climate were the criterion, San Diego would be a world-class city. Some perverse goad is needed to spur people into creating a great metropolis. Professor Kenneth Jackson's *The Encyclopedia of New York City* tells me New York's average annual temperature is—or at least was around the time of its 1995 publication—54.5 degrees Fahrenheit. A light raincoat or a warm jacket of some kind is about right for that temperature, but of course it's only an average. Most years the range is from a few degrees above zero to not quite 100. Some years it extends from below zero to above 100. In July of 1977 I photographed a man on the Brooklyn Heights Promenade braving the sun on the dense eighth day

of temperatures above 90. The temperature had dropped from 102 the day before to a mere 92, but by then one could hardly tell the difference. The air was oppressive.

That month was also marked by another widespread power blackout, this time accompanied by looting of stores in poorer neighborhoods—something that hadn't happened in the blackout of 1965. This time at NBC we were able to stay on the air with our own limited power generation, and with a small camera set up in the newsroom I sat through the night opposite anchor Chuck Scarborough. We were able to project unedited videotapes our reporters brought in from the streets (camcorders having replaced film cameras), but mostly we filled

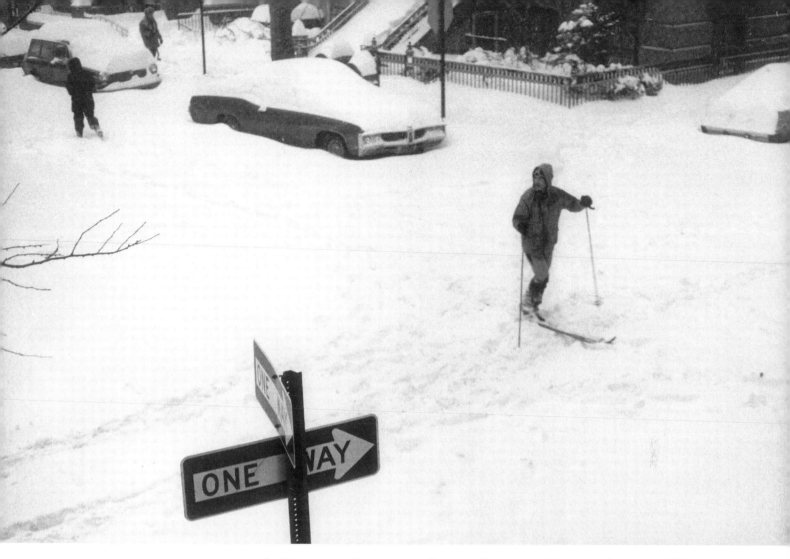

AT HICKS AND PIERREPONT STREETS, BROOKLYN HEIGHTS, JANUARY 1978.

the night with talk and whatever information we could get. *There will never be a record of last night's show unless some television freak outside the blackout area had the means and instinct to tape it,* I lamented in a note to myself. As far as I know, no one did tape it. Although I would win a local Emmy as producer of the best regional news program in '77, my tenure as the 11 P.M. producer came to an end late the next year for what I think was the fifth and final time. As we became more showbiz and less newsbiz, the volatility of personnel changes only increased, and my job assignments would shift at least every year for the rest of my tenure, sometimes for the better, equally often for the worse.

In January 1978, an unanticipated ice storm was followed a week later by an unpredicted 13-inch snowfall marked by considerably higher drifts. Skiing had reached a popularity to the point that skis were owned by many people who in earlier years would not have owned them, and some were trying them out on traffic-stilled streets. Out my window at the corner of Hicks and Pierrepont Streets in the Heights I saw sights reminiscent of my early childhood days in Tampere, Finland. Ed Koch wasn't about to let himself in for Lindsay's humiliation over the snow nine years earlier, and he lost no time in getting the snowplows to the streets of Queens—where, in fact, the accumulations weren't as bad as in some other parts of the city.

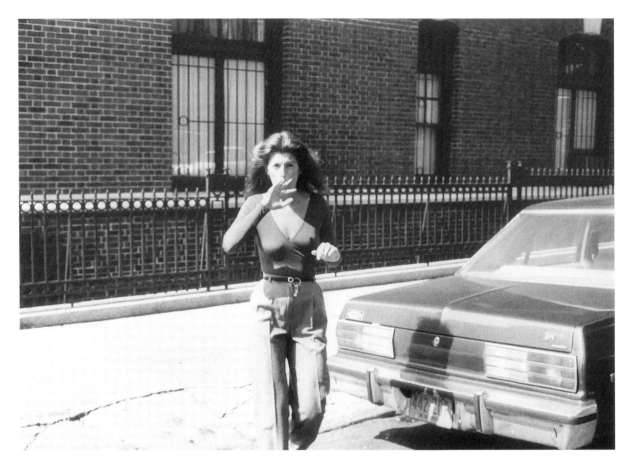

HICKS STREET, BROOKLYN HEIGHTS, SEPTEMBER 1978.

Between the extremes of weather New York could also offer many a day when there was no reason for one to wish to be in San Diego. September 1978 provided pleasant days for strolling the streets and enjoying the passing parade—the styles of dress, the styles of hair, schoolgirls in uniform, formalities and informalities of all degree.

I was the more appreciative of the city's charms for having had a near-death experience a month before. Feeling what had seemed like cold symptoms, I had taken the 12:40 A.M. train to eastern Long Island after a Friday night broadcast. I'd try to stretch out and sleep in the near-empty car, and my

ON THIRD AVENUE BELOW 59TH STREET, SEPTEMBER 1978.

throat would fill up. The train was experiencing many delays, and around 3:30 I awoke with the terrifying realization that I could neither breathe nor cough, nor swallow, nor spit. I tried gesturing to a middle-aged man that I couldn't breathe, but he looked simply uncomprehending and frightened. I tried poking myself under the rib cage by throwing myself against the top edge of the seat in front of me, in an approximation of the Heimlich maneuver our weatherman and science reporter, Frank Field, had been promoting. No air. I was getting faint. Then, painfully, I was able to draw just a bit of air through my nostrils through a constricted trachea. At that point a conductor came through and advised

me to lie down with my knees up. "No," I croaked, "that's what got me in trouble." He radioed ahead for an ambulance, and I was transferred to it at Westhampton. The crew gave me oxygen. By the time they got me to Southampton Hospital there seemed to be nothing wrong with me. Soon after, a doctor who happened to be my doubles partner in a tennis game noticed me wheezing and wrote me a prescription for Theodur at the next changeover. I then saw an allergist, who determined I had developed an allergy to cats (we had to get rid of ours) and was susceptible to asthma attacks. Since then I've carried an emergency inhaler.

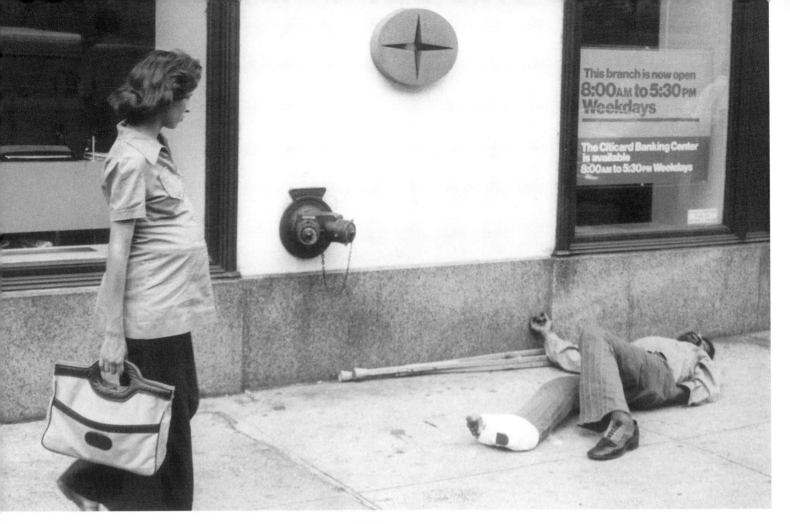

EIGHTH AVENUE ABOVE 15TH STREET, JULY 1978.

ood weather, bad weather, the street was a hard place for many. The growing problem of homelessness was made worse by the courts determining that marginally competent persons could not be confined to mental institutions against their will, rulings compounded by both legal and financial pressures to eliminate SRO's, or rooms rented out singly as rental units. Too many people who were barely getting by had nowhere to go.

No comprehensive or well-coordinated program existed for meeting the housing needs of the city's poor, but some anomalous projects were undertaken—none more anomalous perhaps than the Taino Towers in East Harlem. Four sleek towers, replete with a swimming pool, a gymnasium, and two greenhouses, were built with federal money east and north of 122nd Street and Third Avenue. They contained the rather limited number of 656

FROM A TRAIN ON THE PARK AVENUE VIADUCT PASSING 122ND STREET, APRIL 1979.

rent-subsidized apartments. Originally to have been completed in 1976, they were still not ready for occupancy when I photographed them in April 1979 from a railroad train on the Park Avenue viaduct— at which time there were about eight thousand families on the waiting list.

As the '70s wound down, so did the one-term presidency of Jimmy Carter. Faced with severe gasoline shortages brought on by oil-producing nations colluding to keep prices high, Carter had proposed a far-reaching plan to promote alternate energy sources and expand mass transit. But he buckled at the first sign of opposition from Congress, as the oil companies and car makers flexed their muscles. Once the immediate crisis, with its alternate-day gasoline rationing, had passed, vehicular traffic congestion would start picking up again. Meanwhile inflation was getting worse. By

the end of 1980 the prime lending rate charged by banks would rise to 20½ percent.

Even when Carter achieved a great international triumph—a peace treaty signed by Egypt's President Anwar Sadat and Israel's Prime Minister Menachem Begin—it was followed almost immediately by the bad news of the Three Mile Island nuclear plant breakdown. Though a disastrous core meltdown didn't follow, the incident left many people unsettled. Then, as a mortal blow to Carter's reelection prospects, radical students in Iran, following the Islamic revolution against the shah, whom the United States had foolishly helped to reinstate, held sixty Americans hostage in the United States Embassy in Teheran. When a desperate helicopter rescue mission failed in April 1980, so did Carter's last vestige of hope. The stage was set for Ronald Reagan.

ON 36TH STREET WEST OF FIFTH AVENUE, SUNSET PARK, BROOKLYN, MARCH 1979.

As the degree of pressure from my work assignments had become more variable, there opened opportunities to get around the city during hours other than those I'd been accustomed to. I made some forays into the more interior parts of Brooklyn, feeling I ought not simply be a fringe Brooklynite—after all, my maternal grandparents had lived in Flatbush and elsewhere in the borough. I'm not sure how deep this feeling went: Brooklyn is a very large and rather amorphous place to encompass; and ever since the departure of the Dodgers for Los Angeles in 1957 it had lost a crucial part of its locus. (Actually I had been an avid Dodger fan in my first American years; I had belonged to the "Knothole Gang" that got

cheap admission to Ebbets Field bleacher seats; I had collected autographs from the players; I had seen Jackie Robinson steal home; and I had once baby-sat for the little son of Joe "Ducky" Medwick.) One characteristic I found in many Brooklyn neighborhoods (not all) was a resistance to homogenization; owners of houses often liked adding embellishments to distinguish theirs from neighboring ones—as in the case of the one pictured on 36th Street in Sunset Park that suggested some sort of barred fortification, perhaps a castle in Spain.

Since I could now also often get to bed earlier, it meant I could rise earlier. One May morning I got up before dawn and walked across the Brooklyn Bridge to the Fulton Fish Market, to see the fish

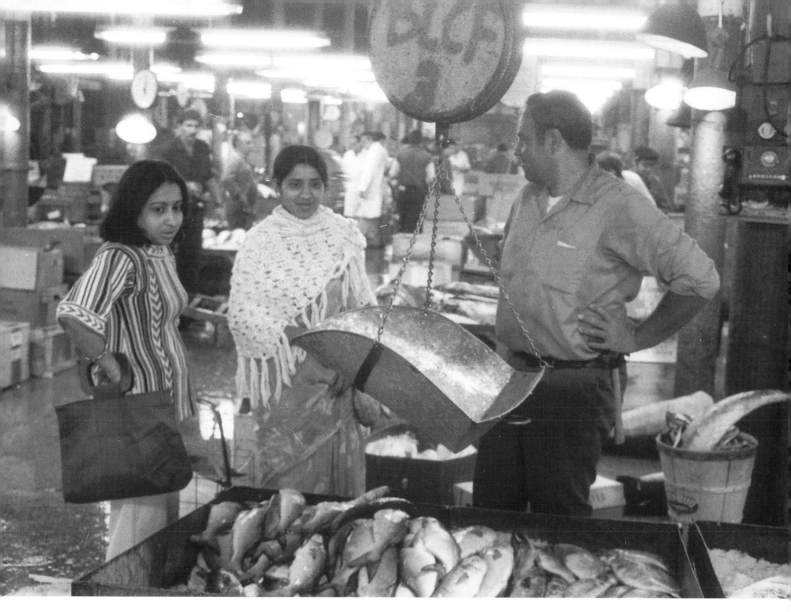

EARLY MORNING AT FULTON FISH MARKET, MAY 1979.

being brought in and sold to early-bird customers, most of them from retail shops or restaurants. Unlike former times, the fish no longer arrived by water but by truck. A rare trawler might still be seen, but its day of bringing the catch directly to the city was ending, as before long the day would end for the fish market's very existence in Lower Manhattan—it would be moving to the Bronx.

Among the stories that occupied space and time on a running basis in the local press and on news broadcasts were the "Son of Sam" murders of amorous couples in parked cars, for which David Berkowitz was eventually caught and subsequently convicted; the never-solved disappearance of a little boy named Etan Patz on his first day of going to school by himself; the continued survival of a young woman in a coma, Karen Ann Quinlan, whose family was eventually allowed to disconnect her from a respirator, although she kept on breathing for almost ten years after that. Several movies that were more than overnight sensations included *Star Wars* and *Close Encounters of the Third Kind*, as well as *Saturday Night Fever*. I enjoyed John Travolta's dancing in the latter, and *Star Wars* had me in thrall from the very first image. I was in the minority on *Close Encounters*, finding it too sentimental and objecting to the corny aliens with heads that looked like upside-down raindrops.

Had we become too solemn? The civil rights and women's liberation movements had fostered a climate that became known as "political correctness," or "PC." Sexual and racial references, as well as references to physical or mental deficiencies, had to be couched with care so as not to sound derogatory or discriminatory. Yet, like all moralistic prohibitions, PC bred resistance. Books with titles like *Truly Tasteless Jokes* began appearing; these had a deliberately provocative and hostile edge that was not lighthearted. Knowing that PC demanded relationships between the sexes be "meaningful" rather than casual, I chuckled at a playful comment made by one of our male assignment editors to a female production assistant: "Why don't we have a meaningful quickie?" She laughed. On the subway some time later I saw a well-built black woman enter a car wearing a blue T-shirt on which was lettered in white:

WHICH DO YOU

PREFER

MY MIND OR MY BODY

TOUGH CHOICE

HUH

She sat down, cast a rather challenging gaze about, and absorbed herself in a paperback novel titled *Heir Presumptive*. I couldn't make out the author's name.

You couldn't stop advertisers from testing how far they could push eroticism to sell their wares. Jeans makers were using younger and younger models in suggestive poses. Calvin Klein, never one to be outdone, put the not-yet-quite-matured movie nymphet Brooke Shields into commercials with the line: "You want to know what comes between me and my Calvins? Nothing!" The vaguely androgynous quality of Shields as well as of other models, both female and male, that Klein was beginning to employ may have subtracted a bit of direct sexual threat from his advertising at the same time as it engendered a certain frisson. Klein wasn't using busty babes or obvious studs (or hunks, as they would soon be called). To quite a few parents and school people, in any event, it was upsetting that an ever younger audience was being targeted by sexually potent advertising and by increasingly violent movies and television series.

Although it wasn't precisely part of PC, another powerful appeal—pretty much a perennial one—was that of dieting. In New York the actual need for dieting, set against its prevalence, was generally less than in most of the country. Of the two hot dog eaters I saw crossing Sixth Avenue at 57th Street, throwing concern for diet to the wind, one at least looked as if she had no reason to worry about calories.

SIXTH AVENUE AT 57TH STREET, JULY 1980.

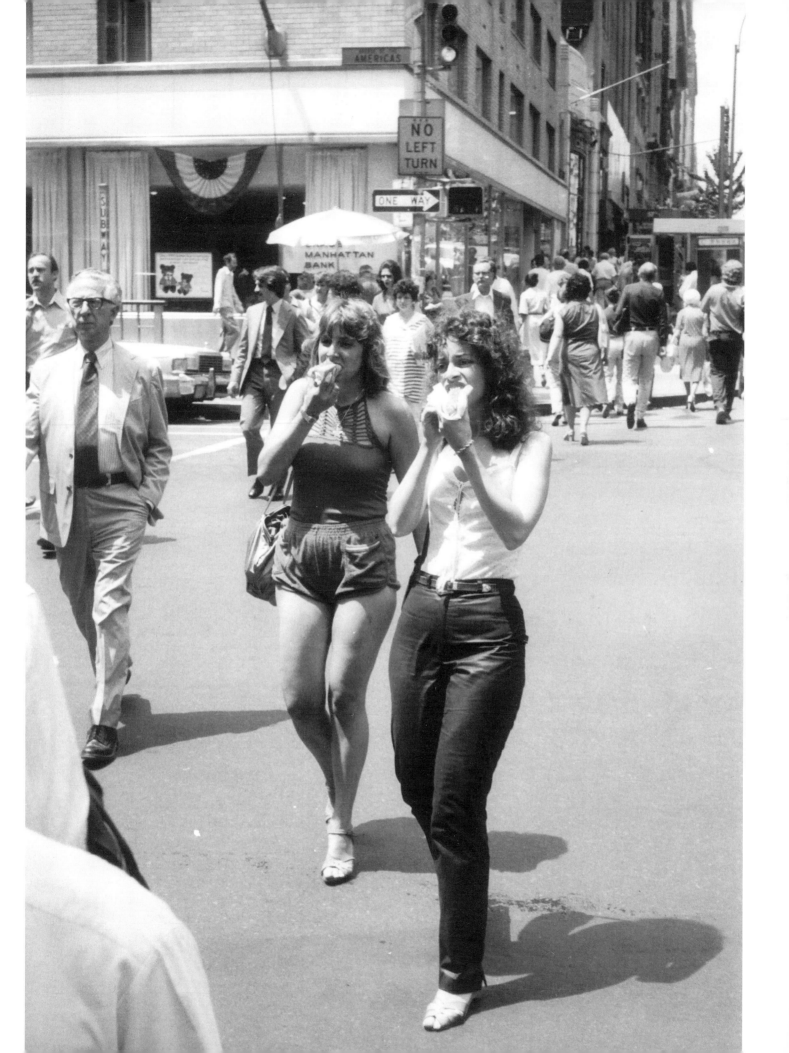

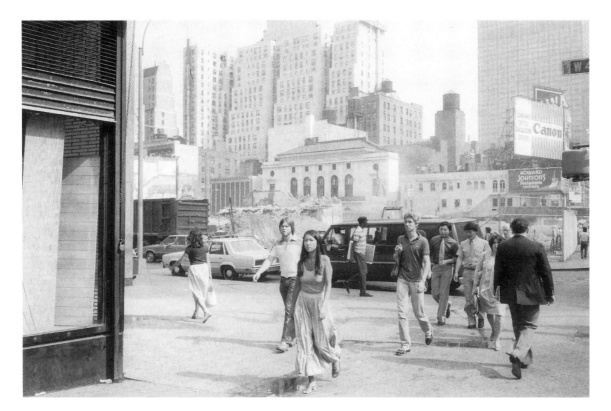

WEST SIDE OF BROADWAY AT 45TH STREET, BESIDE AREA CLEARED FOR MARRIOTT MARQUIS HOTEL, JULY 1982.

Street vendors, such as the one who must have sold those two women their hot dogs, were having a hard time of it. Following a judge's controversial ruling that vendors could be banned, Mayor Koch supported a new law to affirm that ruling, then backed down and vetoed it. So vendors stayed. In a city still struggling to fully erase the threat of bankruptcy—with unemployment high and homelessness conspicuous—street vendors helped feed much of the population, even those with better jobs. Statistics showed that inflation had eaten up people's pay raises during the past decade. In fact, my own pay hadn't kept pace with inflation; I rarely enjoyed the restaurant lunch that had been an almost daily habit.

In many ways, the city was nonetheless getting past the crisis. Office construction was picking up again. There were plans in various stages of advancement—for Battery Park City, for South Street Seaport's commercial and recreational development, for downtown Brooklyn's MetroTech office center, for the redesign and cleaning up of Bryant Park, for Bridgemarket in the Queensboro Bridge anchorage. Times Square was to be redeveloped as a city-state project with four office towers to be designed by Philip Johnson. Sex shop operators fought that plan, as did preservationists who didn't necessarily condone sex shops but who feared a total obliteration of Times Square as it had been known. The Johnson towers never did get

ESCALATORS AND ATRIUM WITH WATERFALL, TRUMP TOWER, FIFTH AVENUE AT 56TH STREET, APRIL 1984.

built, although a monstrous hotel—the Marriott Marquis—did get squeezed into the heart of the crossroads space. Other towers would also crowd in, but with the understanding that Times Square would remain the city's center of billboards and signs. Steps would also be taken to preserve some of the district's "Broadway" theaters.

A brash young builder who had come out of Brooklyn, where his father was a successful apartment house developer, was now challenging the likes of Helmsleys, Zeckendorfs, LeFraks, Milsteins, and Dursts to become the city's top developer. Donald ("the Donald," as some columnists liked to call him) Trump built a black glass tower at Fifth Avenue and 56th Street with a six-story atrium

described as a "vertical mall." There were shops on its various levels, as well as entrances to a department store. The "most magnificent waterfall anywhere in the world" faced diners at the base; it was also visible from the shiny escalators. Pianists and violinists performed at the atrium's entrance. Soon Trump's name would be increasingly visible on many buildings in Midtown and the Upper East Side. He would also propose to build the world's tallest building on the Upper West Side. There, he had to scale down his ambition, though apartment buildings under the Trump name began to sprout in the West Seventies in the early years of the new millennium. And an apartment tower dwarfing the nearby United Nations Secretariat got built despite protests.

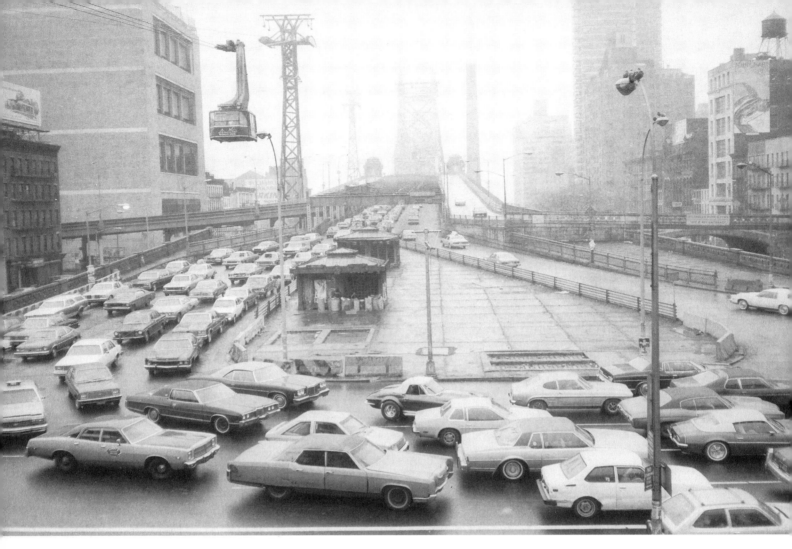

CARS COMING OFF QUEENSBORO BRIDGE TO SECOND AVENUE, MANHATTAN, MARCH 1982.

raffic was always said to be getting worse. No matter how the traffic engineers fiddled with lanes, directions, and signs, wheels on the streets seemed to average somewhere around 7.5 miles an hour, as they had for more than a hundred years past, depending on where and when and who made the measurement. A subway strike in 1980 had turned more people than usual to their automobiles, for a time causing such blockage of Manhattan intersections that the term "gridlock" came into everyday use. I'm not sure that on the whole traffic was any worse than when I had versified about it almost thirty years earlier, but I wasn't writing any more verses. I did, however, see what I thought was a telling picture in the squarish and clumsy-looking cars crawling off the Queensboro Bridge onto Manhattan's Second Avenue on a misty

day. The aerial tram that served the newly developed and car-less Roosevelt Island was working that day; it would be out of commission too often in years to come.

Some progress was meanwhile being made toward fixing the subways. A couple of out-of-towners, Robert Kiley from Boston and David Gunn from Philadelphia, were brought in to set things right. Cleaning up subway graffiti was a first step. Cars were painted white on the number 7 line, something of a showcase as it served the Mets' home park at Shea Stadium and the National Tennis Center, to which the U.S. Open had switched from Forest Hills. At Queens Plaza, a transfer point from other lines, one could watch a white antique emerging into the open, complementing an outdated industrial scene that stretched out horizon-

QUEENS PLAZA NO. 7 LINE STATION, AUGUST 1983.

tally in contrast to Manhattan's verticals. The subway was a convenient way to get to the tennis matches, but I sometimes saw them in the company of a Los Angeles-born neighbor who had never adjusted to getting anywhere except by car. More than once this meant getting lost on the unfamiliar streets of Queens, chosen as an alternative to the clogged Brooklyn-Queens and Long Island Expressways.

This was the moment of the yuppie—young upwardly mobile something or other—and nobody exemplified the ideal better than Donald Trump. You can have it all: money, palaces, yachts, jets, sports cars, resorts, beautiful women. Reaganism encouraged this, and television series like *Dallas* and *Dynasty* enabled the nation at large to share vicariously in the joys and dramatic tribulations of top-level yuppiedom. The American corporate structure

that had seemed so stable—people spending their working lives with one company before drawing a comfortable-enough pension—was coming apart. A new breed of robber barons, "leveraged" with borrowed money, was using "junk bonds" and proxy fights to achieve what became known as the hostile takeover of companies. They fired large numbers of employees to reap quick profits (the "bottom line") and then often got out with the crippled shambles of a company left behind. There was also a federal judge's antitrust decision to break up AT&T, the one system above all that worked in America, and—they said it was progress—we ended up talking to machines instead of to people.

Earthly bliss achievable—tempting like the figure of classical proportions crossing Fifth Avenue above 36th Street—was a dream causing much of the nation to forget the soul-searching it had been through not long before. "It's morning in America," Reagan promised. Only that the loveliness of the concept, if it was true at all, didn't hold true for much that was happening in an outside world no longer distant enough. Anwar Sadat, the hero of Mideast peace moves, was assassinated by religious nationalists in Egypt; an attack on U.S. Marines headquartered in Lebanon left well over two-hundred dead; a hostage crisis occurred, also in Lebanon, but was eventually settled with the release of the captured thirty-nine; an Italian cruise liner named *Achille Lauro* was hijacked in the Mediterranean and an elderly Jewish passenger murdered (the Palestinian hijackers did get caught). More security was ordered at U.S. government buildings and at places like national memorials and monuments. In a flexing of military muscle Reagan sent troops to invade the tiny Caribbean nation of Grenada, to save the region from the alleged threat of Communism. Meanwhile Mikhail Gorbachev had become the leader of the Soviet Union. The dismantling of Communism—even if Gorbachev didn't intend to carry it out to its end—was already underway, although America was behind Europe in sensing the change.

For all that, the world was still the world, something apart from America. Even as I jotted to myself that *the new form of war is terrorism,* I shared that sense of disconnect. Our older son, Sven, had decided he wanted to go to boarding school, and I remarked in a letter to him: "It is actually rather strange to be in a business in which one's life is directly affected by events that, in a more intimate sense, hardly touch one at all."

The classical Venus (with arms, and with maybe even not such youthful hands) could cross Fifth Avenue as if nothing, anywhere, would threaten her.

FIFTH AVENUE AT 36TH STREET, JULY 1983.

BROOKLYN GENERAL POST OFFICE, CADMAN PLAZA, FEBRUARY 1983.

Here I was, the anachronistic man seeing in the changing of the seasons one of the too few reassuring constants of a changing world. A snowfall could make Brooklyn's old General Post Office rise gloriously above what I could imagine as a Russian steppe, the leafless trees of Cadman Plaza seeming almost to disappear. (In summer it was much harder to get a clear view of the building.) Less charming, but still familiar, was the slush that usually followed snow and made street corners, as at Seventh Avenue and 49th Street in Manhattan, a challenge to negotiate. Having written newsreels in a television age, I was now beginning to sense that the "traditional" television work I was engaged in had entered its decline.

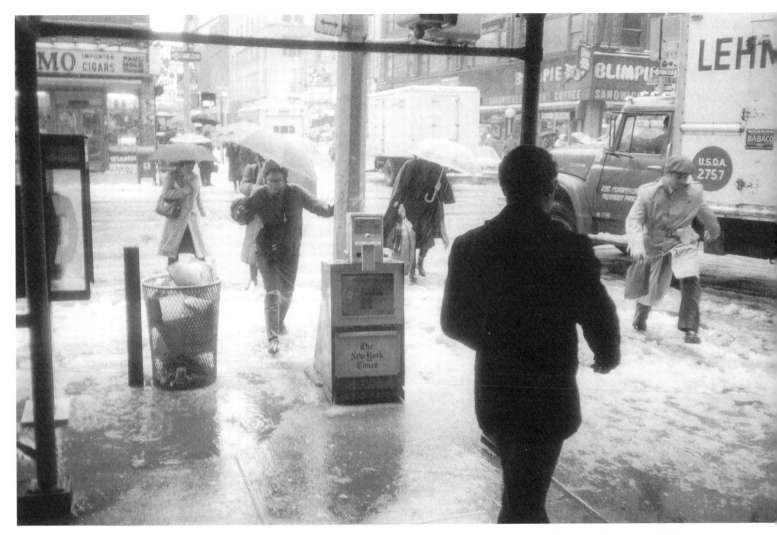

At Seventh Avenue and 49th Street, March 1984.

Other traditions such as the Sunday closing of shops had already gone by the boards. A feeling that much of life was losing its rhythms, that everything was salesmanship all of the time, that nothing was any longer free, was sweeping in along with technological change. Even newspapers were no longer what they had been. The *New York Times* had cut the number of columns on a page from seven to six and had added extra Wednesday and Friday sections (and would go on adding ones for each day)—*filling up with nothing to read, just a bother on the subway,* I griped in my notes. Already by mid-1978 reporters at the *Times* had switched from typewriters to computer terminals, and the pages to be printed were stripped in on paper rather than set in lead type. Something in me didn't like the computer, and at home I still hacked away on a Royal Standard. As for cameras, for years I had used mostly one or two 35-millimeter bodies with interchangeable 35, 50, 90, and 135mm lenses, but I had pretty much come to settle on the 50mm lens to avoid the bother and time involved in changing lenses (which could mean losing the opportunity for a shot). I was still some years away from acquiring a zoom lens, which gives you so much more speed and flexibility in framing the image you want.

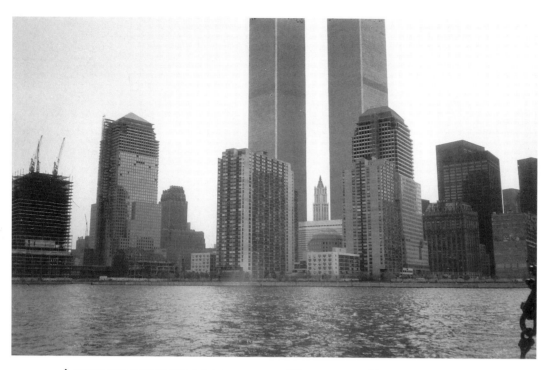

A VIEW FROM THE HARBOR SHOWS THE WOOLWORTH BUILDING, ONCE THE WORLD'S TALLEST, DWARFED BETWEEN THE TWIN TOWERS OF THE WORLD TRADE CENTER, MAY 1985.

New Yorkers didn't care, not really, if the height of the World Trade Center towers was exceeded by buildings in Chicago or, of all places, Kuala Lumpur, Malaysia. Feelings about the twin towers were mixed. They possessed a simple, dominant, primal strength. They were not lovable. They and their mall-like substructure were not quite "New York." They were, I suppose, symbols of American global free enterprise (even if they had been built by a government agency, the Port Authority). What they did not stand for—and this had been a failure of American policy since not long after World War II—was any serious outreach to the less well off, greater part of the world. But what was undeniable was that you could see them from far away and from many directions. It was hard *not* to photograph them, or not to get them somewhere in the background of other Lower Manhattan subjects. As I walked across the Brooklyn Bridge with a storm gathering, the sun illuminated both bridge cables and those towers against the darkening sky. During a harbor exploration trip I found the towers, as they dwarfed the Woolworth Building between them, looking determined to rise beyond

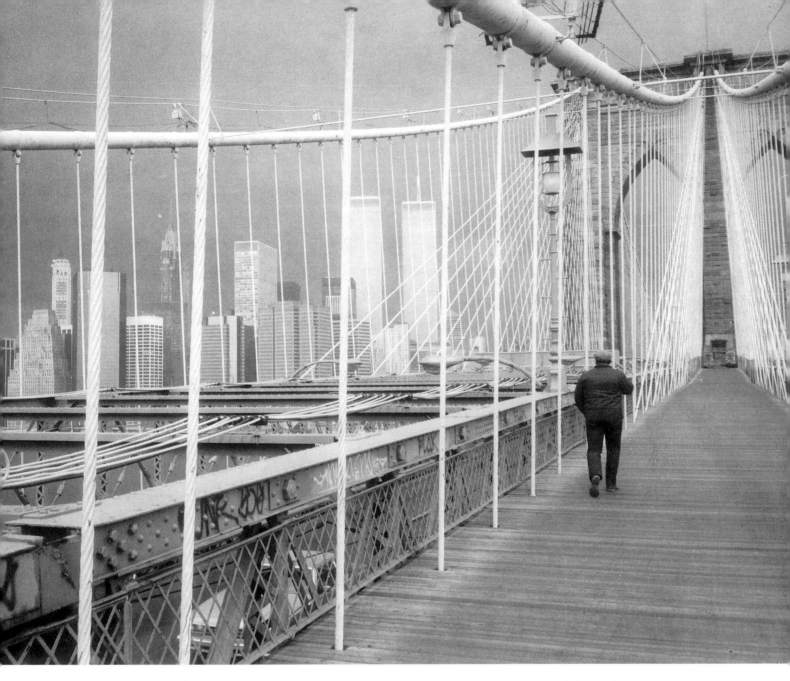

CROSSING THE BROOKLYN BRIDGE UNDER A THREATENING SKY, THE WORLD TRADE CENTER RISING BRIGHT IN THE BACKGROUND, APRIL 1985.

the upper edge of the picture frame.

At this time New York City's population was down from a peak of just under eight million to something nearer seven million (the greater metropolitan area had grown), but you couldn't tell the population decline from the phone books. Telephones—most of them for business—were increasing to the point where a new area code had to be instituted. People in Brooklyn, Queens, Staten Island, and a part of the Bronx lost their cherished 212 and had to accept 718. In years to come there would be yet further area code subdivisons.

We were coming into a time of "crumbling infrastructure," a new expression here and around the country following the neglect of public features like roads, bridges, and water mains. Emphasis on private development, combined with growing antitax sentiment, was shorting the public sector. Although the Brooklyn Bridge was getting an overhaul, the neighboring Manhattan Bridge was exhibiting strains that in a few years would require rerouting subway trains away from it and lead to quite drastic repairs. Some local institutions, like savings banks and department stores, had started going out of business. Manhattan had recently lost Gimbel's, Ohrbach's, and Alexander's, and at the end of 1990 I would bemoan the *shock of going into Altman's—the last civilized department store in New York—and seeing it stripped of merchandise displays. Only a bargain basement sale remaining of what little is left.*

There was some solace for us National League fans that in 1986 the Mets won their first World Series in seventeen years, beating the Red Sox in seven games. This was *news,* as simply one more Yankee World Series win was not. And the stock market kept climbing, climbing, climbing . . . until, on October 19, 1987, the Dow Jones industrials fell a staggering 508 points—more than in any previous day ever, even if, percentage-wise, not equal to what had happened in 1929. Despite the city's unemployment rate having dropped to a fourteen-year low of 5.1 percent, a worried Mayor Koch put a freeze on city hiring and salary increases. Koch's

hopes for a fourth term were fading as the Irish-Italian-Jewish dominance of New York politics came in for challenge by blacks and Hispanics who, though seldom working in concert, were claiming more say. The often undiplomatic Koch didn't build new coalitions. He was not helped by, even if he wasn't responsible for, several corruption scandals that would include the indictment and conviction of the Bronx Democratic leader and the suicide of the Queens borough president following damaging revelations. Apart from election politics, the running of the city changed when the powerful Board of Estimate, in which the mayor's power was somewhat checked by the borough presidents, was found to violate the constitutional one-person-one-vote requirement and was abolished. The board's power devolved to the formerly anemic City Council, whose members were elected proportionately, but the very size of the council made it harder to get things passed.

Walking on 49th Street between Ninth and Eighth Avenues on a day in April (T. S. Eliot's "cruellest month") I came on a scene too good to be true: Winnie and Willie released from Samuel Beckett's *Happy Days* to come walking hand in hand past the ash cans from his *Endgame,* under a faintly decaying marquee that boldly proclaimed: "BETTER DAYS." A defunct disco? Note the determined hopefulness in the gait of Winnie and Willie. As Beckettian characters they weren't giving up but going on. As was New York City.

ON 49TH STREET BETWEEN NINTH AND EIGHTH AVENUES, APRIL 1987.

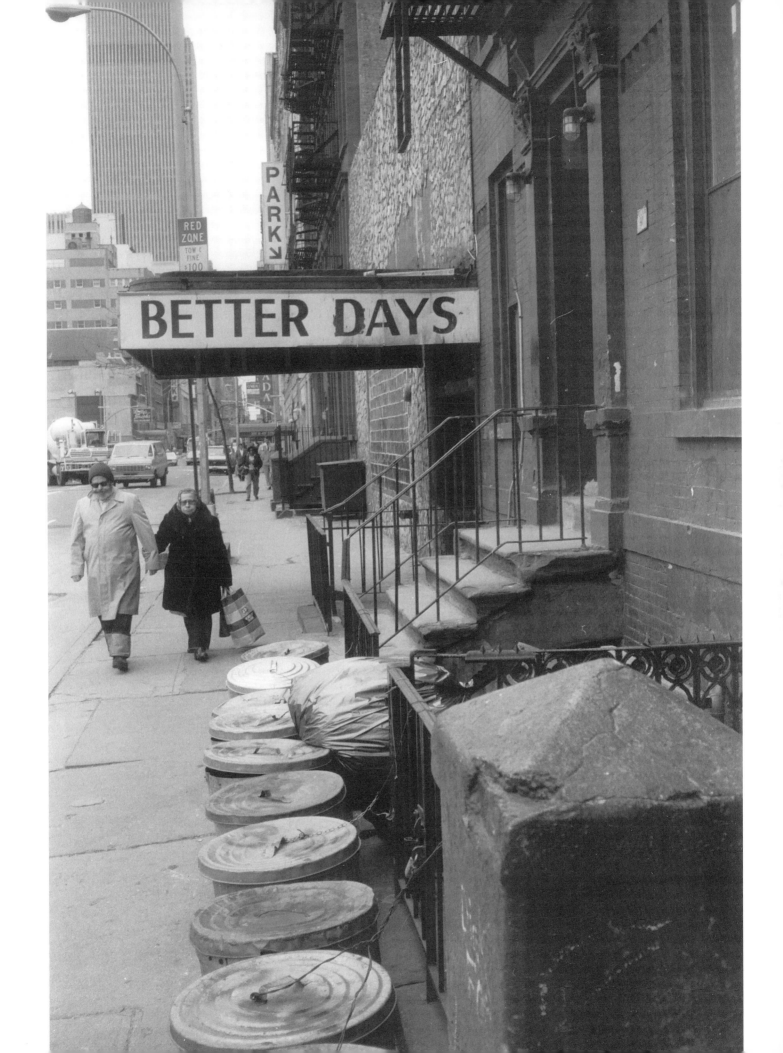

Things were not good in network television. The three nets that had dominated broadcasting, CBS and ABC in addition to NBC, were getting competition from cablevision and videocassettes. Local news programs on Channels 5 (which also was to become part of a network) and 11 were drawing off some viewers from the network outlets. Besides, after having served to provide prestige rather than profits, network news programs were now expected to make money. Staffs were reduced; sensation and entertainment squeezed serious news content. Grant Tinker, who had restored ratings and respect to NBC after several weak years, was replaced by a General Electric executive as that corporation absorbed NBC's parent company, RCA. I had in any case been feeling somewhat underemployed of late and had been using much of my time to follow up research I had done on the history of the Brooklyn Heights Promenade—a walkway cantilevered over two decks of the Brooklyn-Queens Expressway. I saw it as a possible model for joining pedestrian elements to urban highways, and eventually obtained three grants for travel and further study of highway-pedestrian relationships. I hoped to take advantage of attractive buyouts NBC was offering to reduce staff. But NBC management claimed I was still needed and wouldn't be given a buyout. While that was not unflattering, I wanted out, and finally went to chief anchor Tom Brokaw to plead that I was hardly indispensable. He generously interceded, and at the end of 1987 I got a buyout to conclude a little over twenty-six years with NBC. For much of the next three years I would be traveling on this and four other continents looking at more than enough motorways.

People who had been famous in my youth were dying off. In the fall of '87 I clipped an obituary of Madeleine Carroll—no longer a household name, I suppose. Madeleine Carroll had been simply the most beautiful of movie stars to my prepubescent eyes. She was gorgeous in *The Prisoner of Zenda,* playing against Ronald Colman, David Niven, and Douglas Fairbanks Jr. Other boys may have liked Betty Grable and Rita Hayworth, but I demanded more elegance. I also liked the swashbuckling men, the ever-present glint in Errol Flynn's eyes. Sadly, Flynn always seemed to get matched up with Olivia de Havilland, whose charm escaped me. I'd much rather have seen him paired with Virginia Mayo, who would have to settle for Bob Hope in *The Princess and the Pirate.* Not that I necessarily preferred blondes to brunettes. Gene Tierney captivated me, as did Hedy Lamarr and Ava Gardner, more by their looks than their acting. Elizabeth Taylor, the first star my own age, seemed unbelievably stunning when she visited our college in my freshman year and briefly passed me at close quarters. But now we were in the midst of losing the previous generation, the great stars who had turned the movies into a sophisticated talking medium (with certainly some help from writers, directors, cameramen, and film editors, among others).

At this time the beauty goddesses were coming more from the ranks of models than from among movie stars—who, though still very big, were not given quite the earlier glamour packaging—and those who got big contracts to advertise particular lines of cosmetics or were pictured in the annual *Sports Illustrated* swimsuit issue were dubbed supermodels. The image of the six-foot Elle MacPherson, star of several of those swimsuit covers, appeared to ignore and be ignored by East Siders intent on gaining the warm interior of a Second Avenue bus on an icy January day.

The same Elle MacPherson received far different attention when she arrived at Macy's the following year to promote a beauty-care regimen. A crowd of mainly female shoppers cast looks of wonder and dismay on this figure of unattainable glow.

Bus stop at Second Avenue below 57th Street, January 1987.

In Macy's, Herald Square, November 1988.

EAST SIDE: LOOKING WEST ALONG 53RD STREET FROM SECOND AVENUE, AUGUST 1985.

Behind the images that captured the public's attention, the powers that concocted them were making decisions about where and how to carry on their work. Madison Avenue, as identified with advertising as Wall Street was with finance, was being abandoned by its more prominent agencies. A westward migration of office development was drawing both advertising and law firms to what, initially at least, would be lower rents west of Sixth Avenue rather than east of it. (Japan, whose economy seemed threatening to swallow us, meanwhile gave New Yorkers a jolt when Japanese interests acquired Rockefeller Center.) A Zeckendorf development as far away as the west side of Eighth Avenue at 49th Street—Worldwide Plaza—pulled in the prestigious law firm of Cravath, Swaine and Moore as well as the Ogilvy and N. W. Ayer advertising agencies. Advertising firms were going through their own mergers and consolidations, similar to the upheaval that was happening in the corporate world. Two high-flying manipulators of the latter world, Ivan Boesky and Michael Milken, conspicuously got caught for insider trading and deception in the promotion of junk bonds.

Such scandals didn't keep the very rich from doing very well in the '80s. The top one percent of American families enjoyed a 77 percent increase in income between 1977 and 1989, while most people barely stayed even with inflation and the bottom fifth saw a 9 percent decline. Black incomes gained slightly in the Northeast, reaching a little over two-thirds of the white median. The gap between what upper-level executives made and what other employees were paid had become greater than ever and would continue to become greater still.

And a remarkable government scandal had been brewing as operatives of the Reagan administration sold arms to the hostile Iranian regime to get money for funding the so-called Contra rebels who were trying to overthrow the elected leftist government of Nicaragua. As recriminations followed, the secretary of state claimed he had been misled by the CIA chief who had since died; a Marine lieutenant colonel who had greatly exceeded his authority was convicted but escaped jail (to become a right-wing radio commentator); an admiral who was White House security adviser was also convicted; and a bewildered-sounding Reagan, perhaps already in the early stages of Alzheimer's, gave a confused impression of how much he had really understood about the shenanigans, but left no doubt that he supported the rightist Contra cause. Folksy "Teflon president," he managed to remain untainted in the eyes of the majority of Americans.

There were at the same time some hopeful developments, among them a Senate override of a Reagan veto of economic sanctions against South Africa. This helped lead to the release of imprisoned black leader Nelson Mandela and to his accession to the country's presidency—a peaceful resolution of a racial divide that I had never imagined could happen. Whatever his ideological set, Reagan was not immune to personal charm, and he seemed almost to forget that he had called the Soviet Union the "evil empire" when he signed a missile reduction treaty with Gorbachev. The Cold War was fading fast as the Soviet Communist Party relaxed its control. The Berlin Wall was about to fall, Germany reunited. The Soviet Union was about to break up into Russia and a number of smaller countries. The Baltic states would regain independence. Ominously, though, a terrorist bomb blew up Pan Am Flight 103 over Lockerbie, Scotland, leaving 270 people dead. And China was not about to relax its control, its troops

crushing a student demonstration in Beijing's Tiananmen Square, killing more than two hundred.

Neither bad news nor good news kept New York from the process of refashioning itself. Tall buildings in Midtown that had largely been confined to the strips between Lexington Avenue and Sixth Avenue were sprouting on either side of those borders, a spillover to Third Avenue having begun already some time earlier. Whole new massings of buildings in disparate styles were creating unusual skyline effects. Builders and their architects had for the most part left the slab behind, its sterility having become painful through repetition. A "postmodernist" movement looked for a return to more elaborated earlier styles, or at least to echoes of such styles, while other architects shaped their buildings more freely and gave them more color without abandoning the sleekness of modernism. Our old friend Philip Johnson went in both directions, collaborating on what became known as the "Chippendale" skyscraper on Madison Avenue at 55th Street, and on a pink, tubular tower called the "lipstick" building at Third Avenue and 54th Street. The latter is seen still under construction in the 1985 East Side skyline photo, with Hugh Stubbins's shiny Citicorp tower of 1978 rising to a point behind it. On the West Side the contrasts were at least as great. At the center of the 1991 photo is the 1988–90 Morgan Stanley Building at 50th Street and Seventh Avenue, designed by Kevin Roche, John Dinkeloo and Associates; beyond it at right is the main tower of Worldwide Plaza at Eighth Avenue, built 1989 in an effort to recapture a sense of the great skyscrapers that rose downtown in the 1920s and early '30s. The architect in this case was David Childs of Skidmore, Owings & Merrill.

Change is unsettling; some people invariably get hurt by technological shifts and uncertainties in the economy. "Going postal" came into the language after an Oklahoma mail carrier killed fourteen fellow workers and himself, followed by several other violent actions by postal workers elsewhere. Bernhard Goetz, who had shot but not killed four

WEST SIDE: LOOKING WEST FROM SEVENTH AVENUE ALONG 50TH STREET, MARCH 1991.

black youths on a New York subway train in 1984 because, he said, he felt threatened by them—and had drawn a fair amount of sympathy—was finally sentenced in 1989 to a year in jail. In 1990 several cab drivers were shot; a Utah tourist was stabbed to death by robbers in the subway; a woman jogger was badly beaten and raped in Central Park, a case that would continue to have repercussions more than a dozen years later; and the city registered a record of 2,245 homicides. Also in 1990, the stock market got another October jolt, not as bad as the '87 one but worrisome enough that the city's new mayor, David Dinkins, took a 5 percent pay cut and further froze city salaries. Dinkins had decisively beaten Koch in the '89 Democratic primary and then more narrowly defeated a surprisingly strong Republican challenge from the federal prosecutor Rudolph Giuliani to become New York's first black mayor. (By then, incidentally, African American had become the correct term.)

After the genial smoke-and-mirrors presidency of Reagan—he persuaded people he was reducing the federal deficit and the size of government even as he increased both—his vice president and successor, George H. W. Bush, who had once derided as "voodoo economics" Reagan's notion that wealth should best trickle down from the very rich to the general populace, got into trouble with voters when in all conscience he realized he couldn't both wage a war in the Persian Gulf *and* keep taxes at rock bottom.

ON 14TH STREET BETWEEN FIFTH AND SIXTH AVENUES, AUGUST 1991.

I *long for and distrust that which remains—which has not been greatly altered—unspoiled fields, old streets with buildings from earlier days,* I mused in my notes in 1991:

I don't take the simple delight in these things that I think I once did. Now anything that is as I remember it seems to me to be tenuous, fragile, untrustworthy. Shakespeare's "to love that well which thou must leave ere long" strikes me as unrealistic. Like loving a chimera. There's no substance to it. The unchanged is an unreal state . . . I wish I could love it wholeheartedly, but I can't.

Nor do I love change.

Several days later, reading Lillian Hellman's *Pentimento,* I copied down this observation about her relationship with Dashiell Hammett: "I was what he wanted to want, did not want, could not ever want, and that must have put an end to an old dream about the kind of life he would never have because he didn't really want it."

I was going into Manhattan a lot less now that I no longer worked there. Partly, of course, I spent a good part of the years from 1988 through 1990 on travels for my research project on urban highways, but I also found Manhattan oppressive many of the times I did go there. Too much bustle, too much change. Was it just that the agility of foot, body, and mind was no longer equal to the challenge that had exhilarated me earlier? Or was Manhattan really becoming too overcrowded, impersonal, and yet outrageous? Brooklyn Heights, where, through a chance sidewalk encounter with the publisher, I agreed to a two-day-a-week (hah!) job as editor of the *Heights Press,* provided a seeming degree of relaxing sedateness and convenience that took the edge off anxious desires for the trip under the river to that "center of the universe." (Even in Brooklyn Heights the calm was too often shattered by the new scourge of car alarms going off for no good reason; a terrible law provided insurance discounts to car owners who installed them.)

In February of 1993 there came a foretaste of

BROOKLYN HEIGHTS PROMENADE, JULY 1993.

what was to happen. A bomb, exploding in an underground garage of the World Trade Center, killed six people and injured at least a thousand. The towers were closed for about a month. Four men were convicted of direct involvement, and ten others, including a blind cleric named Sheik Omar Abdel-Rahman, were also subsequently convicted of conspiring to wage a terrorist campaign. However, most New Yorkers—I include myself— were soon acting as if nothing extraordinary had happened. When, a little over two years later, a truck bomb destroyed a federal building in Oklahoma City and killed 168, including many children, memories of the World Trade Center bomb led to the initial assumption that this likewise had been the work of Muslim terrorists. But it quickly turned out that the man responsible was a libertarian radical, Timothy McVeigh, who was said to have been enraged by the botched federal move against a cult in Waco, Texas, that had culminated in the deaths of four government agents and seventy cult members.

Such events did not impinge much on life in Brooklyn Heights, where I was busy with things like squabbles within church congregations and construction on the Heights perimeter (the Heights itself being quite fully built up and its historic district designation blocking most new development). I continued taking photographs but focused chiefly on what would have local news value, or be of local interest. In a sense I was shooting on assignment, but, since I was the editor, it was a matter of self-assignment.

One self-assignment was to cover a location shoot for the ABC soap opera *General Hospital*. The character Lois, supposedly a local girl, was getting married to a snooty out-of-towner. Extras congregated on the stoops of Sidney Place, indicating an active street life quite alien to the block's usually empty look, as Lois enthused, "This is what normal people call a neighborhood. Isn't it great!" She repeated this for several takes until she couldn't do it one more time, and then the wedding party proceeded to a nearby Gothic church no longer serving as a church, where exterior shots were made of the people going in. The wedding ceremony itself would be or had already been shot in an interior back in California.

Brooklyn Heights, with its brownstone streets and the great views from the Heights Promenade, had become a most popular setting for movie, television, and advertising scenes. What at first seemed exciting to the residents became a growing nuisance as large stretches of curbside space were reserved for the great trucks and vans that even a more modest operation seemed to require. Local parking habits were badly disrupted. A street might be closed off for seasonal effects, as when artificial snow was dropped in summer on a couple of hundred feet of Remsen Street, whose nineteenth-century buildings were chosen as a background for *The Age of Innocence,* the period film based on an Edith Wharton novel. Sometimes, if a night scene were being shot, there were also complaints about the lights and noise. When locals viewed the final products, they might see only a few fleeting seconds of what had taken so much personnel, time, and equipment to film. And they might laugh at the result. After watching *Prizzi's Honor* our son Tor chuckled over Jack Nicholson entering a car from a stately townhouse on Pierrepont Place only to arrive in the next scene at the apartment building directly opposite.

The great national entertainment around this time was the O. J. Simpson case. Accused of murdering his ex-wife and a friend of hers in June 1994, the onetime football star was acquitted in October 1995 after a televised trial, but was found financially liable in a civil trial that did not end before February 1997.

A young man named Bill Gates had become the world's richest through all but monopolizing computer programming (in fact one federal judge would find him in antitrust violation). The "virtual reality" conjured by computers seemed at times to be replacing the real thing. What had been walkie-talkies were transformed into cell phones with vastly greater range. Every few months seemed to bring a new wrinkle in sound and video recording and transmission. Much as all this change had its enthusiasts, I wondered if it didn't also breed an unconscious desire for a return to the past. Ancient Egypt was turning up in museum shows. Even when, as in a Brooklyn Museum exhibition of 1997, the focus on women carried more than a little contemporary feminist message, there was still the evidence of a culture that had survived remarkably intact and minimally changed for some three thousand years. Comforting thought. (A matter of curiosity: In Berlin a few years earlier I had seen the famous head of Nefertiti and been struck by the uncanny sense that this could have been the face on a late-twentieth-century *Vogue* cover.)

TIMES SQUARE, LOOKING SOUTH FROM 45TH STREET, MARCH 2001.

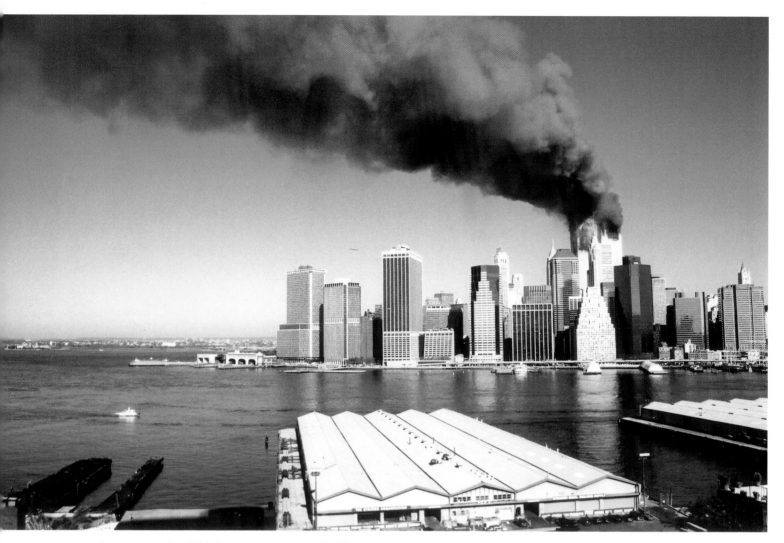

SEPTEMBER 11, 2001, APPROXIMATELY 9:15 A.M.

On a beautiful morning in September 2001—a Tuesday, newspaper makeup day—I slept a little later than usual. I wasn't in the usual doubles tennis game at the club around the corner, and so I didn't need to get up in time for it. As I was shaving I heard a thud and the panes in the narrow bathroom window shook slightly. Perhaps a construction blast somewhere in the vicinity? I looked down and also straight across to the Battery, but all appeared normal. After shaving I walked to the kitchen, on the side of the building that faced Brooklyn. There was another thud, seemingly stronger than the first. Through the open kitchen window came a woman's cry: "My god, a second plane hit the World Trade Center!" On a roof below us, Elaine and I saw a couple standing and gesticulating as they looked toward Manhattan. We ran to

the other side of our building to see the tops of the towers enveloped in smoke and a long black cloud beginning to drift south against an otherwise clear blue sky. Terrorists! It had to be! But how could anyone do such a thing?

I finished off a roll in my camera and, not knowing who else might have recorded it (in retrospect, how naive to wonder about that), I rushed off to the photo shop. The newspaper issue I had planned and in good part already laid out would have to be scrapped for an entirely new one. At NBC, I had thrown together emergency news broadcasts, but I thought nerve-racking circumstances of that sort were behind me. On my way to the shop I felt moments of faintness and loss of balance, and steadied myself along a building wall. In the shop a television set was showing dreadful pictures while

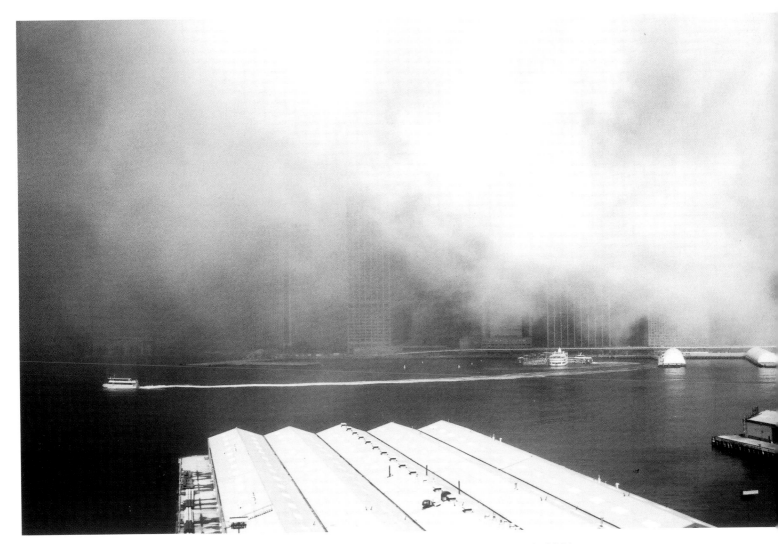

SEPTEMBER 11, 2001, EARLY AFTERNOON.

anxious reporters' voices reflected the general confusion. Then—unthinkable—one of the towers collapsed. I hurried back home and saw crowds streaming to the Promenade to look as the smoke began to obscure the entire Lower Manhattan skyline. What if there was poison gas? Back upstairs, I photographed grayness shading into blackness.

Two members of the newspaper staff had happened to be on the Manhattan side when the planes hit, and they had also taken pictures. This would turn out to be unquestionably and by far the most photographed disaster in history. We got out a small paper almost entirely devoted to what the world had just lived through, was still living through. I was sorry to have lived long enough to see this day; this wasn't anything I had ever wanted to know about.

The whole story, the deaths of all those people,

the brave firemen—eight members lost from the firehouse around the corner from the newspaper—has been told, and yet can never be told. Too real to ever seem real.

Still, disaster is not the end of everything, not the end of the city. In the coming days, Mayor Giuliani would rise to true greatness as he directed the recovery efforts and comforted and reassured his city.

Nothing could, however, quickly dispel the air of depression that hung over us for weeks. As one met acquaintances on the street, as I did frequently in the Heights, the immediate question was—it needed hardly be spoken—"Did you know anyone?" Surprisingly, considering how many Heights people worked in the financial district, remarkably few from the neighborhood had perished.

197

It was two weeks before I ventured again into Manhattan. The air in Brooklyn Heights was still bad, and it was much worse as one got closer to what was being called Ground Zero. (No poison gas, but anthrax-laced items sent through the mail, whether from Islamic terrorists or some domestic crank, claimed five lives in various places along the Eastern seaboard.) Some subway lines were out and stations closed, but people flocked to see what they could—which wasn't much: glimpses of one tower's bit of leaning wreckage still standing, something of the shattered hulk of one of the center's secondary buildings. Although the newspapers and television carried pictures of the devastated area daily, police guarding its perimeter were extremely sensitive about ordinary people taking pictures. For some days there was even an official prohibition. I didn't carry a press pass, and, when I pointed my camera at a distant ruin, a short policeman held up a plastic coffee cup and gave a jump to try to block my shot.

In the offices of nearby buildings that hadn't been hit or that had suffered only light damage, a semblance of normal activity quickly returned. A regular New York tempo resumed, people hardly taking notice of the heavy police presence and National Guard contingents. Almost a month went by before the United States responded militarily—with a near unanimity of patriotic support—by striking at terrorist camps and strongholds in Afghanistan. The offensive, at least in its early phases, appeared very effective, even if the terrorist mastermind and financier Osama bin Laden evidently got away.

The shock wore off, but the memory stayed. Even now I look out my window in disbelief at the changed skyline. In my mind I see the towers burning, the towers gone, the skyline blotted out—the skyline I once thought of as my most reassuring reality and my connection to magic.

Whether or not it had anything to do with the need for reassurance in the months following the disaster—it probably didn't—the need to be on a cell phone when on the street seemed to infect half the populace. Maybe the phones were a substitute for cigarettes, which had become illegal to smoke in New York almost everywhere except the street. Many smokers really wanted to give up the habit, and it probably helped to hold something in one's hand. Be that as it may, what otherwise was beginning to feel like the New York we had known right along was registering unease about the new president. Only the stiffness of Clinton's Vice President Al Gore had prevented his runaway win over the son of former President Bush; even then he won the popular vote by half a million, but young Bush was given the presidency by a 5–4 decision of the Supreme Court after it intervened in Florida's disputed ballot count. The bubble corporation Enron, with close ties to the Bush administration, was only the most egregious offender in a series of scandals that took in a long list of names, including such as Arthur Andersen, Merrill Lynch, Tyco, Rite-Aid, and even Martha Stewart. Companies were laying off thousands. The stock markets were on a downward course that would only get worse. In the summer of 2002, Bush II began speaking of a "pre-emptive" invasion of Iraq, although that country's dictator, Saddam Hussein, had made no aggressive moves beyond his borders for eleven years since his defeat in the Gulf War. A sense of family shame that the elder Bush had stopped short of driving the nettlesome Saddam out in that war may also have piqued the son. With Osama bin Laden still unaccounted for, the war against an elusive terrorist network offering few clear-cut targets, and the economy fraying, the choice of a defined target like Saddam's Iraq offered Bush a way to focus war fever and keep patriotic sentiment rallied behind him. On questionable evidence that Saddam was building a seriously offensive capability through nuclear and poison weaponry and even flimsier evidence linking him to the World Trade Center attack, Bush urged his nation into war as most of the world watched in horror. The so-called "liberal media," under neoconservative assault ever since the sixties, had turned so uncritical that for the most part they hardly questioned Bush's assumptions. And the Democratic party, afraid to look unpatriotic, was so at sea that it lost the 2002 congressional elections it had been expected to win.

AT ALLEN AND EAST HOUSTON STREETS, LOWER EAST SIDE, JULY 2002.

Trivia trumps, even in a time of anxiety. As people tired of sitcoms and cop series, television producers came up with "reality"—a reality as far removed from the real world as possible. The characters in the new shows "survived" competitions on tropic islands, they married "millionaires," and did whatever other "real" things their creators could dream up. The beauty part (sorry, an outdated phrase) was that the volunteers picked for these shows were not actors and didn't have to be paid professional fees, and the shows could be shot with small, relatively inexpensive cameras, while little in the way of special setups or lighting was required. "Production values," once so dear to producers and directors, weren't needed. A cruder, home-movie look made "reality" that much more "real." Audiences seemed to eat the stuff up.

Not to call trivia necessarily bad. After all the heaviness New York had been through, it could use a bit of lightness. Arquitectonica, the Miami-based husband-and-wife team of Bernardo Fort-Brescia and Laurinda Spear, won a design competition for the Westin Hotel at the Eighth Avenue end of the transformed West 42nd Street entertainment block. Paul Goldberger at the *New Yorker* was aghast, but the idiosyncratic critic for the *New York Times*, Herbert Muschamp, was delighted, writing in the October 22, 2002, Sunday issue: "Look up, people. This is New York. We live in one great ugly town. Not being hung up on beauty is what makes life here possible, even thrilling." Even he didn't like the multicolored lower part but praised the tower, split by a willowy arc, as "erotic enough." My own reaction was somewhat the reverse: I found myself liking the yellow, red, and orange triangles and quadrilaterals more or less haphazardly forming the base, but it bothered me that the arc was just a linear device. I wanted to see more dramatic separation of the tower's two halves, one part projecting beyond the other. The tower was a case of jazzy surface decoration, whereas the base came closer to architecture as "form giving"—whose outstanding New York example still was Frank Lloyd Wright's

Guggenheim Museum. At that, the Westin was a cheery arrival.

Michael Bloomberg, a financial media mogul, had spent almost $100 per vote ($75.5 million altogether) of his own money in a campaign for mayor that had Giuliani's blessing. After he won he quickly let it be known that he was not going to advance such Giuliani pet projects as a new Yankee Stadium in Midtown Manhattan. A behind-the-scenes mayor, not a publicity seeker, he differed from Giuliani in other ways, too. He reached out to African American politicians, labor unions, community boards, and other constituencies that had felt slighted. He faced huge economic problems resulting both from September 11 and the national recession. He had to figure out what to do about immensities of garbage that could no longer go into the prematurely closed Fresh Kills landfill on Staten Island. (He negotiated for out-of-town and out-of-state localities to take it, at least for the time being.) He was especially determined to reform the public schools, winning from Albany what no earlier mayor had gotten: full control over the school system. Although low-key and pragmatic, Bloomberg occasionally was given to seeming quirks, like his insistence that the new school administration, and a sample school, be housed behind City Hall in the ornate Tweed Courthouse that for well over a century had been a symbol of Tammany Hall corruption. (The Museum of the City of New York, far uptown, had counted on getting the building.) In traffic matters, Bloomberg departed from Giuliani policy by favoring pedestrians and mass transit over private vehicles. He also looked for ways to support the barely employable and the unemployable. He struck me as a mayor I had more confidence in than in any predecessor. And the city as a whole welcomed his refreshingly factual, unpolitical approach . . . until hard choices, requiring cuts and layoffs, began to hurt people, and loud grumbling grew about a billionaire mayor perceived (wrongly I thought) as unfeeling.

WESTIN HOTEL, EIGHTH AVENUE AT 42ND STREET, JANUARY 2003.

The city may have been going strictly on momentum, but construction and planning hardly seemed affected by the hard times. The Museum of Modern Art was into a big expansion; downtown Brooklyn was sprouting buildings; a long fought over project to replace the Coliseum at Columbus Circle was materializing as a twin-towered megastructure, designed by David Childs for AOL Time Warner, a huge communications conglomerate that would soon itself be in dire financial straits, making one wonder if it would be able to foot the bill. Not one but two competitions were held for the World Trade Center site. Daniel Libeskind, architect of the Holocaust Museum in Berlin, won with a design that would preserve part of the pit exposed by the disaster. On the day after the decision was announced I went to the site and saw the rubble now replaced by provisional construction.

The city was becoming ever more challenging. Frank O'Hara, a poet I had known slightly in college—he died tragically early—understood and loved it in all its gritty magnificence. Here is "Walking":

I get a cinder in my eye
 it streams into
 the sunlight
 the air pushes it aside
and I drop my hot dog
 into one of the Seagram Building's
fountains
 it is all watery and clear and windy

the shape of the toe as
 it describes the pain
of the ball of the foot,
 walking walking on
asphalt
 the strange embrace of the ankle's
lock
 on the pavement
 squared like mausoleums
but cheerful
 moved over and stamped on
slapped by winds
 the country is no good for us
there's nothing
 to bump into
 or fall apart glassily
there's not enough
 poured concrete
 and brassy
reflections
 the wind now takes me to
The Narrows
 and I see it rising there
 New York
greater than the Rocky Mountains

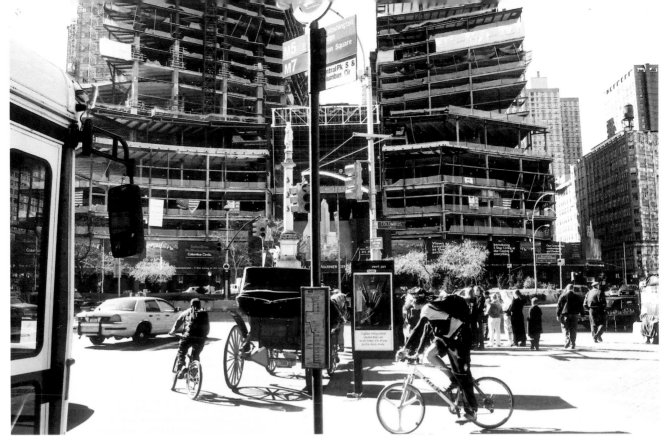

COLUMBUS CIRCLE: AOL TIME WARNER BUILDING UNDER CONSTRUCTION, MARCH 2002.

WORLD TRADE CENTER SITE, FROM LIBERTY STREET, FEBRUARY 2003.

For centuries, New York had been a creature of the sea. A great harbor had invited the creation of the city. Shipping had nourished its growth into the world's leading commercial and financial center. When I arrived here as a boy, the bay and the rivers were alive with ocean liners, freighters, tugboats, ferries, tankers, lighters, trawlers, barges, scows, patrol vessels, Coast Guard cutters, sightseeing ships, pleasure boats, and all manner of smaller craft. At night in Brooklyn Heights one heard a constant, friendly din of toots and whistles. When it was foggy, there was the deep, mournful sound of foghorns. A distant but particularly profound blast in the evening would signal the departure of a great transatlantic liner.

With the years, the harbor grew quieter. Jet planes replaced the liners. Container ships and tankers grew too big and deep for the old piers, and other ports took business away. Ferry crossings were replaced by tunnels and bridges. Fish arrived by trucks rather than fishing boats. People could live in Manhattan without knowing they were on an island. To be sure, the Staten Island Ferry still ran. The Circle Line still took tourists around Manhattan. A sailboat or a speedboat would be seen here or there. But the working din of the working port was stilled.

To the eye that had missed the sight of the former activity, the new millennium brought some amends, even if the ear still had to go begging. Smallish commuter ferries, many of them hydrofoils, were arriving and departing at Lower Manhattan in the morning and evening rush hours. Following the September 11 calamity, their number grew. Perky yellow "water taxis" were added to that number. Even as the subway token finally died, victim of the electronic MetroCard, Walt Whitman's "you that shall cross from shore to shore years hence" took on new truth. Worrisome as the future looked as we began coming out of a long, cold, and snowy winter in 2003—but when did the future ever not look worrisome?—this city of the sea was recapturing something of its nautical heritage.

New York, I suggested earlier, had not entirely banished nature but had instead sprouted something that seemed almost greater than nature: the soaring habitations of humanity creating a new universe. But water—nature—was part of its being, and was reclaiming its place in this wondrous construct.

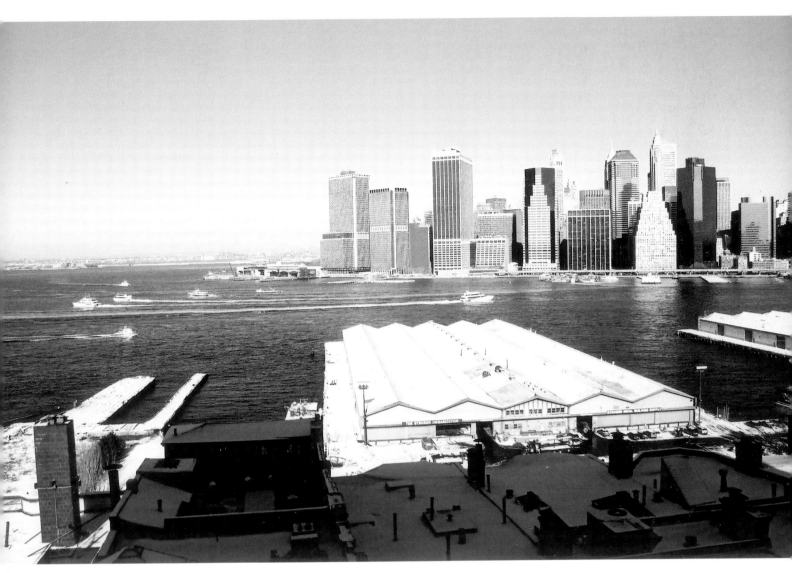

SMALL COMMUTER FERRIES HAD GREATLY INCREASED IN NUMBER SINCE SEPTEMBER 11, 2001,
BRINGING A NEW KIND OF ACTIVITY TO THE EAST RIVER ALONG LOWER MANHATTAN.
MARCH 2003.

PHOTOGRAPHY NOTES

While never deeply interested in the technological side of photography per se, I've needed to know enough about cameras, films, and processing to get the results I hoped for.

My first camera, as mentioned earlier, was a Kodak 620 Brownie Special, a mildly streamlined version of the rectangular boxes then most commonly in use for taking "snapshots." In addition to an "I" setting ("instant") for a shutter speed of about 1/25 second, it also had a "T" setting for time exposure and two distance settings for "5 to 10 feet" and "beyond 10 feet." The camera took roll film whose 2 x 3-inch negative frames were horizontally aligned along the film strip. Since the orthochromatic film (Kodak Verichrome) then in popular use was sensitive to all colors except red, the use of lipstick made women's lips come out simply black. My "Uncle Rote" Rothmaler, who gave me the camera, had his film processed by Pavelle Laboratories at 16 East 42nd Street, a place favored at the time by serious amateurs, and I had at least some pictures also processed there.

In June 1953, after buying a used Voigtlander Vito II 35mm camera at Willoughby's, 136 West 32nd Street—one of few camera shops from the period still surviving—I began taking my films to Weiman & Lester Photoservices at 106 East 41st Street on the suggestion of a Voice of America analyst. Following my entry into Columbia Journalism that fall I began learning to develop negatives and to print enlargements in the school's darkroom. I also learned to handle a 4x5 Speed Graphic and some other cameras. When I began my globe-girdling scholarship travel in 1954 I had with me chemicals and a small 35mm film developing tank, but a roll or two developed on shipboard turned out imperfectly—besides, it was a lot of trouble—and I decided to rely thereafter on commercial developing even if it put a strain on my meager budget.

I primarily planned to take black-and-white pictures, but I also thought it would prove useful and perhaps profitable to bring back color slides of my travels. A second camera would be needed if I wanted to switch quickly from one medium to the other. In Frankfurt I tested a Retina 1B 35mm camera and found the lens very good, but I didn't like the way it handled, and decided instead to go for a larger-format 2 x 2-inch twin-lens reflex Rolleicord. For the remainder of my travel year I used this for most of my black-and-white pictures.

In Paris I came across the brother of a college roommate who was sampling the expatriate life and doing a lot of photography. I asked him for a good place to take my undeveloped rolls of film. He directed me to Pictorial Service: "They do the work for Cartier-Bresson." Somewhat intimidated at the thought, I made my way to 17, rue de la Comete—its courtyard paved with stones, the stucco of its ancient low buildings cracked and peeling. Did I have the wrong address? No, a small sign outside a stairway indicated "Pictorial Service." Up the worn steps I found a counter, behind which a wall held great enlargements of photos unmistakably by the master photographer. Developed negatives plus contact sheets would not cost more than in an ordinary photo shop. I decided to order a few enlargements. Their quality was astonishing. Finally I was seeing my photographs as I thought they should look when I took them!

The head of Pictorial Service, Pierre Gassmann, was outgoing. "I knew these fellows," he said, "Henri-Cartier [he always referred to Cartier-Bresson that way], Robert [Capa], Chim [David Seymour], and I told them, 'You have great eyes, but you're terrible darkroom workers. Let me handle the darkroom and you take the pictures.'" As I understood him, that was the genesis of Magnum, the agency that became a byword in photojournalism. When I asked Gassmann the secret of the beautiful blacks in Pictorial Service prints, he said, "We use Ilford paper. Ilford has three guys working out their formulas and Kodak has hundreds, but the Ilford guys beat them." Gassmann also said he had visited Weiman & Lester, Modernage, and other New York labs, and had found their enlarging operations too automated for the very best results. "Our people still focus by hand," he said. "This gives them a second or two to really judge the density of a negative and adjust the exposure time."

All throughout my travels I made careful notes of every exposure: the camera, the film, the date, the place, the subject, the weather, the speed setting, the f-stop. I wrote the information in tiny print on 2 x 3-inch cards. I kept this up after my return to New York as long as I was still using the Voigtlander. This somewhat time-consuming discipline had the effect of keeping down the number of exposures I made—very good for my tight budget—and forced me to make sure I really wanted the picture I was aiming at. As a result I got a high proportion of negatives that seemed worth printing. The Voigtlander also imposed another discipline, since it lacked a coupled range finder, and I worked without a light meter. Thus I had to learn to estimate the distance to my subject accurately for the result to be in focus, as well as to gauge the amount of light. This would prove useful when I later moved on to more sophisticated cam-

eras. Often shooting moving subjects and fluid situations, I would find it faster to estimate distance and exposure than to arrive at them by means of instrument—and thereby risk missing the picture.

The two earliest photographs in this book—of the HMS *Malaya* and of me at Gowen Field—were made with the 620 Brownie Special. The 1953–54 photos were taken with the Voigtlander. I can document, for instance, that the October '53 picture of cars approaching the Brooklyn-Battery Tunnel was shot on Kodak plus-x film at 1/100 second with an f11 setting in a condition of hazy glare, while the one of the two boys squaring off on East 106th Street in March '54 was made on a cloudy day, at f8 and 1/50 second, with Kodak super-xx film (rated at 200 ASA, this was still the fastest general-use film with good resolution; I had tested the new 400 ASA tri-x film in Hong Kong near the end of my travels, but found it at that time too grainy).

Only two photos in the book were made with my Rolleicord: the one of Mike Wallace in the DuMont studio and that of the last of the Third Avenue El, both dated October 1955. They were made on Kodak Verichrome film (which by then was panatomic, sensitive even to red). About this time I made a chance acquaintance with a man in Brooklyn Heights who was a great fancier of cameras and photographic equipment, but by his own admission couldn't take a picture that was any good. He said he had a Leica that ought to be in the hands of someone who knew what to do with it. So—for what I think was $125—he sold me his Leica 3C and a set of lenses: 35mm, 50mm, 90mm, and 135mm. The 1956 photos were made with that camera, but since I now had a well-paying job and could afford to shoot in somewhat more profligate fashion, I no longer tried to keep a finely detailed exposure record.

Early in 1957, the Leica equipment was stolen from the tiny apartment I then had on Morton Street in Greenwich Village. However, through insurance I was able to replace it with comparable equipment, including a Leica 3F body. All the pictures from February 1958 through June 1971 were made with that camera, the earlier ones on plus-x film, but many, starting in December 1965, on improved tri-x film, which I began increasingly to prefer, even in sunny weather, for its greater range of gray tones. At the same time, I always wanted to be prepared for situations with less light (I never used flash). Plus-x, more fine grained, I now found overly contrasty at times. (In October 1963, I also tried Adox KB 17 and KB 21 films—note the Brooklyn and Verrazano Bridge photos of that month—but for what-

ever reason, perhaps cost or lack of easy availability, I didn't stay with that brand.)

The work that would eventually lead to this book really began in March 1959, when I started keeping a record on 8½ x 11-inch sheets under the title "New York Series." I noted down the date, camera, film, subject, plus lens focal length and whether I employed a filter, but no longer noted exposure time or f-stop. I've kept that record ever since. In the beginning, I used a light yellow filter for most of my black-and-white work and have almost always used an ultraviolet (or daylight) filter with color film. The yellow filter was for bringing out any blue sky that might show, but from about 1962 on I rarely used filters with black-and-white film.

A 90mm lens comes into play in such pictures as the upward view of building tops along lower Fifth Avenue in March 1959, the sculpture above the Parke-Bernet entrance in July of that year, and the unfinished Time-Life Building that August. The view up Broadway south of Times Square, April 1959, and also, I believe, the view down Fifth Avenue past the Guggenheim Museum in the same month, were made with a 135mm lens. Aside from the view down Park Avenue to the Pan Am Building under construction in July 1962, there are no other photos made with a lens of that length. After a period of flirtation with the longer lenses, I decided that I generally got more interesting results by working closer to my subjects with a 50mm or even 35mm lens.

Most of the pictures I've taken have been single exposures at moments when the subject elements seemed to fall into place, and there was no opportunity for a second shot. Too often, though, some unnoticed element would mar the composition. There have also been many times when I watched a situation unfolding before me, and I would make several exposures until I thought I had the right one.

For instance, the February 1961 photo of a woman with a pastry box taking leave of a friend with a baby carriage on Washington Street was the last of nine exposures. I had been intrigued by the conversation taking place outside a defunct café with that "vase" painting of a nymph chasing a faun, and when the women stopped to talk, I tried to capture them in effective relation to the setting. I was using a Leica with a 90mm lens and plus-x film. In another case—that of a girl leaning languorously against a post at the Times Square subway station in September 1973—the exposure I chose to print was the second of four. Not being sure I had caught her and the others quite right, I made two more exposures, but these turned out not to be an improvement. Here I was

using a Nikon 2S with a 50mm lens and plus-x film.

At the end of my globe-trotting I had used almost all that remained of my money to buy that Nikon 2S camera together with an astonishingly fast (at that time) f 1.4, 50mm Nikkor lens to give to my father. "What did you waste your money on that for?" my ever-practical mother complained upon my return to Brooklyn. The camera nevertheless proved a joy to my father, who went on to acquire additional lenses and another Nikon body that he bought secondhand. He took great delight in photographing his grandchildren and a variety of other subjects. Following his death I inherited this Nikon equipment, and most of my pictures between October 1971 and 1975 were made with a Nikon. But I was beginning to want a smaller camera to carry around with me—something I could carry in a pocket—and I found that my wife Elaine's simpler Konica gave me quite satisfactory results, so I "borrowed" it for most of my pictures between 1976 and 1979, including the ones of the Bronx underpass in February 1976 and the Brooklyn underside of the Manhattan Bridge in June 1977. I similarly borrowed my son Tor's Ricoh 500G for the shot of the hot dog-eating women crossing Sixth Avenue in July 1980 and also for the "Better Days" one from April 1987.

From 1982 through 1988, the record tells me, all the other pictures in the book were made with a Chinon Bellami. I have no recollection of that camera, but it must have been fairly compact and have had a lens with focal length of about 40mm. In the early '90s I used an Olympus OM-1, another pocket-sized camera. I don't know what camera I used for the soap opera scene in May 1995, as I took that picture on a camera briefly borrowed from the *Heights Press* office and have only the newspaper date and story to verify the location and time of event.

By the mid-90s I was beginning to suffer from cataracts, which made focusing and reading camera markings difficult. For my birthday in 1995 Elaine therefore bought me a Canon EOS Elan, with autofocus and a 28-80mm zoom lens. You could call it an advanced idiot camera. A bit larger and heavier than what I had been carrying, it nonetheless provided a new versatility in framing my compositions (without the need to change from one lens to another) and took care of focus. The latter capability lost some importance after I had cataract operations in 1996, but the zoom lens advantage remained welcome.

Because the newspaper began printing some color pages in December 1997, I phased out my use of tri-x and have shot only color since August '98 (color being readily translated into black and white as needed for reproduction). Mostly I have been using Fujicolor 400, feeling that Kodak colors tend toward gaudiness. Much as I've liked the EOS, I wanted a new pocket model for a trip abroad in 2002 and bought an Olympus Stylus Epic, an autofocus camera with a 35mm f2.8 lens. This has proved very useful, its only drawbacks being the need to turn off the automatic flash and the fact that, like most autofocus cameras, there's a slight delay between pressing the release and the shutter going off. But the lens is just fine. The cover photograph for this book was made with the little Olympus.

While I found it both easier and more affordable to get my film developed and contacts made by a professional outfit—first by Weiman & Lester and after 1965 by Modernage, the price of enlargements was another matter. From 1958 through 1993 I made my own enlargements in makeshift darkrooms either in a kitchen or next to a bathroom, where I could get fresh water for washing prints. At first I used an enlarger made in Czechoslovakia, a country that maintained production standards even under Communist rule, but this limited me to 35mm negatives, and I soon bought an Omega D2, which could handle negatives up to 4x5 inches—not that I ever used it for much except 35mm negatives. Following Monsieur Gassmann's counsel, I used Ilford paper until a camera shop salesman persuaded me to try Agfa Brovira, which became my choice. Mainly I used contrast grade 3, but I also used anywhere from grade 2 to grade 5 depending on emulsion density. Now, for my color processing, I go to a tiny shop called Photoreal in Brooklyn Heights, which does very satisfactorily by negatives and gives me 4 x 6-inch prints. For the very occasional bigger print I go to Modernage, which has proved most reliable.

I remember a story, possibly apocryphal, that *Life* magazine sent a photographer to make a picture of the sculptor Constantin Brancusi in his Paris studio. The photographer shot several rolls of 35mm film, more than two hundred frames. In the midst of it the noted photographer Brassaï arrived. He studied the layout of the studio, appraised the quality of light, then set up his bulky view camera on a tripod and placed Brancusi where he wanted him. Brassaï next examined the composition upside down on the ground glass at the camera's rear, adjusted Brancusi's position, slipped in his negative plate, briefly removed and replaced the lens cap, knocked down his camera setup, packed up the equipment, and left. According to the story, Brassaï's resulting picture beat the *Life* man's efforts all hollow.

Which suggests that it's not enough just to make a lot of exposures and to count on one turning out well.